# DIY WEDDING PHOTO AND VIDEO

PROFESSIONAL TECHNIQUES FOR THE AMATEUR DOCUMENTARIAN

Joanna Silber

**Course Technology PTR**

*A part of Cengage Learning*

**COURSE TECHNOLOGY**
CENGAGE Learning·

Australia, Brazil, Japan, Korea, Mexico, Singapore, Spain, United Kingdom, United States

# COURSE TECHNOLOGY
## CENGAGE Learning

**DIY Wedding Photo and Video:
Professional Techniques for the Amateur
Documentarian
Joanna Silber**

**Publisher and General Manager, Course
Technology PTR:**
Stacy L. Hiquet

**Associate Director of Marketing:**
Sarah Panella

**Manager of Editorial Services:**
Heather Talbot

**Senior Marketing Manager:**
Mark Hughes

**Acquisitions Editor:**
Dan Gasparino

**Project Editor:**
Kate Shoup

**Technical Reviewer:**
Donna Poehner

**Copy Editor:**
Kate Shoup

**Interior Layout Tech:**
William Hartman

**Cover Designer:**
Mike Tanamachi

**Indexer:**
Sharon Shock

**Proofreader:**
Melba Hopper

For product information and technology assistance, contact us at
**Cengage Learning Customer & Sales Support, 1-800-354-9706.**

For permission to use material from this text or product,
submit all requests online at **cengage.com/permissions**.
Further permissions questions can be emailed to
**permissionrequest@cengage.com**.

All trademarks are the property of their respective owners.

All images © Cengage Learning unless otherwise noted.

Library of Congress Control Number: 2012934296

ISBN-13: 978-1-4354-6093-5

ISBN-10: 1-4354-6093-6

**Course Technology, a part of Cengage Learning**
20 Channel Center Street
Boston, MA 02210
USA

Cengage Learning is a leading provider of customized learning solutions with office locations around the globe, including Singapore, the United Kingdom, Australia, Mexico, Brazil, and Japan. Locate your local office at: **international.cengage.com/region**.

Cengage Learning products are represented in Canada by Nelson Education, Ltd.

For your lifelong learning solutions, visit **courseptr.com**.

Visit our corporate website at **cengage.com**.

Printed in the United States of America
1 2 3 4 5 6 7 14 13 12

# Acknowledgments

Like an actual DIY wedding, this book came together only because of the generosity of family, friends, acquaintances, and perfect strangers.

I am so grateful to all the photographers—professional and amateur—who so kindly lent their images to this project: Brant Bender, Katie Clark, Rick Collins, Aaron Hathaway, Remy Hathaway, Myleen Hollero, Ronen Kinouri, Pete Laub, Christian Maike, Carlo Silvio, and Mary Tunnell. Several brides generously opened their weddings to my prying cameras, and I am especially thankful to Mrs. Katie Nelson (cute as a button elf!) and Mrs. Tania Esther for sharing their day with me. Modeling gratitude, general appreciation, and assorted thankfulness for favors large and small (book related and otherwise) go to Mandy and Dany Levitt, Kaley Vander Kodde, and my very adorable and dedicated problem-solver, Remy Hathaway.

I don't really have the words to thank my editor, Kate Shoup, who has (again) shown nothing but kindness, support, and blessedly skillful paring and organization. If I *did* have the words, she would undoubtedly find better ones—and I am so grateful for that. Steady and invaluable editorial guidance also came from Donna Poehner, with whom I happily got to work for the first time. I am also fortunate to be working with Cengage Learning again, and appreciate acquisition editor Daniel Gasparino's tireless patience and encouragement.

Book writing is fun to do, but the people who do it aren't especially fun to be around. I'm lucky to have such wonderful friends and family who manage to look beyond that. To Ben Long, who isn't looking beyond my book writing but rather back at it, thank you for well over a decade of friendship and mentorship. You make me un-crazy.

## About the Author

**Joanna Silber** is a freelance producer, editor, and writer living in San Francisco, CA. A wedding videographer for more than a decade, she has shot and edited hundreds of weddings all over the West Coast. In addition to wedding video, she has produced and edited several award-winning documentaries that have screened at film festivals around the world. She teaches at the Bay Area Video Coalition and writes for peachpit.com. Find more of her work at www.onetakedv.com.

# Contents

# Chapter 2
# Understanding Your Camera Options    27

# Chapter 3
# Basic Production    47

# Chapter 4
# Types of Wedding Coverage                                75

## PART II: THE MARRIAGE

# Chapter 5
# Wedding Preparations                                     95

# Chapter 6
# The Ceremony                                             121

# Chapter 7
# Formal Shots and Cocktails                    139

# Chapter 8
# The Reception                                 155

# PART III: THE HONEYMOON

# Chapter 9
# Image Editing                                        177

# Chapter 10
# Video Editing                                        207

# Chapter 11
# Output and Sharing                                             235

# Glossary                                                        248
# Index                                                           258

# Introduction

Welcome to *DIY Wedding Photo and Video: Professional Techniques for the Amateur Documentarian.* A DIY documentarian is an excellent alternative to expensive professional shooters, and brings creativity and personalization to photo and video projects in ways that professionals can't.

This book is designed to help both the wedding couple and their DIY documentarian navigate the world of wedding photography and videography. If you are considering asking a friend to shoot your wedding, or if you are an accomplished hobbyist shooting a wedding for the first time, this guide will help you plan and execute the project. With detailed information about organization, technical skills, and the common issues in each part of a wedding, this book serves as a roadmap from pre-production to presenting your final work.

There are all kinds of images in this book: pictures from seasoned professionals, snapshots from friends, video stills, intentionally flawed demo shots, and the work of highly practiced hobbyists. This is intentional; this book is not meant to teach the reader to become a professional photographer or videographer, but is instead meant to teach the DIY shooter how to get the best shots possible *with the skills and equipment he or she already has.*

Of course, the best way to improve your images is to practice, practice, and practice some more. Practice involves more than just shooting; it includes looking at your own images to see what works and what doesn't. It also includes looking at other people's work to see what you like and what you don't like. You don't need fancy equipment to practice—or, for that matter, to shoot a wedding. You just need to know how to use the equipment you have well.

Ideally, this book will inspire photographers, videographers, and couples to be creative about their storytelling. I have included ideas in every chapter that highlight some fun and clever ways that DIY shooters can find the imagery and stories that professionals don't have the time, interest, or access to obtain. DIY documentarians can have a real advantage over the professionals: Different expectations, timelines, and access to the characters can make for exceptional storytelling—both in the end product and in the experience of making the piece!

# Who Is This Book For?

Presumably, you picked up this book because you are going to have DIY photo or video (or both!) at your wedding or because you have been tapped as the DIY documentarian at a friend's wedding. Either way, this book will guide you on some important decisions throughout the process. These range from major preliminary considerations, such as going DIY versus professional, to smaller questions, such as whether to use a flash during the reception or a black-and-white filter on the dancing sequence. This book will also give both the bridal couple and the shooter a sense of what to expect at all points in the day, from preparations to the last dance. More specifically, this book shares preparation, production, and post-production techniques and tips with the DIY shooter to improve how well and how quickly that shooter captures the images he or she wants—and to adjust those images as needed.

## For the Bridal Couple

In DIY wedding photo and video, the couple can improve the quality of the final product by helping the DIY shooter understand the timeline and the venue(s) and build a shot list (samples are provided here), by participating in shooting before and after the event, and by contributing ideas and materials. The "DIY Idea" sections in each chapter of this book propose creative projects for giving the wedding documentation a personal feel and hopefully fuel more ideas for both the couple and their documentarian(s).

Of course, when using a DIY documentarian, a couple must manage their expectations. This book helps with that by pointing out some of the difficulties of wedding shooting and situations in which DIY shooting might differ from what a professional might be able to accomplish.

## For the DIY Wedding Documentarian

For the DIY documentarians among you, there is a lot of practical and technical advice crammed into these pages. Some of this information will apply to your ideas and setup, and some won't; some will be new information, and some won't. Regardless of your equipment and experience level, remember that a wedding shoot is unlike any other type of shoot. It's often quite harder. Even experienced professionals can be thrown by certain weddings; changing light, fast-paced action, and high tension don't always make for the easiest working conditions. Going in armed with the skills to manipulate your camera quickly and knowing what you are looking for and what is coming at you is invaluable.

With that warning in place, weddings are also quite often the happiest working conditions you will find. The excitement, joy, and gravity of the event is so thick it is tangible—and it shows in your images. Families are united, friends reconnect, and your

couple takes an important and meaningful step. Being able to capture that and shape it into a story is gratifying—all the more so when you get to put it together and retell it for friends. While it is always an honor for me to shoot a client's wedding, it is sheer joy to shoot a friend's.

# Why DIY?

Depending on your perspective, there are a number of reasons you might go for DIY photo or video. If you are the bride or the groom (or making decisions on their behalf), money and the type of project will be key factors in your DIY decision. If you are the creative given the task, the experience and the artistry will be driving factors for trying your hand at wedding documentation. Let's take a closer look at some of those factors.

## The Price Is Right

According to one report, the average American wedding in 2010 cost more than $26,000—and many available estimates place it closer to $30,000. That figure represented a slight decrease from the previous year, but an almost $8,000 increase in the last 10 years. Except for the reception, photography is often the most expensive line item on the budget, with an average price tag of about $2,500 (estimates vary). Videography doesn't command the same fees as photography, but still carries a hefty average price tag of about $1,500, and can go as high as $10,000. Keep in mind these are *average* prices across the American market. Your local area could command rates closer to $4,000, and photographers to the stars can charge in the tens of thousands, offering multi-camera teams, make-up touch-up artists, helicopters for aerial shots, and sword-swallowing assistants. (Well, maybe not the sword-swallowing assistants, but certainly the team and the helicopter.) To find the costs for the professional services you'd want, look online and call around. Many aggregate websites, such as theknot.com and herecomestheguide.com, compile local listings of vendors as well as provide statistical data about what costs you can expect in your area.

Is DIY cheaper? In a word: yes. DIY wedding photo and video is absolutely less expensive than hiring a professional. With a pro, you are paying for their equipment, expertise, and time, and for the materials and costs of running their business—marketing, liability insurance, office space, etc. Presumably, a DIY shooter will be working for you for free (or for an arrangement you have specified). Of course, even when you disregard the cost of the shooter's time (which may be a huge investment), shooting a wedding will still incur some expenses—batteries, blank media, extra equipment, printing costs, albums, website hosting fees, etc. These should either be covered by the couple or acknowledged as a gift from the shooter.

It's not free, but figuring out the difference is easy math. The DIY approach will be less expensive every single time; it is simply a question of by how much. That being said, there are other trade-offs that are less obvious but must also be considered. Despite the benefits, I do not think that DIY is a good route for everyone just because it is less money! (Those trade-offs are discussed in the upcoming section called "A Bit of Warning Before You DIY," and I encourage you to consider them carefully should you be deciding between a professional and a DIY photographer.)

## A More Comfortable Atmosphere

I have been a professional wedding videographer for over a decade, and the thing I tell my clients and friends is that when they are looking for any day-of-event services, they must be certain they like the vendors they select. A good test is to imagine spending a day with the vendor and decide if that sounds like fun. (For the record, "bearable" is not "fun.") For the couple, vendors are, in effect, guests at the wedding; in fact, most brides will spend more time with their photographer and videographer than they will with many of their guests. Wedding guests will spend time with the shooters, too, so it is crucial to have a person who will mix well with the crowd and who can be authoritative without being intimidating or annoying.

A wedding shooter is often in on some pretty emotional and intimate moments. It can be wonderful and comforting for the couple to share those moments with a friend instead of a paid stranger. Taking that one step farther, the friendship between a DIY shooter and the bridal couple can lend itself to better, more natural images. In professional wedding shoots, the first rule is to make sure your clients are comfortable and at ease; shooting happy and natural pictures of uncomfortable subjects is near impossible. To facilitate that ease, wedding professionals are encouraged to get to know their clients, as the couple's back story will guide the emotional moments, important details, and funny setups that will make for excellent photography. DIY shooters are likely to have the advantage of that knowledge and comfort before they even begin—a benefit that shouldn't be overlooked. (See Figure I.1.)

Finally, for the many couples who don't like showered attention, high drama, and the time spent on professional photography and videography, DIY might make for a more relaxed, low-production atmosphere. That isn't always true; there are certainly professional wedding shooters who aim to minimize the production aspect of their work through a more journalistic style (and DIY shooters who emphasize a high-production approach). In general, though, couples find having a DIY documentarian to be a more low-key experience.

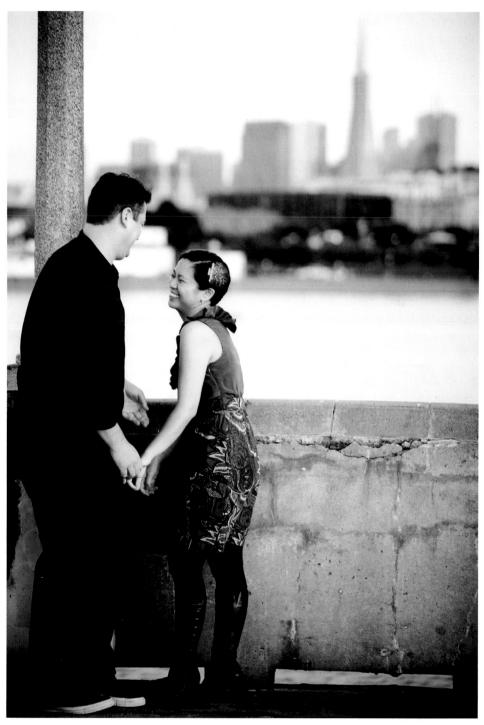

**Figure I.1** Capturing natural expressions of emotion is one of the highlights of wedding documentation—and one of the strengths of a DIY shooter. (Image courtesy of Myleen Hollero; www.myleenhollero.com.)

# A More Customized Product

One of the most compelling reasons to consider DIY documentation is the ways in which you can stray from the package deals and old habits of wedding-industry professionals. I mean no disrespect to the professionals whatsoever (I am one!), but they are catering to an extremely competitively priced market, often with an old recipe that works very well. That is not inherently a bad thing—but it might not compete with the creativity, ingenuity, and hours that someone who is working for fun can muster.

For example, I recorded a close friend trying on different wedding dresses before she actually purchased one. It was a blast and made for hilarious footage that I used in the final video, months later. At that point, she hadn't even hired a photographer—and if she had, that person certainly wouldn't have been in the dressing room of the bridal store with her! Only a DIY shooter—and friend—could have gotten that footage.

I am not suggesting that a DIY documentarian needs to follow his or her subjects for months before the wedding. I'm simply pointing out that a friend can get much more interesting footage and pictures, spanning a longer period of time. Take advantage of that access to make your project creative, fun, and different from the usual fare. (See Figure I.2.) This book is set up to give you some ideas, but the joy of DIY is that there are no rules, no formulas, and no limits to the effort and ideas you can build in.

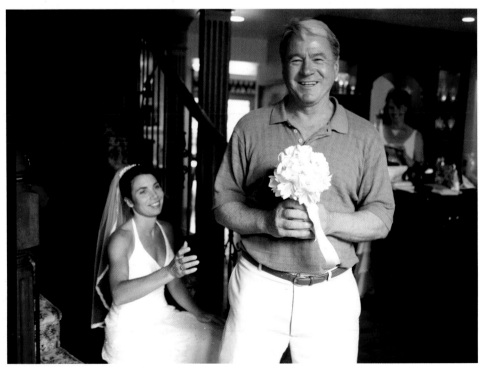

**Figure I.2**  Sometimes a DIY shooter will understand a family dynamic better than their professional counterpart ever could. (Image courtesy of Brant Bender; www.brantbender.com.)

# A Bit of Warning Before You DIY

I mentioned this earlier, but wedding shooting is hard—arguably harder than most kinds of shooting. A professional colleague of mine likes to say that shooting weddings is "every kind of shooting at the same time." By that he means a wedding shooter will be dealing with bright light, low light, action, emotion, candids, formals, portraits, interviews—all while carrying a lot of gear, handing Kleenex to the mother of the bride, scribbling notes on a shot list, trying to learn the bridesmaids' names, and attempting to figure out where grandma went. (See Figure I.3.)

Although I know professional wedding shooting is expensive, I won't argue for a minute that wedding photographers are overpaid. A good vendor combines skill, creativity, gear, energy, and complete attentiveness to capture the couple's whole day in images. It is quite a lot to ask! Furthermore, their reputation rests on it, which means all precautions will be taken to make sure that nothing from equipment failure to natural disaster gets in the way of delivering the final product. (If you think I am exaggerating, I'm not; I keep raw media in a fireproof safe in my office until the moment a project is complete and handed over to the client.)

Why am I touting the skills of a professional in a book celebrating amateurism? Because it's important to know that they are very different. There are wonderful advantages to using a DIY documentarian, but those advantages do not necessarily include the consistency and reliability that you can expect from professionals, who will exhibit their style in their demo work and stick to it. Furthermore, it is important for the couple to understand what a professional goes through on the day of the event and to ask themselves if they want to ask that much of a friend or guest, as it will certainly impede that person's participation in the day's events.

The success of a DIY project relies on the lack of set rules and embracing the idea that you get the images you get (and work with them in post production, if need be). If you can't let go of a particular style or look, or you need consistent coverage of every part of the day, using a DIY documentarian might not be the best idea for you. If, however, you like the idea of a creative free for all that might miss some bits but be rich in emotion and fun, a DIY approach could give you everything you are looking for.

# A Successful DIY Partnership

A successful DIY partnership between the documentarian and the bridal couple relies on extremely clear communication about expectations. (See Figure I.4.) The last thing anyone wants is to lose a friendship over a misunderstanding about what is actually a gift. And of course, many DIY-ers have grand ideas and little follow through after the event is shot—which can be incredibly frustrating for a couple waiting for their video or photo collection.

**Figure I.3** Catching the perfect details in stillness amidst a flurry of activity is just one of the skills in a wedding shooter's repertoire. (Image courtesy of Brant Bender; www.brantbender.com.)

**Figure I.4** The shooter, the bride, and the groom should work as a team to get the best coverage possible. (Image courtesy of Brant Bender; www.brantbender.com.)

Here are some things that should be clarified ahead of time between the couple and the documentarian:

- **Expectations before the wedding day.** Will there be any shooting before the wedding day? An engagement sitting? Interviews? Coverage of the rehearsal? Both sides should know if that time commitment is expected of them.

- **Type of coverage.** There should be agreement about the basic type of coverage—whether it is documentary style, candid, or formal. There is no need to stick entirely to one type of coverage, but it would be a disappointment to shoot for a 60-minute documentary when the couple wants a three-minute, MTV-style, edited video. Having a general alignment in the sense of style is helpful.

- **Wedding timeline.** It is crucial that the couple go over the wedding timeline with the documentarian, discussing the points in the day that are most important to cover. Both parties must understand that the documentarian won't be able to do much else while shooting for complete coverage; other wedding responsibilities are pretty much out of the question, as even participation as a guest will be severely limited. It may be beneficial to discuss the possibility of having a few shooters or

simply not covering parts of the wedding with the same depth as the crucial parts. A shooter can have a great time while also taking a few pictures now and then; just make sure there is understanding when full coverage is important. (See Figure I.5.)

- **Shot list.** The shot list should be built as a team—the couple and the documentarian. Knowing the important people, details, and toasts will also help dictate the shooter's timeline—i.e., when he or she needs to be totally in shooting mode.

- **Equipment.** There are no rules for DIY coverage; theoretically, the whole day could be shot on a cell phone (although I don't recommend it). What is crucial, however, is that the shooter and the couple know what equipment is being used and what the ramifications of those decisions are. For example, if there is no tripod used, video footage will be shaky and low-light still photography will be severely limited. If you shoot video on a point-and-shoot or DSLR camera, audio quality will likely be poor when shooting from a distance. Discussions about equipment beforehand will afford the opportunity to talk about purchases or rental gear, workarounds, and shots that might not happen—all of which will keep expectations in check and disappointments at bay.

- **Money.** The implication of DIY documentation is that a friend will be shooting for you at no cost. There is, of course, every variation on that. Whatever arrangement you have with your documentarian is fine—as long as you both agree to it ahead of time. The couple should remember that the gift of time provided by the shooter is tremendous; the documentarian should remember to take his or her tasks seriously, regardless of compensation (or lack thereof). Costs outside of time (media, batteries, rental equipment, printer paper, albums, etc.) should be discussed.

- **Post production.** Some couples will want to handle image processing or video editing themselves; others will wait anxiously for a finished album or video to be dropped in their lap. Make sure to clarify at what point the documentarian has finished his or her job and in what format the media should be handed over.

- **Post-production timeline.** Oh boy, this is the big one. As a professional video editor, I have been contacted numerous times for editorial services by couples who had a friend shoot their wedding with the expectation that it would also be edited. After a year or two and no results, the couples were anxious to see their videos but hesitant to bug their friends, who had kindly shot the footage but hadn't gotten around to editing it. It's easy to sympathize with both parties here, but this type of situation can jeopardize a friendship if it isn't managed carefully. Avoid potential problems by outlining a reasonable timeline of deliverables.

**Figure I.5** Make sure the couple and the shooter agree on when photo and video coverage stops. It might be when the vows are exchanged or it might be when the last sparkler goes out. (Image courtesy of Brant Bender; www.brantbender.com.)

## On with the Show!

While it might seem tedious to consider all of these nuances before you even pull out a camera, I assure you that having a mutual understanding of what the project is will make everything run more smoothly—and will ultimately be more fun for the shooter and the couple alike. That reminds me: the main reason to do DIY documentary? It's really, really fun. Let's get started!

# PART I

*The Engagement*

- Chapter 1: "Gearing Up"

- Chapter 2: "Understanding Your Camera Options"

- Chapter 3: "Basic Production"

# CHAPTER 1

## Gearing Up

**In this chapter:**

- Gear essentials
- Gear extras

If the bridal couple tapped you to be their wedding historian, chances are good that you already own a camera and have displayed some interest, talent, or expertise in photography or filmmaking. Covering a wedding can be as simple or as complex as you want it to be (and perhaps as the couple requires of you), with the complexity (or lack thereof) starting with your gear. For example, you could cover the whole ceremony using just a camera phone and an excellent eye, or you could rent a kit of professional gear including external microphones and different lenses. This chapter discusses both the equipment you likely already have and the equipment you might want to best shoot a wedding for your—and the bridal couple's—particular goals.

# Gear Essentials

It goes without saying that to photograph a wedding or record one on video, you need a camera. If you are shooting both photographs and video, you might need two separate cameras—although in many situations, one camera will be able to perform both roles. Just in case you haven't fully grasped this point, I'll repeat myself: To shoot a wedding, you need a camera. Got it? Okay, good. Moving on. Let's talk a little about just what form that camera might take.

## Point-and-Shoot Camera

Also called a *compact camera*, the *point-and-shoot camera* was initially designed to be a simple film camera for amateur users wanting something easy to carry and ready to capture life's moments. Originally developed with *fixed focus* lenses, which require no power for electronically moving parts, most point-and-shoots today offer *automatic focusing*. Automatic focusing relies on a sensor to analyze the image and determine the correct *depth of field*—or which part of the image the camera should focus on. Figure 1.1 shows a typical point-and-shoot camera.

**Figure 1.1** An example of a point-and-shoot camera. (Image courtesy of iStockPhoto.com/Aeolos.)

## What Is Depth of Field?

*Depth of field* (*DOF*) is a term you'll hear thrown around a lot, and it's something you should understand. It is defined as the range in distance between the nearest and farthest points in a scene that appear in focus. If a large area falls into the range focus, you have a *deep* or *wide* DOF; if the range of focus is a small area, it is called a *shallow* or *narrow* DOF. Playing with DOF enables you to focus an entire image, or to create an image that is crisp in one part and soft in another. Managing DOF is especially useful in wedding imagery, where the contrast of sharp focus and soft blurriness is regularly used to accentuate the subject and create a warm and romantic feel. (See Figure 1.2.)

The DOF in any given shot is a number that is calculated by several variables, including how far the subject is from the camera, the focal length of the lens, the lens f-number (or *f-stop*), and the format size. Camera lenses often give clues on how to best achieve particular DOF measurements with specific markings, but calculating exact DOF numbers will likely not be part of your wedding-day shoot. Understanding the factors involved, however, will give you greater control over DOF so you can quickly try different options to achieve the look you are after. Let's go through the variables briefly:

■ **Distance from the camera to subject.** The greater the physical distance, or depth, between you and the subject, and between the foreground and background of the image, the easier it will be to create contrast between the sharp and fuzzy parts of the image. If you are close to your subject, and he or she is flat against a wall, there won't be room to create the differential between the areas that are in and out of focus.

**Figure 1.2** The crisp and focused image of the decorative wood work on the pew and the soft, unfocused image of the wedding scene below is an example of playing with depth of field.

## What Is Depth of Field? (continued)

Ideally, you will stand a good distance from your subject, who in turn will have a great deal of space or depth behind him or her. Playing with these distances will change how dramatic your contrast between sharp and soft parts of your image is. A good way to start is to stand back as far as the zoom on your camera will allow while still maintaining nice image composition. (You don't want your subject to be too small.) From there, move closer in and zoom out, noting how the image changes. (Note that if distances are noted on your camera lens for precise calculations, they will be noted in meters.)

- **Focal length.** In photography, *focal length* measures how much a lens bends light to converge onto a camera sensor. A short focal length bends rays strongly and focuses with a wide angle of view. This is called a *high optical power*, because the light rays are bent at a sharp angle. A long focal length bends light more gradually and is considered a lower optical power. This is used to focus an image that will be magnified and with a narrower angle of view. Focal lengths are described in millimeters, and actually measure the distance between the middle of the lens and the point at which the light rays converge. A *prime lens* will have one focal length, such as 35mm or 50mm; a *zoom lens* will be described by its range of focal lengths, such as 70mm–200mm, which would be a telephoto lens that magnifies images. On a point-and-shoot camera or on a DSLR with a zoom lens, you control the focal length.

- **F-stop.** The *f-stop*, or *f-number*, is an expression of the aperture size, or the diameter of the opening that allows light onto the sensor. A big aperture allows in a lot of light, or exposure; a smaller aperture reduces exposure. Somewhat complicating that simple concept is the fact that a small f-stop describes a large aperture, and a large f-stop describes a small aperture. Moving your camera aperture one f-stop higher doubles the amount of light you let in; moving your aperture one stop lower reduces the amount of light you let in by half. Many cameras include half and one-third stops, so the differences between the stops are more gradual. In case things aren't messy enough, you can express the f-stop in two ways. For example, f/2.0 and f2.0 signify the same thing, and both indicate a large aperture opening. F-stops may go as high as f/22 (a small aperture opening) or as low as f/1.4 (a large aperture opening). On a camera with manual controls or semi-automatic modes, you have some control over the f-stop.

- **Format size.** *Format size* refers to the shape and size of the camera sensor, which determines how much of an image can be seen, or the *frame of view* (also called the *angle of view*). Your naked eye has a frame of view, too: It is literally what fits into your scope of vision. A full-frame digital camera has a 24mm×36mm image sensor; this is the size of a full-frame negative made on 35mm film, and is thus the standard. Most cameras, however, have smaller sensors and crop the image slightly. This is called the *crop factor*. There is a range of crop factors; the lower the number, the less the image is being cropped from a true 35mm full-frame image. DSLR crop factors are measured in millimeters, with a typical DSLR camera crop factor being 1.5.

With point-and-shoot cameras, image-sensor measurements are less standardized; in addition, they are calculated in inches, which gives a much wider range of crop factors. Although the format size of a camera will affect the DOF you can produce, you don't have control over that variable; it is set for your given camera.

Learning to control DOF will make for much more exciting images. I'll talk about this more in upcoming chapters, too, but before the specific scenarios come up, I encourage you to play with your focal length, f-stop, and physical distances as much as possible to see what your camera can achieve. (See Figure 1.3.)

**Figure 1.3**
The gentle blurring of the background adds warmth and softness to this otherwise austere table setting.

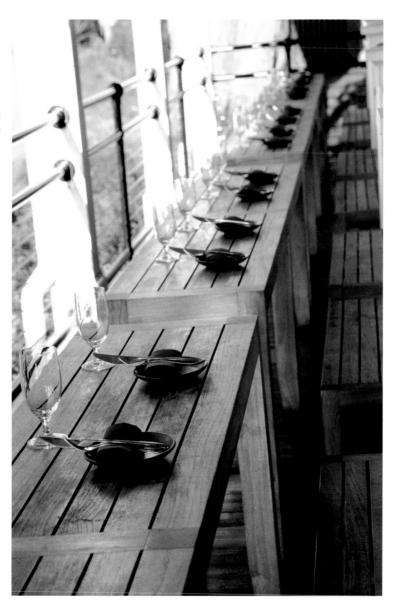

Most new point-and-shoot cameras offer a menu of various settings that will help your camera choose the best exposure variables for what you are shooting, such as portrait mode, landscape mode, and action mode. Understanding the presets will let you best capture in different settings—many of which are likely present themselves throughout a long wedding-day shoot. We'll cover these settings in Chapter 2, "Understanding Your Camera Options."

Point-and-shoot cameras usually have an *optical zoom* option, which enables you to physically extend the lens to magnify the subject. This allows you to get a closer image of the subject without changing your physical position. Not surprisingly, this feature is vital in covering many wedding situations such as the exchange of rings during the ceremony, when you want a tight image of the couple's hands but you aren't permitted to stand at the church altar with the couple.

## Resolving Resolution

The term *resolution* describes the amount of detail, or data, that an image holds. In photo and video, that detail is measured in *pixels*, which are the smallest amounts of data into which a digital image can be divided. In effect, each pixel is a dot of color; the more dots in an image, the more detail and clarity an image will hold.

A digital camera's resolution is measured in *megapixels,* which equals 1,000,000 pixels. The total number of pixels is calculated by multiplying the number of pixels vertically (also called the *vertical resolution*) by the number of pixels horizontal (or the *horizontal resolution*). So, a camera that shoots at the common 2,048×1,536 resolution will produce images with 3,145,728 pixels, and will be known as a 3.1 megapixel camera.

In video, resolution standards are either standard definition (SD) or high definition (HD). Not surprisingly, HD cameras offer more pixels, resulting in greater image definition. In both cases, resolution is described by multiplying the number of horizontal pixels by the number of vertical pixels, like still cameras. Though nearly pushed out of the market by the ever-decreasing prices of HD cameras, North American SD video cameras typically have a resolution of 720×480—or 720 horizontal pixels and 480 vertical pixels, for a total of 345,600 pixels. Another common SD resolution is 640×480, for a total of 307,200 pixels. There are a number of different HD resolutions that might be used on your video camera. You might shoot full HD at 1,920×1,080 or 1,280×720. While it is tempting to assume that full-frame HD is always better, it might not be for your purposes. Remember, the more image data you have, the more file storage you need. Because people tend to keep video cameras rolling for awhile at weddings, make sure you have enough storage space to accommodate these file sizes if shooting full-frame HD!

It's becoming more and more standard for point-and-shoot cameras to also offer an option for capturing video, and often, that video is *high definition*, or *HD*. HD video offers more pixels than standard definition (SD) video. Understanding pixels and resolution is an important part of determining how you want to shoot both photo and video. Higher-resolution files provide more clarity (better images), but come at the cost of digital storage space and ease of manipulation in post production.

## Camcorder

The word *camcorder* is a portmanteau of the words *camera* and *recorder*, and comes from the time when cameras and the recorders that captured their images were actually separate machines, connected by a cable. When the two units could be made small enough to be joined in one housing, presto! The camcorder! (See Figure 1.4.)

While all modern video cameras are technically camcorders, the word has informally (and inaccurately) come to stand for a consumer model video camera. Camcorders have a tremendous range in their capabilities; a higher end camcorder may be able to shoot in a number of different resolutions, offer an optical zoom, have multiple sensors and settings to accommodate different lighting situations, allow for the addition of external lighting and sound inputs, use stabilization techniques, and have manual adjustments of some of the features, which offer greater operator control over the images you can capture. Understanding all the features that your camcorder has (and doesn't have) will help you best use it in the rapidly changing shooting conditions of the wedding day.

**Figure 1.4** An example of a camcorder. (Image courtesy of iStockPhoto.com/Plainview.)

# Camera Phone

Can you shoot a wedding on a camera phone? In a word, yes. This is DIY documenting, so you can, in fact, do whatever you want. (Or, more accurately, you can do whatever the bride and groom want.) But that is not just lip service to the free-for-all nature of DIY; newer camera phones offer incredible picture clarity and features that will dramatically improve your shooting options, such as high dynamic range shooting, focusing options, and built-in flash. (See Figure 1.5.) With practice, a good eye, and basic shooting skills, a phone can be a completely competent tool to get the wedding documentation job done. (See Figure 1.6.) It is an especially convenient tool for the wedding documentarian who might have other responsibilities at the wedding, such as being in the bridal party, because it's a piece of gear you can carry on you easily as you bustle the bride's dress, hand the groom the rings (or a shot of whiskey), and join them both on the dance floor.

**Figure 1.5** A example of a camera phone. (Image courtesy of iStockPhoto.com/ronstik.)

**Figure 1.6** Modern camera phones can capture high resolution, clean, well-exposed images. (Image courtesy of Rahnie Smith.)

That's not to say a camera phone is the absolute best tool for the job, however. In situations when convenience doesn't reign supreme, here's what you could miss by shooting with a camera phone:

- Preset modes. (For white balance and focus.)

- Zoom range. (Yes, some camera phones have optical zoom, but it is unlikely to be as much as a point-and-shoot, much less a DSLR with a zoom lens on it.)

- Lower resolution. (This is becoming less true with newer cameras, however. the DROIDX phone offers an 8-megapixel camera and the iPhone 4 has a 5-megapixel camera, and both offer HD video. Lower resolution does remain a fact of life for slightly older camera phones, however—although it depends on the camera you are comparing it to. Many DSLRs offer 10-megapixel resolution.)

- Short battery life, especially for shooting video.

- Small storage space, especially when shooting HD video.

- Poor audio recording.

- Lack of stability.

Some of these problems can be addressed with new products designed to enhance the shooting options of your camera phone. These include the Owle Bubo, a phone housing unit, which acts as both a tripod base and a stabilization unit and comes with interchangeable lenses. You simply snap your phone in; suddenly, you are operating a more substantial device that can shoot various scenarios. This transforms your camera phone into being a serious contender, ameliorating if not eliminating several of the aforementioned problems. Another product, the Photojojo SLR mount, allows you to attach your iPhone 4 to all your Canon or Nikon DSLR lenses, which can dramatically improve your shooting options (although it won't do anything for your battery life, storage capacity, or stability issues).

There is no shortage of products to address the various shortcomings of camera phones, through various mounts, software applications, and external attachments. In addition, several companies make external battery packs that can extend the life of your phone over the shooting day. The workarounds for storage space (especially if you are shooting video) are likely to be inconvenient—especially since you will likely need to adjust things exactly as the father of the bride begins his toast or another equally important moment. (Did I mention that all equipment issues—from changing a battery to realizing your lens is cracked—will inevitably occur at a crucial moment? At least in that frustrating moment, you can say to yourself, "Yeah, yeah…it happens to the professionals, too.")

The question becomes, then, do you want to spend a lot of money making your camera phone into a more serious contender? Or would you rather spend the money (arguably less money, even) on dedicated photography equipment? Or shoot with the point-and-shoot or camcorder you already have and avoid a lot of problems inherent to the camera phone? I can't answer that for you, but I will say that the external products designed to improve your camera phone are stopgaps designed to eliminate specific problems. To bring your camera phone up to the strength of a typical camera over a variety of measures, an awful lot of external products would be required—meaning that suddenly, your camera phone isn't nearly as convenient.

## A Word on Batteries...

As well as the obviously essential camera, there are the slightly less obvious but no-less-essential batteries, used for both the camera and external lights and flashes. That might be a set of everyday alkaline batteries, specialized lithium batteries, or a battery pack like those worn by video professionals. (Actually, that's a series of lithium batteries that are often worn on a belt or strung to camera equipment.) I cannot overemphasize the importance of arriving prepared with extra, fully charged batteries, and bringing more—way more—than you might think necessary.

With some camcorder and camera batteries, buying several spares might be an expensive endeavor. However, if you are shooting the whole event—which could extend from the bride getting ready to the bride and groom driving off at the end of the night—you will easily use your camera for 10 or more hours. Batteries go bad, batteries get lost, and batteries do not last as long as they should; it is imperative that you have extras. Having one battery in the camera and one in the charger—leapfrogging the two all night—might seem like a viable strategy, but even that option is regularly bested by standard wedding obstacles. For example, you could get in real trouble if you use the first battery shooting the bride getting ready and the second battery shooting the ceremony on the beach, with no charging options nearby to prep you for the following reception. The leapfrogging strategy also fails when one battery doesn't last as long as it takes the other to charge.

In short, don't underestimate your battery needs. Err on the side of caution to ensure you get that final shot of the cake cutting. Batteries are as essential as the camera itself.

Blank storage media should also be carried in excess when shooting a wedding. You might be shooting to hard drive or media card or tape; regardless, make sure you have enough to cover all of the events of the day. Remember, it is very likely that you will shoot far more than you will use in your final product. While everyone has a different shooting ratio (the amount of footage shot compared to the amount of footage used), don't let your project be restricted by lack of media when it is such a relatively light and inexpensive item to carry on you.

**Note**

The rules, tricks, and techniques for capturing a wedding will hold true for everything from a camera phone to a professional video camera. If you picked up this book simply to learn to take better images, but not necessarily be the sole historian of the day, then your camera phone will suit you fine—and your images will likely improve tremendously as you learn the ins, outs, and particulars of shooting weddings on it.

## DSLR Camera

A digital single lens reflex camera, or *DSLR*, is defined by the mirroring system that allows the image from the lens to be transferred to the optical viewfinder of the camera. The result is a more accurate view of lighting and framing than possible through the viewfinder of a point-and-shoot because the image is shown in near real time and adjusts with changes in the camera position or lighting. As well as the advantages in previewing, DSLR cameras usually offer a large and sensitive sensor (to collect more image data) and the option to swap out lenses. A large camera sensor is especially advantageous in wedding shooting, as more picture data helps camera performance in low-light situations, which are prevalent at wedding receptions. (See Figure 1.7.)

**Figure 1.7**
Whether you are shooting on a point and shoot, a camcorder, or a DSLR camera (shown here), many of the basic shooting features and techniques will be the same. (Image courtesy of iStockPhoto.com/jsemeniuk.)

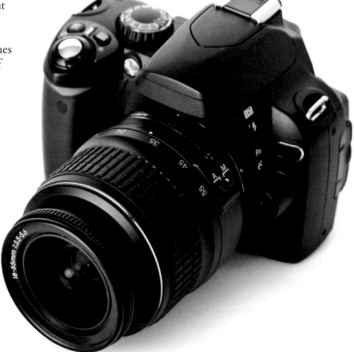

Multiple lenses can be daunting to the DIY-er, but they can also be what brings a documentary project to a new level of artistry. Multiple lenses are daunting because they can be expensive to buy, hard to lug around, and somewhat confusing to the novice. However, these are factors that can be mitigated should the options and looks that the lenses provide be important to your piece. Lenses can be borrowed or rented, as can camera bags to make transport much easier. Using detachable lenses requires some practice, certainly, but no more than any other part of wedding shooting. Finally, DSLR cameras are no longer just still cameras. Many high-end ones offer video, which maximizes the benefits of multiple lenses—offering a depth of field that is impossible with traditional camcorders.

## Computer and Software

After you have shot all the photo and video from the big day, you'll want to pick, choose, and edit your shots. To do that, you will have to transfer your digital images from your camera onto a computer—a relatively simple process that usually requires only a cord (which comes with you video or still camera) and, of course, a computer.

You will also need a post-production software application to edit your images and video. Many still cameras come bundled with a basic proprietary image-editing application; video cameras usually do not. It is much more common to import your images and video into dedicated applications. While some applications can run hundreds— even thousands—of dollars, there are also numerous free, inexpensive, and moderately priced applications to do the job. Common video editors include iMovie (Mac), Final Cut Pro 7 (Mac), Final Cut Pro X (Mac), Windows Movie Maker (PC), Sony Vegas (PC), and Adobe Premiere Pro (Mac and PC). Common image editors include Aperture (Mac), Lightroom (Mac and PC), iPhoto (Mac), Picasa (Mac and PC), and Adobe Photoshop (Mac and PC).

In this book, I have chosen to use Adobe Photoshop for image editing and Adobe Premiere Pro for video editing. Both applications offer robust capabilities, but I am using them here because they are multi-platform, and both are offered on the Adobe website as 30-day free trials. The concepts covered will apply to comparable applications (Final Cut Pro 7, Final Cut Pro X, Sony Vegas, Aperture, Lightroom, and so on), if not the exact tools. Less robust applications (for example, iMovie) will still offer a wide variety of the techniques discussed in this book, if not all of them.

> **Note**
>
> Depending on the level of post production you want to do and the software you want to run, there may some requirements with respect to your computer processor. If your computer is very old, there will likely be some type software out there that will work with it—although not necessarily with all the bells and whistles of a new computer.

# Gear Extras

It is definitely arguable what is considered an "extra" piece of gear, as opposed to an "essential" one. For example, I suspect there is not a professional videographer out there who would say that a tripod is anything less than desperately needed for a wedding shoot. However, as discussed in this book's introduction, DIY wedding documentation has no rules or boundaries; as a result, what's "essential" is more arbitrary. If, for example, your couple wants a more stylistic, arty look for their video (as opposed to a more journalistic approach), a tripod could be deemed unnecessary.

In the name of objectivity, I've called everything but the camera (and batteries and media) and computer "extra." Within that realm, however—and depending on the style you are looking for—some of the following items could make a huge difference when it comes to giving your DIY project a professional look.

## Tripod

Dependence on a tripod varies according to the style of shooting. As a rule, when there is a piece of the day that calls for a continuous shot of video, it is far easier to use a tripod. For example, while there is nothing that says your video must include the entire father-of-the-bride toast, starting and stopping the camera while Dad is talking is likely to give you incomplete sentences that are extremely hard to edit around, meaning you are unlikely to wind up with any usable pieces. It is far easier to shoot the whole thing and use your editing application to carefully pare it down to the pieces you want later. To have relatively steady video, putting the camera on a tripod is almost necessary, as wedding speeches often last 10 minutes or more. Seeing as 10 minutes is a long time to try to hold a camera steady even at the best of times, you can be sure it'll be near impossible at the end of a long day.

Even if you are a steady shooter, remember that the natural camera movement associated with handheld video is terribly exaggerated if you are zoomed in. The tiniest camera movement will appear as a huge shake on the footage, which can easily change handheld camera work from being "authentic," "natural," and "personalized" to "headache-inducing." Before you decide to go without a tripod, make sure you will be able to shoot from close to the subjects—ideally with something like a wall or a pillar on which to steady yourself.

Moments in the wedding where a tripod becomes especially helpful for video are the ceremony, the toasts, the first dance, and guest interviews. It can also be used to get steady *establishing shots* (introductory shots that provide context to the viewer) and *detail shots*. For many professional wedding videographers, a tripod is used to gather almost all the footage; they go "off-sticks" only as needed due to setup time or space constraints.

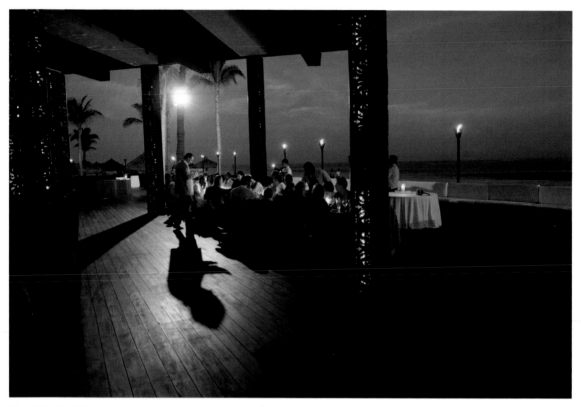

**Figure 1. 8** Tripods facilitate low-light shooting by allowing long exposure times without blurred images. (Image courtesy of Rick Collins; www.rickcollinsphotography.com.)

Still photography also benefits from a tripod, most particularly in long-exposure shots (see Figure 1.8) and time-lapse photography. When the shutter is open for long amounts of time, even the slightest movement will result in a blur; a tripod is recommended for any shutter speed slower than 1/60 of a second. Time-lapse photography requires the camera to remain in one position over a period of time, as the camera records the change in the scene. Both of these situations are discussed in later sections of the book.

Video tripods, or *fluid-head tripods*, differ from still-photography tripods in that the *head* (the part of the tripod to which the camera is attached) isn't fixed in any plane and it can allow the operator smooth movement in all directions without adding jerkiness to the footage. If you want a continuous shot with movement in it—for example, tilting to the couple's hands as they exchange rings or panning the bridal party as they walk down the aisle—a fluid-head tripod, shown in Figure 1.9, is key. Fluid-head tripods can be very expensive to buy but can be rented quite cheaply. There is no reason you can't use a fluid-head tripod to shoot still pictures.

There are a few alternatives to a fluid-head tripod, including a still-photography tripod (also called a *fixed-head* tripod) and a monopod. Although neither of these options can

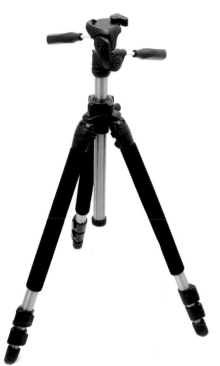

**Figure 1.9** A fluid-head tripod is necessary to get smooth video camera moves, but is a significant expenditure—not to mention a formidable piece of equipment to be carrying around all day. (Image courtesy of iStockPhoto.com/jeffwqc.)

**Figure 1.10** A fixed-head tripod can be used for still photography or video; however, it does not allow video camera movement, such as pans or tilts. Using a fixed-head tripod for videography gives steady video shooting when your arm cannot, and is generally much less expensive and less heavy than its video counterpart. (Image courtesy of iStockPhoto.com/dem10.)

offer smooth camera movement in all directions like a fluid head, both options are both less expensive and much easier to carry around. A fixed-head tripod (see Figure 1.10), which can be easily attached to any video camera that isn't too heavy for it, will give you the benefit of a steady shot—although it lacks the ability to add camera movement.

Tripod legs vary in length, materials, the number of places you can lock the legs, and fun extras like built-in levels, hooks on which to hang your camera bag (handy for stability), and movable center columns. While it would be wonderful to have a tripod that was tall, sturdy, and lightweight, you generally can't find one with all three qualities. Tall and sturdy generally means heavy; tall and lightweight generally lacks stability. For wedding shooting, I prioritize lightweight over the other characteristics; you'll be moving fast!

---

**Note**

Tripods can be purchased as a complete piece; alternatively, you can buy the head and legs separately. If you are purchasing a tripod, whether it is fixed head, fluid head, a complete system, or individual parts, make sure that it is light enough for you to carry it around all day. If you are borrowing a heavy tripod, consider getting a helper or scout out places you can stash it when you aren't using it.

---

A *monopod* is a stick with a tripod head that is easily supported by the shooter, in order to stabilize the camera. (See Figure 1.11.) While decidedly less controlled than a tripod, with practice, monopods allow some smooth camera movement and significantly mitigate accidental jerky camera movements. Monopods are also fun to use to get a birds-eye angle of a scene, as you can employ one as an extension of you arm. Picture standing on the stage with the wedding band and extending the monopod out over the dance floor; you'll wind up with an angle looking down that would be otherwise near impossible to capture!

Another tripod that can be used to get fun, creative photo or video is a flexible tripod. Flexible tripods come in various sizes, and their legs are designed to go on unstable ground or even to wind around and grab onto something. (See Figure 1.12.) Small and lightweight, flexible tripods can be extremely fun in the wedding setting; imagine a

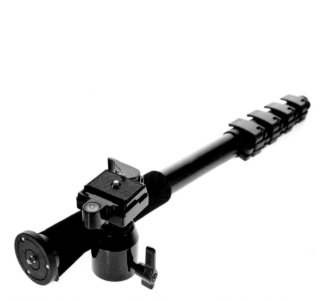

**Figure 1.11** Often significantly less expensive than their tripod counterparts, monopods are lightweight and allow for fun and artistic angles for both photography and videography. (Image courtesy of iStockPhoto.com/iceninephoto and iStockPhoto.com/Lusoimages.)

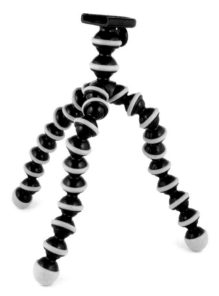

**Figure 1.12** A flexible tripod can be a fun way to get additional footage from an unmanned camera. (Image courtesy iStockPhoto.com/SundeepGoel.)

tiny, still camera (even a camera phone!) with a remote control clinging to the trellis above where the couple is reciting their vows. The guests won't see the camera, which can occasionally sneak a shot of the couple from overhead. The flexible tripod might also be fun attached to the DJ stand, on top of the mirror where the bride is getting ready, or any number of other angles that might otherwise be difficult to shoot from. Flexible tripods come in all shapes and sizes, with some large enough to hold a small or mid-sized camcorder to capture video in the same manner.

## External Lights and Flashes

Sometimes you get perfect, even golden light. (See Figure 1.13.) Other times, you need some tricks in your bag to find it. A *flash* is an additional light source that provides a burst of light for still photography. External lights will do the same for both photo and video. There are several reasons you might want an additional light source, the most obvious being that you simply may not have enough light available in the scene to get an adequately exposed image. In that case, an external light source might boost the available light headed to your camera sensor enough to brighten the resulting image. In more complicated settings, you might use a light or flash to brighten a portion of an image. For example, if bright sunlight is bearing down on the couple from one side, a *fill light* (a compensatory light used to fill in shadows caused by the main light source)

**Figure 1.13** Sometimes you get perfect, even golden light. Sometimes, you need some tricks in your bag to find it. (Image courtesy of Rick Collins; www.rickcollinsphotography.com.)

might even out the light on the other side. Similarly, lights can be used to highlight certain aspects of an image, providing a glow that might not otherwise exist.

In terms of gearing up for low light, take a look at what your equipment has. It is likely that your still camera has a built-in flash. Does it also have the ability to attach an external flash? (See Figure 1.14.) Can you override the flash in one of the semi-automatic modes? How about the video camera—does it have a *hot shoe,* or metal plate holder, to accommodate an external light? (A hot shoe is a fairly high-end feature; many consumer-level camcorders don't have one.) If so, do you have an attachable light and batteries? Ideally, you will want to work your camera settings to avoid having to drag along the weight, expense, and complication of external lights. However, in some situations, it is simply unavoidable: Additional light may be necessary.

Another way to get extra light is to use a reflector, which, as the name implies, bounces or reflects light onto the subject. There are numerous fabric reflectors manufactured specifically for photography, but a large piece of poster board or a fabric-covered wire frame will do the trick, too. Different-colored reflectors will generate different colors of light. For example, a white or silver reflector will be neutral, a gold reflector (see Figure 1.15) will be warmer, and a blue reflector will be cooler.

**Tip**

Get some basic information from the bridal couple about what the lighting scheme of the event will be. You don't need precise information about wattage or anything like that—just whether the ceremony venue allows flash photography or if the ceremony is going to be mostly candle lit. You can prepare for those situations by practicing with your settings and, in extreme situations, getting additional lighting accessories.

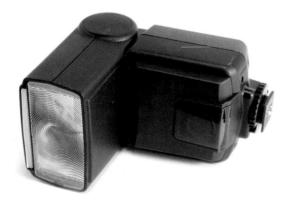

**Figure 1.14** This external flash mounts to the camera's hot shoe with the small metal plate on the bottom. (Image courtesy of iStockPhoto.com/Canoneer.)

**Figure 1.15** Professional reflectors are lightweight and fold up to a much smaller size than the expanded one seen here. Often, there will be different colors on either side, offering versatility in the color of light provided. (Image courtesy of iStockPhoto.com/Anthony Mayatt.)

# External Audio Recorders

If you are shooting video and plan to use *natural audio*—that is, the sound that is actually occurring with the images you are capturing (as opposed to layering the video images over music in post-production)—you must consider microphone quality. Most camcorders collect audio *non-directionally* (also called omni-directionally), meaning they pick up the sound that is in all directions around them instead of the sound in the area where the camera is pointed. For example, if you point the camera at the couple cutting the cake, the non-directional camera microphone won't differentiate the couple speaking and giggling from the surrounding crowd cheering and the DJ's announcements. Furthermore, even if a *directional* microphone—that is, a microphone that discriminates the sound it picks up by only capturing sound in one direction—is too far away from the source audio (say, at the back of a church during the ceremony), it will pick up all kinds of sounds between the camera and the audio source: people shuffling around, coughing, flipping pages of their programs, or that dreaded crying child.

Non-directional audio capture (or audio capture from a distance) may or may not be a problem for you; it depends on the project you have in mind. There are times when the sounds of the crowd might be as fun as the sounds of the subject—the cake cutting is an excellent example of that. However, the ceremony and toasts are examples of times when you want to make sure you are picking up the right sounds on your microphone.

Clean audio might require extra gear. Some higher-end camcorders allow for additional sound inputs, enabling you to collect the audio from an external microphone right onto the media you are shooting. In this situation, you would have a microphone (or a receiver from a wireless microphone) that plugs directly into your camera, which captures sound more sensitively or directionally than the on-camera microphone. When you import the footage into a post-production editing application (as discussed in Chapter 9, "Image Editing"), you will see the audio from the built-in microphone on one track (or set of stereo tracks) and the additional microphone that you attached on another track (or set of stereo tracks). You can choose to use either or both. (See Figure 1.16.)

Many consumer-level camcorder and DSLR cameras that shoot video don't allow for extra audio input. Fortunately, in DIY video, there are ways to get around this. One idea is to get a separate digital audio recorder to use that sits near the subject (for example, the couple reciting their vows) while you are shooting video far away (for example, at the back of the aisle) or moving around the subject. This will provide an additional track (or tracks) of audio that you can sync with the video in post production. The separate recorder might be an MP3 audio recorder (these are relatively inexpensive) or another unmanned camcorder designated to capture sound but not necessarily video. In this situation, you will capture uninterrupted, high-quality audio (and possible marginal video as well) from a location optimized for audio collection and

**Figure 1.16**  Higher-end camcorders will allow feeds from external audio sources, as well as from their own built-in microphone. This is not a feature you need to shoot a wedding, but if it is available on your camera, it is worth exploring as microphones such as this wireless lavalier (left) and this directional shotgun (right) can add a level of professionalism to your piece. (Images courtesy of iStockPhoto.com/iceninephoto and iStockPhoto.com/soundsnaps.)

video (with marginal sound) from a location optimized for video collection. In editing, you can match the sources to get a mix of the best audio and video in your piece. The only trick in this situation is to remember that the unmanned sound recorder needs to have enough battery life and media to collect sound the whole time if left unattended.

---

### Tip

Remember that old mini DV camcorder that you have lying around from 10 years ago? Or the one your parents bought to shoot you as a kid? What about the one you replaced with a cute little compact HD camcorder? That old camera makes a perfect audio collector in places where you want an additional audio track. Just make sure you have enough tape for it!

---

What about if you don't have the budget, time, or interest to stash an additional recorder for the important audio bits? Not to worry. DIY wedding video has no rules. There are lots of ways to artfully use video images without the natural audio; I'll talk about them later on. The reason for this discussion now is to simply consider all the extra pieces of gear you might want along with you—and a dedicated audio source can be an extremely handy one for documentary-style pieces, where you are looking to get somewhat complete and traditional footage.

## Next Up

It's important to think pretty carefully about the results you are looking for in your DIY wedding project so you know if your gear will be sufficient. I'll happily argue that you can shoot a wedding on any camera and in any style. That being said, certain coverage

styles might dictate certain shooting requirements, such as audio recording or zoom lenses. Knowing what you want your final project to look like—even if your ideas are vague—will ensure you get the right equipment for the job. Once you know what gear you'll be working with, you need to spend some time getting to know your equipment. Optimizing your shots quickly is the cornerstone of wedding shooting!

# DIY Idea: Brand New Old Footage!

If you have access to old footage of your bride and groom, adding that footage to the mix can be a phenomenal way to incorporate some DIY personality. To use the footage, you will have to get the developed film *digitized* by a company that works with old film formats so you can put the digitized file in your video piece. That is a process you can do at home if you have a projector, but unless you have a lot of experience, it is well worth spending the money to get it done right; you will achieve better color and image quality in the transition, and you won't risk damaging the film strip. Make sure to get the old video *transcoded* to a video format compatible with your editing software. (See Figure 1.17.)

To go an extra step with your shooting, consider the old cameras that you or your friends might have lying around. A friend's Super 8 film camera, Polaroid camera, or 16mm film camera could add a lot of character and personality to the footage you are shooting. Old cameras lack the technology we have become used to (exposure controls! automatic focus!), but can offer a fun and quirky retro feel or the timeless and dreamy quality of old film (think super-saturated Super 8 film or fun Polaroid candids). Shooting with a film camera is great fun; we're so accustomed to seeing our images immediately that the sensation of shooting blindly (so to speak) is exciting—not to mention the fun of the film cartridges, canisters, and camera bodies themselves.

Consider the mood of the footage and your skills when you shoot with old cameras. While a bride might love the idea of your experimenting with a Super 8 while she is getting dressed and putting her makeup on, something a little more reliable might be comforting while she is reciting her vows. Similarly, a Polaroid might be a perfectly fun way to capture the bridesmaids lined up to catch a bouquet at the reception, but not provide the gravity required for formal shots.

If you like the look of old cameras but don't have one (or are hesitant to risk shooting important moments with one), you can also achieve some of these looks by editing your images in post production. Adding filters and effects can mimic old camera styles and, depending on your strengths and equipment, might be a better way to achieve the looks you are after. (See Figure 1.18.) I'll talk more about that in Chapter 10, "Video Editing."

**Figure 1.17** Adding old footage of the bride and groom will give a very distinct feel to that section of the video. The low-resolution, super-saturated colors and fuzzy focus contrast nicely with the HD footage we are so accustomed to seeing today. (Images courtesy of Carlo Silvio; www.carlosilvio.com.)

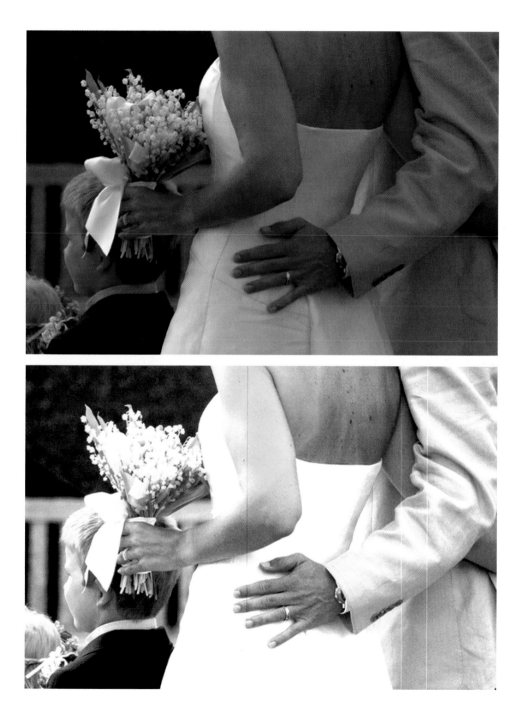

**Figure 1.18** Though possibly less appealing to the camera geeks, film lovers, and hard core DIY-ers, adding video filters after the fact is a much safer way to get "aged" images from the safety of your familiar and reliable modern camera. (Images courtesy of Aaron Hathaway.)

# CHAPTER 2

## *Understanding Your Camera Options*

**In this chapter:**

- How your camera works
- RAW versus JPEG
- Manual and semi-automatic modes
- Preset automatic modes
- Exposure compensation
- White-balance modes
- Continuous shooting
- Removable lenses

Seasoned photo and video professionals know that shooting weddings often involves unusually difficult conditions. Harsh sunlight, dim candlelight, crucially important yet hard-to-hear audio, and action in several places at once—any of these can be the undoing of even a steeled and savvy photographer or videographer. Clearly understanding all the options your camera provides will help you determine quickly what to use in any given scenario. Because wedding-day action never stops, that speed can mean the difference between catching a moment and missing it entirely. I'll spend this chapter talking about features of your equipment to help you maximize its use when wedding conditions become difficult.

# How Your Camera Works

Perhaps you've seen them, wearing all black and melting in the sunlight—the wedding professionals who tote around heavy bags of gear and fancy equipment. You could do that too…if you want. But before you go too far accumulating gear and lenses and sticks and lights, it's probably worth understanding exactly what that tiny little camera you already own is capable of. Chances are it is much more than you imagine. With full knowledge of what you can do (and can't) do with your camera, you will have a better understanding of how to best maximize your shooting potential with the gear you have and determine what other bits of gear you might want to obtain before the big day.

Odds are, your camera offers various *modes*—that is, shooting settings that are automatically determined by your camera based on input you provide. To understand your camera modes, however, you must first have a basic understanding of how your digital camera works. The previous chapter touched on a few of these concepts; this chapter takes a closer look, starting at the beginning, because understanding basic camera operation is crucial to more advanced photography and videography.

A photographic image is created when light strikes a digital camera sensor and creates the digital pixel data, which is then recorded on the media of your camera. Your various camera settings manipulate how light hits the sensor to create different looks. Basic camera operation involves the opening of an *aperture*, or a small circular hole, to allow light to strike the sensor, creating the image. The wider the aperture is open, the more light is allowed in, and the more *exposure,* or brightness, the resulting image will have. Aperture size is quantified in *f-stops*. Somewhat counterintuitively, the larger the f-stop number, the smaller the aperture opening; this is because the f-stop measures the ratio of focal length to aperture size, not the aperture size itself. So, for example, an f-stop of f/2 represents a larger aperture opening than an f-stop of f/8.

Aperture size is not the only thing that affects exposure; shutter speed does, too. On a still camera, the *shutter* is a mechanical gate in front of the aperture that opens and closes to reveal the aperture, and thus expose the sensor to light. Leaving the shutter open for a longer period of time will expose the camera sensor to more light. The length of time the lens is exposed is called the *shutter speed*. In videography, there is technically no shutter that opens and closes, so in that context, *shutter speed* refers to how much time the light is allowed to build in the camera sensor before being discharged.

In addition, the sensor itself can be adjusted to become more or less sensitive. This is called *ISO*, a term left over from film photography. In film photography, ISO describes film's sensitivity to light. A low ISO (or low sensitivity) produces fine-grained pictures, while a high ISO provides more light sensitivity but at the cost of image quality. Similarly, in video, a higher ISO speed will allow the sensor to accept more light; this is helpful in a dimly lit setting, but might cause a drop in image quality if boosted too

high. This drop in image quality is due to the introduction of *noise,* which is a fine-grained pattern of multi-colored pixels that appear when the sensor is too sensitive.

Manipulating these variables—aperture (f-stop), shutter speed, and ISO—can help you best capture an image in any given setting. For example, low-light shooting will require more exposure, so the shutter speed might be slower, the f-stop might be lower (indicating a wider aperture opening), and the ISO might be higher.

Modern digital cameras all come with a fully automatic setting, which interprets the light and scene for you and determines the best aperture, shutter speed, and ISO settings. This happens in both still and video shooting. While cameras are certainly very advanced about these things, your eye is far more advanced. Learning to override some of the automatic-mode features will allow you greater flexibility in certain areas. For example, if the camera opts for a flash that creates a washed-out appearance (see Figure 2.1), you can manipulate the camera settings to provide more exposure to the sensor to avoid using a flash (see Figure 2.2). Flashes can also cause trouble by creating a glare in reflective surfaces, such as mirrors and windows. Alternatively, you might manipulate the camera settings to create a stylized look that allows some motion blur or a narrow depth of field.

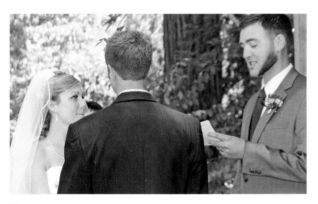

**Figure 2.1** This shot was taken in fully automatic mode; the flash fired, washing out the image.

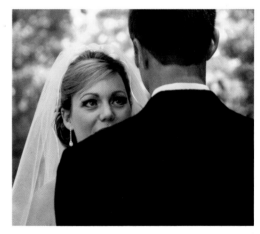

**Figure 2.2** Moments later, I captured this version with better contrast by manipulating the manual controls and prohibiting the automatic flash.

# RAW Versus JPEG

Most DSLR cameras give you the option of shooting RAW or JPEG files. Some cameras even allow you to shoot both, saving one RAW and one JPEG file for each shot taken. Exhaustive material is available discussing the relative merits of RAW and JPEG; rather than rehashing these in detail, let's just take a quick look at each.

JPEG files are processed in the camera, which means the resulting image is finished. It will have blacks, contrast, noise reduction, and sharpening added to the image. The image is then rendered and compressed so that it comes out of the camera as a compressed and (hopefully) pretty file. In contrast, RAW files are unprocessed and uncompressed. They come out of the camera looking dark and flat, with a much bigger file size. RAW files must be viewed and processed in your camera's software or in an image-editing program such as Photoshop, Aperture, or Lightroom.

Based on that description, why on Earth would anyone shoot RAW? Simple. These shots contain much more data. That means once you are working within an image editor, you have a lot more leeway to change your image, adding the blacks, noise reduction, and sharpening yourself, in any way you choose. RAW images wind up having more *dynamic range,* or distance between blacks and whites, than JPEG images do, even though it might take a little more work to get there.

Does that mean you should be shooting JPEG or RAW? RAW files allow a lot more control in post production, so if you haven't managed your exposure settings properly during shooting, you can make a lot more adjustments after the fact. Because it is so difficult to get exposure settings perfect in a rapidly changing wedding environment, this is the single most important reason to shoot RAW at a wedding. With that in mind, however, here are some other considerations:

- RAW files are much larger, so your storage needs will be much greater. Media storage is relatively inexpensive, so ideally you always have enough. If you find yourself running low in the middle of a shoot, however, switching from RAW shooting might be a better option than not catching the cake cutting!

- The large size of RAW files means that continuous shooting, or burst mode, will be slowed down as your camera gathers and stores that data. Some cameras have such advanced burst modes that this is less relevant, but it will still be significantly different from shooting JPEG only. Experiment on your own camera to find out.

- RAW files aren't especially pretty for review. If you are looking to post shots immediately without editing them first because Grandma couldn't travel to the wedding, you might want to reconsider whether RAW is right for you. (RAW plus JPEG mode solves that problem, if it is available.)

- Because you aren't a professional photographer, you simply might not want to deal with the additional post-production step of processing RAW images. Besides, JPEG shots might serve your needs just fine. If that is the case, I still encourage you to shoot RAW and JPEG if possible; that way, you would have the stored data later in the event you change your mind. That being said, other factors, such as storage space, might prevent that.

# Manual and Semi-Automatic Options

It's likely that your camera allows complete manual adjustment of aperture, shutter speed, and ISO, as well as offering a variety of semi-automatic modes. Let's take a look at some common options.

- **Fully manual mode.** In fully *manual mode* (marked with an M or Man), you have complete control over your camera's aperture, shutter speed, ISO, and white balance. (I'll get to that.) Needless to say, it takes some practice to understand which options to use in a given setting. Wedding lighting scenarios can be quite dramatic—and change incredibly quickly—so make sure you are extremely comfortable and familiar with this mode if you plan to use it during the event.

- **Aperture priority mode.** In *aperture priority mode* (marked with an A or an AV), you set the camera aperture, and the camera adjusts the shutter speed to give you a well-exposed image. This is especially useful in scenarios when you want to control the depth of field. If the aperture is smaller, you will have a greater depth of field (more of the image will be in focus); if the aperture is wider, you will have a smaller depth of field (less of the image will be in focus). Wedding photography often incorporates subjects with slightly blurry, out-of-focus backgrounds, which serves a dual purpose: making the subject stand out and lending a soft and romantic texture to the image. If your camera has an aperture priority mode, play with your depth of field to achieve this look. (See Figure 2.3.)

- **Shutter speed priority mode.** *Shutter speed priority mode* (marked with an S or a Tv, for "time value") allows you to set the shutter speed; the camera then sets the aperture. Optimizing for shutter speed is a good idea when you are capturing action. If you want the image to be sharp, you pick a very fast shutter speed—for example, in a wedding, you might use this to capture the reception dancing. Alternatively, you might want the action to be blurred—picture a waterfall at the ceremony venue or a stylistic shot of the flower girl running through the reception hall. In that case, a slow shutter speed will soften the moving portion of your image.

- **Program mode.** *Program mode* is a mostly automatic mode (usually marked by a P) that functions like automatic mode in deciding aperture, shutter speed, and ISO settings but gives you more control over certain features such as white balance and flash options that might otherwise be automatic. Different cameras have different program modes (if they have program modes at all), so check your own camera manual and experiment.

**Tip**

If you don't have time to tidy up a messy background or can't hide an unattractive one, try blurring it by adjusting your aperture!

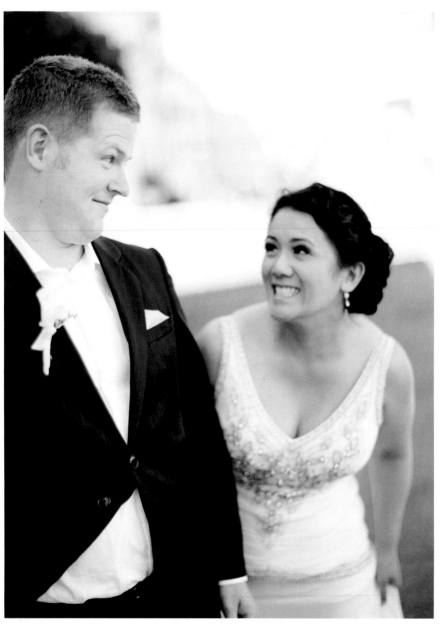

**Figure 2.3**  Using aperture priority mode allows the couple in the foreground to stand out from the blurry street scene in the background. (Image courtesy of Christian Maike; www.christianmaike.com.)

# Preset Automatic Modes

In addition to the semi-automatic modes, most still cameras offer a range of fully automatic modes. The primary automatic mode makes all the decisions for you: aperture, shutter speed, ISO, white balance, and flash. It makes these decisions all on its own, with no input from the user. There are also preset modes where the camera has control over all of the exposure variables, but will make its determinations with considerations to what type of image you are shooting. These can be especially helpful in weddings; shooting happens quickly and changes in scenery are especially fast, and the automatic program modes offer an excellent way to help you move as quickly as the events.

Before you use them, practice shooting with and without the automatic program modes on so you can make sure you like the images you tend to get within a particular mode. (As an added bonus, this helps you learn the nuances of a given mode on your camera.) Here is a list of common preset automatic modes that your camera might offer.

■ **Action/sports mode.** *Action* or *sports mode* attempts to boost the shutter speed enough to give you crisp images of fast-moving scenes. The aperture and ISO allow more exposure to accommodate for the faster aperture opening. You'll probably use action mode less frequently at weddings than some other presets, but it can be handy during the dancing sequences.

■ **Landscape mode.** Using a very narrow aperture, *landscape mode* gives a very wide depth of field. This allows you to put an entire scene in focus (see Figure 2.4). It is an ideal mode for capturing shots with several subjects, such as the bridesmaids getting ready, or for capturing wide establishing shots of the setup or scenery. It is also the perfect mode for capturing a wide shot of the ceremony, including everyone in nearly, if not perfectly, equal focus.

■ **Macro mode.** *Macro mode* lets you shoot images with perfect clarity (well, ideally, anyway) at extremely short distances. Because the depth of field is very shallow when you work that close up, focusing may be difficult; you may have to adjust your position quite a bit to make it work. Macro mode assumes that the subject will fill the whole frame, making it an excellent mode for capturing the details of the wedding such as jewelry, signage, the wedding program, and flowers, as shown in Figure 2.5.

■ **Night mode.** *Night mode* is a bit complicated to use, but can be an awful lot of fun. The idea of night mode is to get detail in low-light settings by keeping the shutter open longer with a slow shutter speed. The aperture opening lets in light from all parts of the scene equally; in addition, night mode uses a flash to better illuminate just the foreground. Without a tripod, it's easy for night shots to get blurry due to the long exposure; sometimes, however, that can be a very arty and fun look. (Picture a dance floor with the DJ's colored lights blurring in the background and a clearly focused guest dancing in the foreground.)

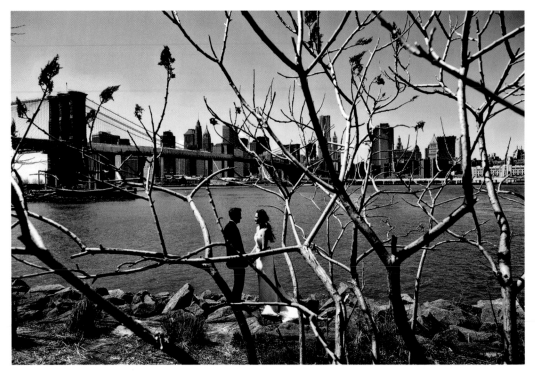

**Figure 2.4** A small aperture opening gives a wide depth of field. Here, nearly all of the entire scenic picture is shown in crisp detail. (Image courtesy of Rick Collins; www.rickcollinsphotography.com.)

**Figure 2.5** By fitting the entire subject within the frame and within the small depth of field allowed by macro mode, tight shots can be made especially crisp.

■ **Portrait mode.** Like macro mode, *portrait mode* is designed to capture one subject. Unlike macro mode, however, it slightly—just slightly—blurs the background (see Figure 2.6). The setting does this by opening the aperture a little wider than the normal light settings would require and shortening the depth of field. This is an extremely handy function for weddings; there are so many opportunities for portrait shooting—the bride and groom, of course, but also the guests. Keep in mind, though, that the portrait setting is optimized for one subject that takes up most of the frame of the image, so use this setting when you are shooting close up (either physically close up or zoomed in) so your subject fills a good portion of the image. Despite its name, this setting will not work well if you are shooting one guest at mid range and showing the entire reception table she is seated at as well.

## Tip

Incidentally, the slight softness that portrait mode brings is not just flattering for people; it is an effective way to shoot some of the details of the event, such as close-ups of the place cards, flowers, and rings.

**Figure 2.6** This wedding guest stands out from her subtly soft background because of the slightly shorter depth of field provided by the portrait mode.

## A Word on Black and White

Lots of wedding photography is black and white, for various reasons. It can be argued that the absence of color allows the subjects and their emotions to be seen more fully. Black and white can also be flattering to skin tones and skin imperfections. Finally, black-and-white images tend to have a timeless sense about them—almost as if you are already looking back years later on events that only recently took place.

Film photographers often carry two cameras at a wedding: one loaded with color film and one loaded with black-and-white film. With black-and-white film, the grain and depth of colors that the resulting prints give can be especially beautiful, making that extra effort well worth it. The modern DIY wedding shooter is unlikely to be shooting with film, but is very likely to be shooting with a digital camera (still or video) that has a black-and-white option, as well as some other built-in effects such as sepia filters, cropping, and fades to black (video). Some cameras let you apply filters after the picture is taken so you have both the effected version and the original; with other cameras, that your effect version *is* the original.

Are in-camera filters a good option? I would argue against them. If you shoot an image in full color, you can make it a black-and-white image by desaturating the color in post production in an image editor. If you shoot with a black-and-white filter on, however, you can't retrieve that color. The same goes for other filters and effects. While there is nothing lost if you add a filter after the picture is taken, with some advanced post-production skills, you can make customized, careful, and more nuanced decisions about how you desaturate (or otherwise effect) an image. The only advantage to in-camera filters is that they can save you a post-production step. While that might be a valid argument, I'll vote for flexibility to use and adjust images in a lot of different ways over that convenience.

# Exposure Compensation

Despite all the preset modes designed to perfectly expose your shot, there will be times when the camera's automatic features simply can't do everything you want them to do. The calculations will be just slightly incorrect. Fortunately, *exposure compensation* enables you to adjust the image to be relatively lighter (compensation up) or darker (compensation down) than the calculations the camera has devised. The difference is based on the exposure settings already present; you can take a shot and review it, and then make slight variations to your settings without entirely starting over.

Exposure compensation is measured in *EVs*, or exposure value units. Adjusting your exposure compensation one EV up or down is approximately the same as adjusting one f-stop, or aperture size—although the actual compensation might be made via changes in aperture, shutter speed, or occasionally ISO. Your camera may have two or three levels up and down of EV.

Exposure compensation is extremely useful at weddings because the complicated lighting conditions may regularly confuse your camera. For example, if your subject is standing against a bright window, your camera will likely choose settings based on the exposure behind your subject, not the subject itself, causing your camera to underexpose the subject. By increasing the exposure compensation, you can make your subject brighter. This will likely blow out the image detail of the background, which was bright to begin with. But better to lose the background than the subject. In fact, sometimes losing that background detail makes for a more compelling shot of the subject itself. If your camera offers exposure compensation, make sure to read the manual about the particulars of its function.

## The Four Handiest Features for Wedding Shooting

While I certainly advise you to learn all the capabilities of your camera, you might have picked up this book the night before you are planning to shoot a wedding. If so, here is a brief list of especially handy features for shooting in wedding scenarios, all of which are described in more detail in this chapter.

■ **Program mode versus automatic mode.** In automatic mode, your camera dictates all the settings, including the flash. In program mode, *you* control the flash. As discussed, an automatic flash is generally a bad addition to your shot; default to program mode, not automatic mode, when you want the camera to do most of the exposure work.

■ **Exposure compensation.** Exposure compensation is a way to quickly dial up or down the amount of exposure, or light, your image receives. Even if the camera is doing most of the work of determining your exposure settings, exposure compensation will help you help your camera. Left to its own devices, your camera might default to exposing the wrong part of your image (such as an overly bright background), or you might simply have a different look in mind than what you will achieve with the camera setting.

■ **ISO control.** Boosting your ISO will increase the sensitivity of your sensor, allowing you to shoot in lower light and still get image data. Often, your camera will offer a much higher ISO than you should reasonably use because the resulting image will be noisy. Make sure you know how to quickly boost your ISO for low light levels, but also make sure to experiment to determine the ceiling for boosting ISO in different light levels before your images are unacceptably noisy. (See Figure 2.7.)

■ **Burst or continual shooting.** Burst shooting is a gift to wedding photographers. By shooting a number of shots without break, milliseconds apart from each other, you can better wrangle groups, catch minute changes in expressions, and ditch the nervous energy that so often accompanies posing.

**Figure 2.7**
The ISO of 1600 was too high for this camera (Canon EOS Rebel T3i) at this light level, resulting in the extreme noise seen throughout image—especially evident in the model's face.

## Preset White Balance Modes

I mentioned *white balance* a few times earlier in this chapter. What is it, exactly? Digital cameras express color by deeming one color white and building the other colors in the spectrum around it. Therefore, if the starting white, or *reference white*, is off (that is, not truly white), then all the colors will be off in a systemic fashion.

Whites appear different under different light. For example, the sun casts a different light than a fluorescent bulb. That difference is measured by the *color temperature*. Cool color temperatures, such as what is found in the sky, cast a light blue tinge; warm color temperatures, like what's emitted by candlelight, give a yellowish light. A bright white wedding dress under both types of light will appear white to our eyes because our eyes naturally adjust and disregard the color casts, or tints. A digital camera won't make these adjustments naturally, though; the white bridal gown might look extremely different under the lights in the hotel room where the bride is getting ready than in the bright sunshine of the outdoor ceremony. The white balance simply tells your camera an appropriate white to use as a reference white so that all the other colors will fall in line appropriately.

In a wedding situation, white balancing is crucial for both photo and video. You will be shooting the same subject in dozens of different settings. When you watch the video clips or put together an album, having dozens of shots lined up where the couple has an entirely different color cast in each shot can be distracting. Luckily, white balancing at a wedding is easy; there is almost always something white in front of you to use as a reference.

Ideally, you will be able to manually white balance your camera; higher-end DSLRs and camcorders will let you do just that. To manually tell your camera what to call white, you simply fill the frame with a white subject that is far enough away to allow a lot of the ambient light on the camera sensor while holding down your camera's white balance button. This indicates to the sensor what constitutes "white" in that setting—in other words, it sets your reference white—so the camera can adjust all the colors around accordingly. As you change environments—say, walking indoors, walking outdoors, turning on overhead lights, or opening all the blinds in a room—be sure to reset your reference white to the new color temperature, and your resulting images will not look jarring next to each other.

Even if your camcorder or point-and-shoot camera does not allow for manual white-balancing, you can often select from a few white-balance preset modes that, like the preset automatic modes, attempt to account for various typical shooting settings you might be in with a uniform adjustment. Following is a list of typical white-balance settings. (Your camera might not have all these options, or might sport a few other ones.) Knowing which setting to use can even out the look of your images over a long shooting day. Remember, cool lighting is slightly blue and warm lighting is slightly yellow; the white-balance presets will try to counteract that, reining either side of the spectrum into neutral. (See Figure 2.8.)

- **Tungsten.** Tungsten light is the incandescent bulb lighting that we are used to seeing indoors. Tungsten lighting is warm; the *tungsten setting* will cool it down by white-balancing to a more bluish white.

- **Fluorescent.** The *fluorescent setting* is the near opposite of the tungsten setting. It compensates for the cool cast of fluorescent lights with a warmer, yellower tone.

- **Daylight/sunny.** Also called an *outdoor setting*, the *daylight* or *sunny setting* assumes a white is a "true" white—there is no color cast. Although rare for some types of shooting, this is, funnily enough, regularly the case for large portions of the wedding shoot—which, if all goes to plan, often happen outside in the bright sunlight.

- **Cloudy/shady.** A *cloudy* or *shady setting* will warm things up a bit, adding some yellow to counteract the cool overtones of less-than-perfect wedding-day weather. The correction for clouds or shade won't be quite as dramatic as the warming achieved with the more extreme fluorescent setting.

*Automatic white balance*

*Tungsten white balance*

**Figure 2.8**
Different white-balance settings provide different temperatures, or tints, to the same images. The differences are especially noticeable when the shot is nearly entirely white, as is the case with this veil, which is shown in automatic white balance, tungsten, fluorescent, daylight, and cloudy.

*Fluorescent white balance*

*Daylight white balance*

*Cloudy white balance*

The white-balance settings are fairly straightforward. Typically, if you are indoors, pick between tungsten and fluorescent. Outdoors, decide whether you want to shoot natural (daylight/sunny) or warm things up a bit (cloudy/shady). It'll take a little practice to learn, but once you know what your camera does with a particular setting, it could be argued that the hardest part about the white-balance settings is remembering to use them.

# Continuous Shooting

A feature on most point-and-shoots and DSLRs, *continuous shooting*, or *burst mode*, enables you to fire off multiple shots by holding down the shutter button. Different cameras vary in their burst capabilities; the limiting factor tends to be the ability to write the digital data to the camera memory fast enough. Burst mode is fabulous for shooting weddings for a number of reasons. By shooting a number of images, you tend to lose the nervous, posed energy in the first shot and get a more natural look in the ones that follow. With groups, you must herd the people into a spot and get their attention. Someone's eyes are always closed, and someone is inevitably looking away. Because getting everyone's attention is often the hard part, once you have their focus, shooting in burst mode offers multiple chances to get a clean, flattering shot of everyone. Finally, burst mode is great for nuanced emotional changes—the time between laughter and tears is filled with small emotional changes that you can catch if you are shooting fast enough.

# Removable Lenses

If you are shooting either photo or video with a DSLR camera, you likely have the option to change lenses on your camera body. As will be discussed later in more detail, certain parts of the wedding lend themselves to certain types of lenses. For example, a zoom lens is especially handy in the ceremony to get close-ups even when standing far away, and a wide angle is great for establishing shots. If this seems daunting, rest assured that you can cover a wedding perfectly well without this extra expense and item to tote around. Then again, if you have the lenses—or the capacity to buy, borrow, or rent them—they can certainly lend distinction to your work. Here are some common removable lenses (see Figure 2.9) and tips on when they might come in handy in a wedding setting.

- **Prime lens.** A *prime lens* has one focal point, as opposed to the range associated with the zoom lens. It is often the starter lens that comes with the camera. While limited in its capabilities, a prime lens typically performs those capabilities extremely well; it will be fast and high-quality. The speed of an especially high-quality prime lens can be a particular benefit to wedding shooting, when you want to get a few shots of a particular moment. A typical prime lens is 50mm, an angle of view fairly similar to the human eye.

**Figure 2.9**

If you are shooting with a DSLR camera, get to know the lenses that you have available to you. It could dramatically improve the possibilities in your shoot. (Image courtesy of iStockPhoto.com/Noctiluxx.)

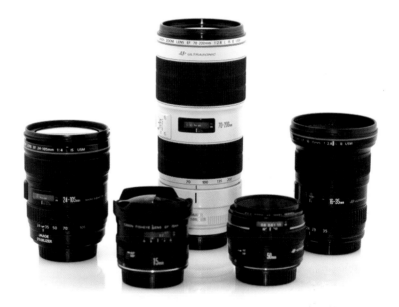

- **Telephoto lens.** A *telephoto lens*, often called a *zoom lens*, has a range of focal lengths and can focus at any point along the continuum. Zooming is wonderfully convenient in wedding shooting, as you can't always be as near to subjects as you would like without being intrusive. Remember, though, that zooming and getting closer to the subject are different. You can zoom in and use a longer focal length, or you can get closer and use a shorter focal length. The results will differ. (See Figure 2.10.)

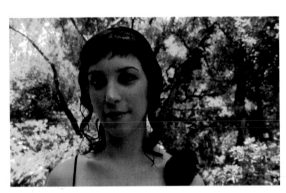

**Figure 2.10**  Although both of these photos appear to have the same approximate framing, the first was taken while the shooter was physically close to the subject while the second was taken from farther away but zoomed in. Notice the difference in both the subject's features, which are slightly distorted in the first photo, and the background, which appears blurred in the second photo.

- **Macro lens.** The macro shooting preset mimics the *macro lens* itself, which can focus very close up with a small depth of field. This results in fun images of small things. If you happen to have a macro lens, use it on the rings, boutonnières, place cards, and other small objects.

- **Wide angle.** *Wide angle lenses* have a deep depth of field. You don't need to work hard to find focus, even if there is an awful lot crammed into the frame. A wide angle lens is excellent for shooting posed group shots, where family members or the bridal party are lined up around the bridal couple. In fact, in some cases, a wide angle lens might be the only way to capture such a shot.

- **Fisheye lens.** A *fisheye lens* is a quirky lens that distorts the perspective so that the center of the frame appears close up and the rest of the frame seems farther away, as if wound around a ball. (See Figure 2.11.) It can make for fun images of the dancing, reception, and event details, but is usually a poor choice to cover the more serious moments of the wedding ceremony itself.

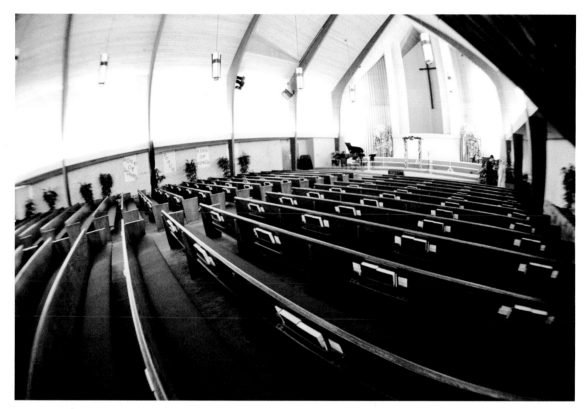

**Figure 2.11** A fisheye lens certainly doesn't suit every situation, but its distortion can add an artistic and fun perspective when used well. (Image courtesy of iStockPhoto.com/adamkaz.)

If you are using detachable lenses, check whether they feature image stabilization. Lens-based image stabilization is used to reduce the effects of camera motion that show up most often in slow shutter speeds and with telephoto lenses. Some camera bodies have image stabilization built in; in contrast, Nikon and Canon cameras tend to have stabilization features in the lens instead of the body (although not every lens that fits on a Nikon or Canon will have stabilization). If you are working with a zoom lens that doesn't have image stabilization, you will want to make sure to adjust the settings to have as short a shutter speed as possible—especially when using a long focal length (zoomed in). Alternatively, if you have a long lens that doesn't have stabilization, consider carrying a tripod to help reduce motion shake in your images. If you are in the market to buy lenses, stabilization is well worth the additional cost, especially for weddings.

# Next Up

Now that you know the features of your camera, we're going to talk about how to best use it to compose beautiful pictures. One of the primary skills in wedding shooting is creating good shots without spending too much time setting them up. The next chapter covers some shooting basics so that you have the skills to compose your images beautifully and quickly. We'll start at the beginning, with how to hold your camera, and then move on to more advanced concepts such as composition, framing, and lighting.

# DIY Idea: Group Engagement Session!

Often, professional photographers will shoot a series of engagement shots of the couple—usually casual and fun shots in a pretty setting. This serves the couple and the photographer alike. The couple gets to "audition" their photographer and collect some nice images to use in their wedding collateral—the invitations, wedding website, table centerpieces, and other décor. The photographer gets a chance to hone and showcase his or her skills and to get to know the couple, which helps in shooting the actual event.

An engagement session with the bridal couple is a great idea on its own—but DIY shooting lets you go much further than the professionals can take it. Consider a group session, shooting the couple and their families, their siblings, or their bridal party. This will be great camera practice for the DIY shooter in preparation for the actual event, as well as providing a set of pictures that can be creatively used to personalize the wedding and honor the people closest to the couple. A shower or a bachelor party might be a good time to practice, especially if some of the key people are likely to be in from out of town.

As well as the photography practice and the album of images, there are lots of reasons to do some portraits of your group before the event. Here are some fun DIY ideas to use those practice shots for the wedding itself:

- Table centerpieces that honor family members and special friends of the couple

- Shower, bachelor party, or save the date mailers that feature a group of friends excited about the upcoming event (see Figure 2.12)

- Personalized place cards for the bridal party or honored guests (see Figure 2.13)

- A running slideshow of family and friends that can play on a laptop or projected onto a wall during the reception

- Photo credits in the wedding video

We can't stop toasting!  Please join us for the next round!

# Mary's Bridal Shower

May 27, 2012,  2-5 pm

Bearcat Winery, Napa

**Figure 2.12** This shot of Mary's girlfriends makes a cute shower invitation, and also was great practice in bright light shooting! (Image courtesy of Mary Tunnell.)

**Remy Hathaway**
**Best Man**

scientist, uncle, planner, princess, nerd, cat-lover, patron of the arts, care-taker, best friend

**Figure 2.13** Uniquely recognizing your guests is a wonderful way to personalize the event. This practice portrait session doubles as a series of handmade place cards.

# CHAPTER 3

## Basic Production

**In this chapter:**

- Holding a camera
- Framing your shot
- Composition
- Using the light

There is a moment—sometimes a very, very brief moment—between seeing a shot worth taking and actually taking it. An experienced photographer or videographer can maximize that moment, using skills, instincts, and muscle memory to record the shot quickly. In many settings, a photographer might have to sit, wait, and watch for those photo-worthy moments. In contrast, a wedding photographer will be scrambling to capture as many of those moments as possible. To a certain degree, the plentitude of possible shots works to the shooter's advantage, as there is always a story worth telling!

> **Tip**
>
> Get used to the fact that you may be missing a shot and concentrate on the one you have. One good photo is better than four bad ones! Don't worry about the shots you *aren't* getting; just worry about the ones you *are* getting.

This chapter considers the decisions you'll make once you see something worth shooting: how to hold the camera, how to best position yourself to use available light, and how to artfully compose and frame your shot. To shoot well, it is extremely important to know (if not follow) various rules. These rules exist for a reason and will enable you to capture pleasing images. Knowing these rules will also help you break them well, with decisiveness and purpose, instead of simply making random and sloppy guesses. In other words, know the basics so you can move beyond them!

# Holding the Camera

Chances are you are rolling your eyes right now. "Hold my camera? She wasn't kidding about basics!"

Yes, I *am* going to explain how to hold your camera. Hold it correctly, that is, since it is such a common and fundamental mistake. When you are holding your camera well, both your flexibility (how fast you can change settings) and your stability (less likelihood of blur in your shots) will improve dramatically. If your shot is blurry, either the subject or the camera moved; let's do our best to make sure it isn't the camera.

There will likely be times when you are standing on your tiptoes, arm stretched above your head, shooting at something you can't quite see on the dance floor. Or maybe you are lying on the ground getting a shot of the bridesmaids' sandals on the grass. So be it. In those times, it is a fun and good idea to break the basic recommended positioning. But again, setting the correct positioning as a default from which to stray is excellent practice, which will be reflected in your product.

The general goal of your positioning is to keep your body as still as possible. To be still you need to be comfortable and relaxed, not rigid. Your camera should be supported and as close to your body as possible. In fact, think about trying to make your body a tripod, and consider the ways in which you can be firmly planted and still, given your location and the shot you are trying to obtain.

Here are a few points to consider. (Note that most of the basic ways in which to make yourself most stable apply to both photo and video.)

■ Stand with your legs shoulder width apart and your legs slightly bent. This is primarily to secure a stable position with regard to camera shake and blurry images, but serves an important dual purpose at a wedding: Just as bridesmaids are warned throughout the wedding not to lock their knees, as they could faint and topple over (yes, I've actually seen that), the same is true for a shooter. This is most especially true in long ceremonies and hot summer events.

■ Keep your shoulders relaxed and your elbows tucked in. This is primarily for image stability (you can hold the camera much more steady with your elbows at your side), but serves the additional purposes of keeping you from being jostled by wedding guests and allowing your arms to remain in a far more relaxed position than if your elbows were sticking out.

■ When shooting still photographs, hold the camera handgrip in your right hand and use your left hand to stabilize the camera body or lens. The camera should be resting or cradled (as opposed to held or gripped) in your left hand; your right hand is doing the heavy lifting, so to speak. Your left hand should serve to carry some weight but also be a stabilizing factor and ready to make adjustments. Make sure your left hand is positioned below the lens, since that position will both distribute additional weight and prevent the shake and movement that is much more likely to occur if the left hand makes adjustments from over the lens. (See Figure 3.1.)

**Figure 3.1**
Good images start from good basics. Make sure to firmly hold the camera with your right hand, freeing up the left hand to provide stability and make adjustments. (Image courtesy of iStockPhoto.com/valery08.)

■ With video, hold the camera in your right hand. Many cameras will have hand straps that can be tightened to help hold the camera steady. Make sure that tightening the strap doesn't impede your ability to quickly get to any buttons or menu options. If you use a second hand to support your camcorder, use it the same way as with a camera—gently cradling the body or lens.

■ When shooting a photo, exhale before you press the shutter button to take the picture. Or, if it is more comfortable for you, inhale and hold your breath while you shoot the picture, and then exhale. Either way, don't breathe and press the button that opens the camera shutter at the same time; that can cause blurriness in your pictures.

■ With both photo and video, if you are shooting off-tripod, you can use your own body for additional stability. Rest your elbows on a table or lean against a wall. That will give a tripod effect and keep your camera much more still than you can do on your own. Remember, the further the camera is from your body, the more likely you are to introduce shake.

---

**Tip**

If you have a bad habit in the way you hold your camera—such as taking a lot of the camera weight in your left hand, or sticking your elbows out—I urge you to try your hardest to break it. You will very likely notice an improvement in both the ease of shooting and your image quality. Break the habit through practice, comparison, constant reminders, and practice. Did I say practice twice? Yes. I sure did.

---

# Framing Your Shot

Now that your camera has the right settings applied and is being held in the correct position, your options for setting up your shot are dizzyingly large. How do you think about ways to set up the image prettily? Your image composition is a combination of a lot of decisions: the angle, the shot, the subject, the frame, and the movement (for videographers), and how the light interacts with all of those factors. Let's look more closely.

## Angles

If you watch a professional shooter covering an event, you will see that it can be a strenuous activity. Aside from the running around to follow the action and the lugging of all the gear, there is the movement required to get the interesting and fun angles that will make the images more compelling to look at. Mixing your camera angles is especially important when you consider compiling your work in post production. In video sequences, you will want a variety of angles so that your montage of images can flow

nicely into each other. Changing angles avoids both jarring jump cuts of shots that are too similarly framed and the monotony of seeing everything from one perspective. Using a variety of angles in photography offers the same benefit; an album of images that are all taken from the same angle would be very dull.

As well as keeping things visually entertaining, knowing your angles will help you also keep things flattering—a crucial aspect of wedding photography and videography. No bride will thank you for an unflattering shot. Following is a list of common angles, examples of which are shown in Figure 3.2.

- **Eye level.** This generally neutral shot appears to the viewer as a real-world angle. It is what we are accustomed to seeing with our eyes.

- **High angle.** This shot shows the subject from above, with the camera pointed down. This is often a flattering angle for brides because it tends to reduce rather than enlarge features. Stylistically, a high angle can lend a pensive, reflective, or demure air to the subject.

*Eye level*

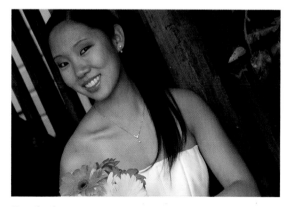
*High angle*

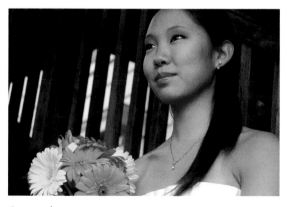
*Low angle*

*Dutch tilt*

**Figure 3.2** The eye level, high angle, low angle, and Dutch tilt lend a very different look to otherwise very similar shots.

- **Low angle.** This shot shows the subject from below, with the camera pointed up. This tends to be less flattering for brides as it tends to enlarge or distort features. A low angle may work better for grooms, as it can have the tendency to make the subject appear powerful—larger and dominant. It also can work well for large group shots from afar or to create an interesting look for an establishing shot.

- **Bird's eye.** This angle shows the scene from directly above. If space and equipment permits, this can be an excellent shot to use at the ceremony, the receiving line, or during the dancing. Some professionals carry a small step ladder to help facilitate this angle, but it is often easy to just use your surroundings. A chair, a boulder, a second-floor window, or a hill might offer a different vantage point that lets you look down on a scene.

- **Dutch tilt.** This is achieved by tilting the camera to one side so that the horizon is on an angle. This can be fun and dramatic, and plays well with close-up shots of the wedding details such as jewelry and flowers. It can also enliven dance images.

Angles can be combined for especially cinematic effects. For example, a low-angled Dutch tilt is an excellent way to catch the wedding aisle with rose petals strewn on it in the foreground and the altar or wedding arch in the background. Figure 3.3 shows an example of a low-angled Dutch tilt.

**Figure 3.3** This dramatically low-angle shot of the tea ceremony required some creative thinking and awkward positioning, but the results were certainly worth the effort! (Image courtesy of Rick Collins; www.rickcollinsphotography.com.)

# Shots

As with angles, using a variety of shots will provide you more options in editing for video and a livelier photo album. Especially within one section of a wedding, make sure to get a variety of shots. Moving from medium shot to medium shot is dull, but moving from medium to close-up to wide to extreme close-up will enliven any sequence of video or series of photos. (See Figure 3.4.)

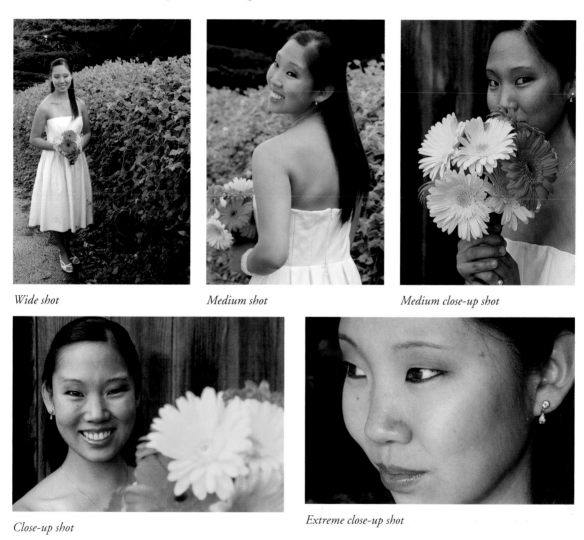

*Wide shot*                    *Medium shot*                    *Medium close-up shot*

*Close-up shot*

*Extreme close-up shot*

**Figure 3.4** A variety of shots, such as the wide, medium, medium close-up, close-up, and extreme close-up shown here will keep your images interesting, as well as allow you to show off everything from the bride's entire outfit to her tiny diamond earrings.

- **Two-shot.** This shot has two people as its subject and is usually (but not necessarily) from the torso up. This shot is common during posed shots with the bride and her attendants and the groom with his groomsmen.

- **Point of view (POV).** A POV shows the view from the subject's perspective. This can be very fun to use in bridal preparations as well as with the bouquet and garter toss.

- **Extreme wide shot (EWS).** Often, this shot is so wide it might not have an obvious subject. It is extremely helpful for establishing context; indeed, it is often referred to as an *establishing shot*. Wedding videographers use it to give an overview of the setting—that is, to indicate to the viewer where the video takes place, such as a vineyard, a hotel, or a church.

- **Wide shot (WS).** A wide shot shows a person from head to toe. Make sure to get lots of wide shots of your bride in her dress. You will also need wide shots to get formal pictures with lots of family members.

- **Medium shot (MS).** A medium shot of a person will generally be from the waist up. It is handy to mix in medium shots to give visual variety.

- **Medium close-up (MCU).** A medium close-up will be tighter than a medium shot, generally showing a person from the shoulders up.

- **Close-up (CU).** In a close-up, the subject fills the entire frame. You will want to get lots of CU shots of the pretty particulars that go into the wedding: place cards, jewelry, bouquets and boutonnieres, shoes, and dress detailing.

- **Extreme close-up (ECU).** An extreme close-up will be even tighter than a CU, showing perhaps only a portion of the subject's face. Like a CU, they are good shots for details and are also effective for depicting bridal preparations such as the bride applying makeup and putting on jewelry.

- **Master shot (MS).** In video, the master shot is also called a safety shot, and is usually a wide, static shot. Although it may appear dull, it is extremely handy for establishing a scene or for when a more dynamic, planned shot doesn't work. Often, in a two-camera shoot of a wedding ceremony, one camera will be set up for a master shot the entire time while the other camera tries for more interesting coverage. Master shots can be extremely useful for photography, too; like an EWS, they can be used to establish context and lend better understanding to the CU, ECU, and POV shots that may be part of the same series.

Establishing shots are used to provide context to the viewer—where or what is going on. It is extremely useful to have a few establishing shots to provide a logical and gentle opening to your video sequence or your photo series. As noted, master shots or extreme wide shots are handy for establishing context; a photo of a church or a beach will tell the viewer exactly where they are. Establishing shots don't need to be wide shots, though, as shown in Figure 3.5.

**Figure 3.5**
While many establishing shots for weddings are wide shots that show off the venue, a close-up of a program, a sign, or an invitation can also provide context for the viewer. (Image courtesy of Brant Bender; www.brantbender.com.)

## Moves

Novice videographers spend a lot of time trying to get accidental moves out of their shots; the shake of a handheld camera can go from "authentic" and "stylistic" to "nausea-inducing" pretty quickly. More experienced shooters, however, tend to put the move back in their camera work—though ideally, it is movement of the controlled and intentional flavor. Camera moves will lend a sophistication and visual variety to your video footage that can make editing and watching your piece more fun.

Almost all camera moves are aided—dramatically—by a fluid-head tripod. That doesn't mean you can't successfully use these moves on a lesser tripod or while shooting handheld, but it does mean you should do so with careful execution, precision, and lots of practice. The last thing you want to do is incorporate a lot of handheld camera moves into your shooting on the wedding day before you've determined where they fall on the "authentic and stylistic" versus "nausea-inducing" scale.

Here are some basic camera moves to try out:

- **Follow.** In this move, the camera follows the subject at a roughly constant distance.

- **Pan.** This refers to horizontal camera movement, either left or right.

- **Pedestal.** This refers to moving the whole camera vertically, with respect to the subject, while maintaining a constant angle.

- **Tilt.** In this move, the camera's angle changes vertically while the camera itself maintains a constant vertical position.

- **Zoom.** Technically, this is not a camera move; rather, it is a change in focal length that makes the subject appear closer (zoom in) or farther away (zoom out).

Following are some more advanced camera moves:

- **Dolly.** Here, the camera is mounted on a cart for smooth movement. In the wedding setting, this can be simulated by placing a tripod on a cart or even in a car for establishing shots.

- **Dolly zoom.** In this case, the camera moves closer to or farther from the subject with the lens zooming out or in, respectively, to keep the subject the same size within the frame.

- **Track.** Similar to a dolly, a track is any shot that moves while maintaining constant distance from the subject. It may also be called a *truck*.

# Composition

*Composition* refers to how the elements of your picture are arranged within the frame. Composition is used for both storytelling (what is going on here?) and aesthetics (how does this image make me feel about what is going on here?). As mentioned earlier, knowing the basics of composition will allow you define your personal style—both in the ways you follow the basic rules and the ways in which you break them to tell your own story.

# Determining Your Subject

At its most basic level, composition tells the viewer what the subject of the scene is. While that might sound obvious, it is a very common mistake to assume that the viewer will naturally see what you want him to see. Remember, when you pick a shot, there are all kinds of contextual clues that drive you to the subject: the events of the day, the key people, and the audio and visual cues that tell you the fun things that are going on that moment. In contrast, the person who sees the image only has that picture to tell the story. For example, if everyone is laughing and cheering about the five-year-old kid break-dancing on the dance floor, you innately know your subject as you take the picture. However, unless you position that five-year-old to be the subject of the image, it will just look like a bunch of people—including a five-year-old—having a good time on the dance floor. Something that is visually compelling in person might not jump off the frame in the image, without your help. (See Figure 3.6.)

**Figure 3.6** This shot could have been merely a wide shot of a group of people, but it is composed so that everything in the picture tells the viewer to look at the child in the middle: the height differential, the centering, and the cameras and eye lines of the adults looking at the boy. (Image courtesy of Rick Collins; www.rickcollinsphotography.com.)

The way you position your subject within your frame will also lend a particular style to your storytelling. If you place the subject in the middle of the frame at eye level, you will give your image a straightforward, documentary-style feel—like journalism. If you frame the same subject on the edge of a frame or at an angle, your work could wind up with a jaunty or quirky or arty look—like a music video or a romantic dreamy montage. (See Figure 3.7.)

**Figure 3.7** A jaunty up angle allows us to see the action of the shot—the sash being put on—as well as adding a playful twist and a glimpse at the bridesmaid's concentration. The sash and the facial expressions might well have been lost without the careful composition. (Image courtesy of Rick Collins; www.rickcollinsphotography.com.)

# Rule of Thirds

Typically, a viewer's eye will work its way across an image as opposed to taking it all in at once. This means, contrary to intuition, key elements do not need to be centered. In fact, they can be more visually appealing and engaging when located off center. An uncentered subject will help guide the viewer's eyes to keep moving across the whole image instead of stopping the eye in the middle.

Derived from classical painting, the rule of thirds provides some basic guidelines that enable filmmakers and photographers to set up images that are naturally compelling and pleasing to the eye by indicating places on a frame that the eye will naturally flow across. To apply the rule of thirds, divide your frame into thirds, both horizontally and vertically; then place key elements of the subject on those horizontal and vertical lines or where the two lines intersect. (See Figure 3.8.)

**Figure 3.8** This ring bearer moonlights as a "rule of thirds" model at a wedding rehearsal. Notice how his body is positioned along the left vertical axis and his eye line is along the top vertical axis.

Of course, the rule of thirds should actually be called the *guideline* of thirds. As mentioned earlier, while this and other such rules are useful for strong starting points and solid, usable footage, occasionally breaking the rules can make for innovative, creative work. On the other hand, breaking rules can also make for messy, amateurish shots. Be prepared to use trial and error to practice different looks. Try to break rules with intention and style, not haphazardly.

Natural light can represent a compelling reason to break the rule of thirds. If speckled light on the lawn or the couple's shadow provides an interesting visual balance to the subject, go with it. Don't force a pretty scene into the rule of thirds. (See Figure 3.9.)

**Figure 3.9**
Sometimes, centering an image adds starkness and drama. It can be more direct than the gentler rule of thirds–aligned images. (Image courtesy of Christian Maike; www.christianmaike.com.)

# Headroom

For a lean and visually appealing shot, make sure to capture the right amount of *headroom*, or space between the top of the subject and the top of the frame. Too little headroom (not enough space) will likely cut your subject at an awkward place and most likely be unflattering to the subject and/or uncomfortable for the viewer's eye. Too much headroom (too much space) tends to reduce the importance of your subject and/or allow too much dead space, which makes the image boring. (See Figure 3.10.)

Typically, headroom is something you can sense. An image will just *feel right* when you find the right headroom. If you don't sense headroom naturally, however, try slowly zooming your camera out, waiting for a framing when your eye feels relaxed looking at the scene and not much space is wasted. If that seems confusing, or you can't tell when your eye is feeling relaxed, a guiding principle with close-ups is that a person's eye line should fall on the top horizontal line if the image were divided into thirds.

With video, ideally you can figure out your headroom before you start shooting to avoid awkward and jerky adjustments at the beginning of your shots. For example, focus and frame the best man as the DJ is introducing him so that by the time he starts his toast, you have a clean and comfortable view of his speech. Regardless of how well you start out, you will likely need to make adjustments during longer shots, such as the ceremony or a toast because your subject will likely be moving (Oh! The frustration of the pacing toast-giver!) and guests or other vendors might wander into your shot uninvited. Those adjustments can make your footage look choppy and jerky if they are happening constantly, so consider holding a shot for a little while or until the framing becomes unbearable before you make your adjustments.

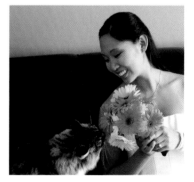

*Too much headroom*    *Too little headroom*    *The right amount of headroom*

**Figure 3.10** Paying attention to headroom will enable you to make the most of your image real estate, without wasting space awkwardly or making uncomfortable cuts. The right amount of headroom is relaxing to the eye.

# Clean the Edges

The first time I shot anything (a music video), a more experienced shooter told me, "The musicians are always compelling, so watch the edges of your frame for everything that *isn't*." This advice has proved invaluable for everything I have shot since—most especially weddings. The items on the edge of your frame—tripods, parked cars, bags of gear, pedestrians, fire extinguishers, or anything else that isn't part of the scene you are showcasing—can distract from the story you are trying to tell with your picture. (See Figure 3.11.)

When you are busy watching your subject, it is amazing how easily this dirt and noise can find its way into your pictures. Upon review, you might ask yourself how on Earth you didn't realize there was a garbage can in your otherwise perfect picture. While you can take consolation in knowing what a common mistake a cluttered frame is, it would be best if you could simply avoid the problem in the first place. To keep your frame clean, force yourself to regularly sweep your eye around the edge of the frame before you shoot in photography and at regular intervals for videography. Either physically move or crop out distractions by zooming. I found this very hard to do at first while shooting video, because I was fearful that my subject would get lost if I removed my gaze for even a moment. I was wrong, of course. Remember to relax the visual grip on your subject and scan the frame for clutter as you shoot video.

**Figure 3.11**  The absence of the unnecessary clutter of CDs, bike tires, and candles (as pictured in the first photo) makes it much easier to concentrate on the subject in the second photo.

> **Tip**
>
> While it is always best to get the image right in the camera, cropping is a very simple post-production fix for a lot of framing problems. The more resolution, or pixels, you have in an image, the easier cropping becomes, as you have more image data to work with.

## Eye Line

For both photo and video, the subject's *eye line*, or direction of gaze, can greatly influence the feel of a shot. It is almost always more natural and appealing to have your subject facing into the shot as opposed to outside it. That is, the shot is more relaxing to look at if the subject's gaze goes across the shot from the side on which he or she is positioned, guiding the viewer's eye across the entire scene. If the subject is positioned on one side and is looking farther still to the same side, it will draw the viewer's eye awkwardly off the image, wasting the space in the middle and right of the frame. (See Figure 3.12.) Of course, looking out of frame can be playful and fun, too, leaving the viewer to wonder what else is there. Shots with the subject looking directly at the camera can be powerful, too, adding intensity; it works well in careful doses. (See Figure 3.13.)

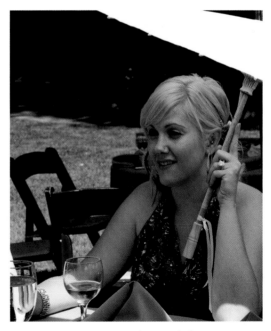

**Figure 3.12** These show different cropping of the same image. Notice how the second image feels more comfortable to the eye—the space in front of the guest is easier for our eye to take in than the space behind the guest in the first image. Our subject's positioning and eye line cause that distinction.

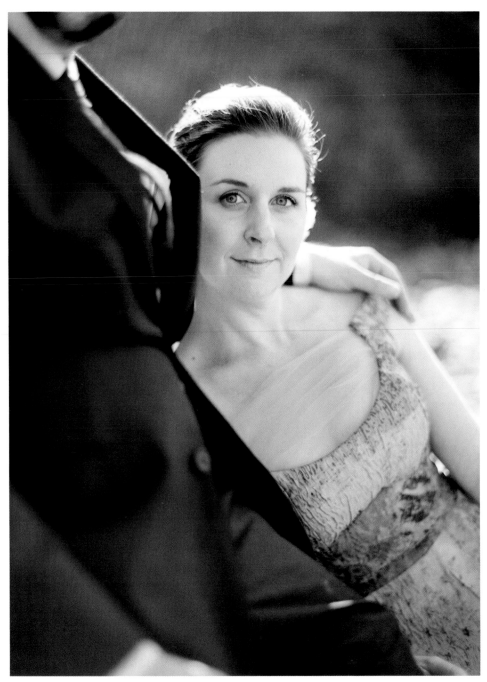

**Figure 3.13** By ignoring the rule of thirds and capturing a direct eye line, the photographer caught a beautiful and powerful shot of this bride. (Image courtesy of Christian Maike; www. christianmaike.com.)

Like headroom, some people don't need to be told about eye line; it seems to come natu-
rally as they compose their shot. If you aren't one of those people, start by making sure
that the people in your shot are looking at what you want your viewer to see in the
scenery or background, not away from it. Of course, keep in mind that these rules aren't
hard and fast, and that breaking them can be fun. (See Figure 3.14.)

**Figure 3.14** These photos are set up similarly but have an entirely different feel. The downward cast eyes of the first
photo lends a pensive and serious mood; the upward cast eyes (and partial smile) in the second photo convey a little
mischief and fun.

## The Margins of Your Shooting

It's tempting to get a good clip of video and then turn off the camera. Often, however,
the *really* good stuff happens on the perimeter of the action, so keep your video camera
running or your still camera poised for a little longer than comfortable. Many candid
and natural moments occur after the shooting is supposedly over, when the subjects let
down their guard and relax a bit. For video, that will result in off-the-cuff comments
that can be endearing and fun; for photo, you will often get a change in expression or
a more natural and relaxed look.

Holding the shot longer will also give videographers a little extra room to work for
transitions between shots and scenes. For example, showing the bride's train slide across
and out of frame as she walks out of the scene might be an excellent shot to use to move
from a section of romantic shots into a sequence of shots during the reception.

Here are a few places where shooting on the margins can be especially beneficial:

- At the end of the ceremony, as the couple is walking down the aisle, you are likely
  to be rewarded with looks and comments of relief and joy if you leave the camera
  running or ready.

- Be ready to shoot the applause of the toasts. Videographers will capture audio of
  the applause to blend into the next event of the reception, and funny comments
  from the guests as they clap and cheer. It's also very common for the toaster to grab

the mic again to add something or for the couple to have a funny rejoinder or a warm thank you. Still photographers should be ready to shoot the reactions of the couple and the action of the applause.

■ At the end of the bridal couple's first dance, you are likely to get applause, whistles, commentary, sighs of relief, and congratulatory high fives or hugs that can brighten and personalize a scene for photo and video both.

■ While the bride is getting ready, you are likely to hear all kinds of fun and funny comments from her family and bridesmaids, as well as from the bride herself. Despite some tension, in general this footage is going to be natural, enthusiastic, and full of joy and anticipation. So don't just shoot the posed shots; capture the feel of those anticipatory moments by letting the camera run a little longer.

---

**Tip**

Many video cameras have a *tally light*—a little red light that tells anyone in front of the camera when the camera is recording. Often, you can find a menu option that enables you to turn the light off. Some people find that their subjects tend to be more natural when they don't have glaring evidence that the camera is on. Shoot with the tally light off, if possible.

---

## Following Action

It would be wonderful if you could direct your wedding participants the way a narrative film director can direct his or her actors. If you could plan ahead of time which direction the dip at the end of the first dance would face, your shots would all be beautifully composed. Weddings aren't like that, though; while you might be able to stage a few shots (we'll talk about that in coming sections), for the most part, you will be desperately trying to keep up with the action in an attempt to make sure it stays in the frame of your camera.

In situations where the video camera is moving to follow the action, such as when the bridal couple enters the reception or during the father-daughter dance, it is very tempting to anticipate the movements of your subjects and place the camera where you will "find" them. In doing this, however, you lead the viewer's eye to unknown areas, which can be awkward, disorienting, and downright sloppy. Instead, take a deep breath and follow the action rather than leading it. Let your subject move first; then slowly and steadily follow them. This makes for footage that is significantly more smooth and natural for the viewer. Furthermore, following the action will give you a much better chance of landing on a well-framed shot. That means you will also generate fewer awkward corrective camera moves that you must either edit out or try to gracefully

incorporate. For still photographers, anticipatory movements can pan out (and if they don't, it doesn't much matter). It is important to realize, however, that following action often means running ahead, crouching down, climbing up, and performing other maneuvers.

# Using the Natural Light

In many professional settings, shooters have the space and time to set up expensive equipment to perfectly light their subjects. A basic studio lighting kit would include a key light (or main light, used to light the scene and subject from the front or side), a fill light (a less powerful light used to fill in the shadows of the key light), and a backlight (to create depth behind the subject). In contrast, wedding photographers must often rely on harsh sunshine, dim church light (where flash photography is often prohibited), candlelight, colored lights, and strobes from a DJ, and whatever small lights or flashes might be in their gear bag.

In this section, we'll cover some ways to use the light as best you can in any given situation to make your shots look studio lit. As we discuss each section of the wedding event in later chapters, we'll revisit lighting to talk about specific ideas. For now, we'll discuss basic concepts that are imperative to your basic shooting techniques.

## Lighting Basics

Ideally, you always want the light to hit your subjects from the front or gently from the side to keep them well-exposed. Even light distribution makes for the easiest and often cleanest shots. As the sunshine is likely to be your light source for a lot of the day, aim to shoot from an angle where the sunlight is hitting your subject (or subjects) evenly, or front on. If the sunlight is hitting your bride from too much of an angle, part of her will be well lit and part of her will be in dark shadow. Will your subjects be squinting and blinking and cursing you when you make them look into the sun? Well, maybe. But they'll like that better than a bunch of backlit pictures later on. If the sunlight is extremely bright and right overhead, watch for shadows. If you have a flash, you can use it to fill in shadows in this situation, or you might want to consider shooting in the shade if it is an option. (See Figure 3.15.)

If you are manually adjusting your camera's exposure settings, make sure to do it based on the subjects, not the background. A blown-out, or overexposed, background is more visually acceptable than a blown-out subject—not to mention easier to fix in post production.

The prettiest time to shoot tends to be about an hour before sunset—when the sun is low in the sky and the light is gold-tinted, warm in color temperature, and evenly dispersed. Depending on what is going on pre-sunset in the timeline of the particular

**Figure 3.15** Even light is the easiest to shoot in, but the speckled, or dappled, pockets of light of outdoors can create a nice highlighting effect, as shown around the cake in the first photo. Be careful of the harsh pockets of light and shadows that outdoor lighting can create, though, as shown in the second photo. (First image courtesy of iStockPhoto.com/segray.)

wedding you are shooting, you might be capturing vows, toasts, setup, or send-off; regardless, if you happen to be outside, make sure you have your camera on you and ready to go when that golden light appears.

## Shooting in Low Light

Shooting in low light is as common in weddings as shooting in the bright summer sunshine. Churches, receptions, and dance floors all tend to be poorly and unevenly lit. Here are some things to consider to improve your exposure in dim settings:

- **Focus.** In low light, your aperture will be more open, shortening your depth of field and making it hard to focus. So hard, in fact, that if your camera isn't receiving enough light to find the subject, it will autofocus on various elements in the scene (or nothing at all) as it searches. This lends itself nicely to getting pictures of blurry, unrecognizable subjects in dark, dingy backgrounds. If you have the option

of manually focusing your camera, you'll have a much better chance of actually getting the shot. Your eye is much more adept at finding focus quickly than the autofocus mechanism, and even in that short depth of field you should be able to get cleaner shots.

■ **Gain and grain.** Many video cameras have the option of adding gain, which amplifies the signal sent to the sensor. Literally more voltage is sent per pixel to be read. Gain is measured in decibels (dB); a gain of approximately 3dB is the equivalent of opening the aperture about one f-stop. That sounds great, doesn't it? All your low-light problems solved! Well…not really. Gain can be very helpful, and I recommend you look for manual gain adjustment on your camera, but be very wary of overusing it. That amplified signal, which in moderation will lend light to your scene, can very easily turn into a source of noise, or grainy images. While each camera performs differently in low-light situations, a general rule of thumb would warn you against boosting your gain by more than 6dB in any scenario to avoid grainy pictures that lack rich color and detail.

■ **Streaking.** When you are shooting video in an otherwise low-light scene, a small area of bright light can cause streaking in camera movements such as pans. While some of those streaks might be artistic and desirable, if you are looking for clean footage, make sure to manually focus to prevent your camera from continually trying to focus on the small light. If your camera doesn't have a manual focus, make your camera movements very slow to avoid continual auto focusing (and refocusing), and consider framing the small lights out of the shot.

■ **Blurring.** Lowering your shutter speed is a great way to boost the amount of exposure your sensor is receiving while you are shooting in low light. Be careful, though. Unless you are using a tripod, you are likely to blur your footage when you reduce your shutter speed too much. You simply can't hold your camera perfectly still for those longer-duration shutter openings. You and your camera might vary slightly, but a general rule of thumb would indicate that anything slower than 1/60 of a second should be on tripod.

## Shooting in Bright Light

Shooting in bright light is difficult. Your camera will adjust for the light source rather than your subjects, which may be underexposed—possibly even silhouetted. You also have pesky shadows and the possibility of overexposure to contend with. Here are some ways to combat especially bright light:

■ **Subject settings.** As mentioned, be sure to adjust your settings to appropriately light the subject, not the background. This might still result in an overexposed background, but that is a better option than a well-lit background and an overexposed subject.

- **Neutral density filters.** Many higher-end cameras include neutral density filters, which reduce the amount of light allowed into the camera without changing the color levels. They can be very helpful; often, your camera will tell you when one should be applied. Don't forget about the filter when you go back inside, though; that is embarrassingly easy to do.

- **Shadows.** There is no way to magically erase shadows. The best you can do is become better at watching for them as you shoot. Of course, sometimes you might actually *want* to shoot a shadowy scene or use the dappled light as part of the composition (see Figure 3.16), but do so with awareness. You'll kick yourself if your own shadow is in every shot by mistake.

**Figure 3.16** Shadows aren't always a bad thing. On the contrary, a shadow can be the element that makes an image work, as is the case here. However, shadows must be used carefully. This shot works only because of the precise placement that is highlighting the child's expression. (Image courtesy of Rick Collins; www.rickcollinsphotography.com.)

■ **Overexposure warnings.** Many camcorders and higher-end video cameras use zebra stripes, or lines over your image to point out any parts of the image that are overexposed (red lines) or approaching too much exposure (green lines). Still cameras often use histograms, or bar graphs, to show which part of an image might be getting too much exposure, or have a feature where overexposed parts of the image can blink red. Some shooters find these warnings a distraction (especially since overexposure on small parts of an image isn't a big deal), while others rely on them to create a well-contrasted image. There is no right or wrong way to do it, but it's worth figuring out what your options are if you think you are going to be shooting in a situation where overexposure is likely.

## Using Additional Light

Flashes are so very tempting to use in the low-light settings that so often plague weddings. After all, if you need some extra light, why wouldn't you use the light that's right there built into your camera—especially when the automatic settings or your camera are telling you it's a good idea?

The fact is, built-in flashes aren't great for low-light shooting because they aren't designed to deliver very much light. Most likely, a built-in flash will highlight your subject a little bit (often in a ghostly and uneven way) and leave your background totally underexposed. The first thing you can do to improve the quality of your low-light shooting is work really hard to avoid using your flash—most especially your built-in flash—by following the advice in preceding chapters: increasing your ISO, opening your aperture, and using longer exposure times. If that doesn't help, many cameras also offer night mode, which will briefly expose your foreground with a flash but use brighter exposure settings appropriate for the dark background in an attempt to even things out. Often, in night mode, the longer exposure of the background will have a soft or blurred look, which is stylistically appropriate for a wedding.

So when do you use your built-in flash? Somewhat counterintuitively, built-in flashes work best on scenes that are already lit, but perhaps unevenly so. A flash can even out and soften poorly distributed light such as sunshine hitting your subject at too much of an angle, creating uneven exposure on opposite sides of the face. A backlit scene (so often warned against) can be mitigated if a flash is used to give the subject additional light to help compensate for the bright background; dappled light can be smoothed with the addition of a little bit of extra light from a built-in flash.

External flashes do an even better job of adding discreet light than built-in flashes. Not only are they brighter, but you can point them in the direction needed. For example, if sunshine is hitting your subject brightly from the left, you can orient your external flash to compensate with additional light on the right. External flashes can be metered; you can adjust the amount of light thrown off manually or using the *through the lens* (*TTL*)

metering function of higher quality lenses. Some built-in flashes can be metered also; check the settings of your camera to see if that is an option.

Another benefit to an external flash is the ability to bounce light. A wide light source (such as the sun) will provide more even light than a narrow light source (such as a flash, lamp, or small window). However, in photography, the last place that the light hit is considered the source, so if you shine your narrow flash at a wall, and the light from the wall bounces onto your subject, you suddenly have a wider source (the wall) sending off a more even, soft light. Bouncing flash requires some practice, but can dramatically change the look of your shots; try bouncing a flash off of a wall, the ceiling, or a piece of white poster board.

Using an external flash can elevate your photography quickly. You can start playing around with multiple flash combinations and bouncing light with more sophistication. Remember, though, that even for professionals, weddings don't offer a lot of setup time, so fancy lighting configurations won't happen all that often. As a beginner, you are much better off having a relatively simple setup that you know how to use well.

## The Most Important Things to Remember About Flashes

Learning to use flashes requires a book in and of itself—and not a short one. But here are some important basic reminders for beginners when shooting with flashes:

- **A built-in flash won't light the dark.** A built-in flash is not designed to put out a huge amount of light. The best use for the built-in flash on your camera is to fill in shadows and even out exposure when shooting in bright light, not to shoot in the dark.

- **A flash has limited range.** When shooting in the dark, anything outside the range of the flash will be underexposed, possibly to the point of being invisible. In these cases, you are better off in night portrait mode (sometimes called *slow sync flash*).

- **You can change the output power of the flash.** Using your camera's flash exposure compensation control (or controls on the flash unit itself, if you're using an external flash), you can dial the output of the flash up or down to shine more or less light into your scene.

# Next Up

Now that you have your gear all ready to go and you've mastered the rules of composition, we're going to figure out how to use it in the different shooting scenarios that weddings present. We'll start with an overview of different types of shooting in Chapter 4, "Types of Wedding Coverage," and move on to the particulars of each section of the day in the chapters after that.

# DIY Idea: Proof Sheets

In film photography, a *proof sheet*, or a *contact sheet* is a photo print of your film negatives, used to look at a whole shoot and decide which shots deserve enlarging and printing. Digital photography doesn't rely on contact prints in the same way that film photography does (photographers are more likely to use galleries where viewers can scroll through larger-sized images), but the look of all those shots lined up has a style that is fun and cool and can make your practice sessions more enjoyable and productive. Most image-editing software has an option for creating and printing a proof sheet; you can use this while you are practicing or as a fun way to present a lot of shots from one section of the wedding, such as the bridal portraits. (See Figure 3.17.) I have a few framed proof sheets from vacations in my house; I love all the memories that so many small images give all at once, and it is always a conversation piece.

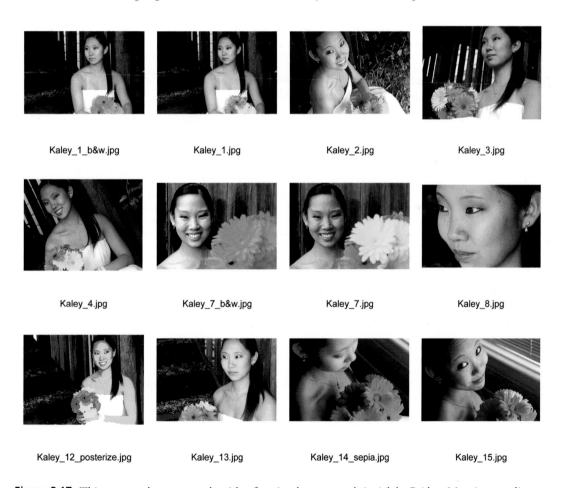

Kaley_1_b&w.jpg     Kaley_1.jpg     Kaley_2.jpg     Kaley_3.jpg

Kaley_4.jpg     Kaley_7_b&w.jpg     Kaley_7.jpg     Kaley_8.jpg

Kaley_12_posterize.jpg     Kaley_13.jpg     Kaley_14_sepia.jpg     Kaley_15.jpg

**Figure 3.17** This contact sheet was made with a few simple commands in Adobe Bridge. Most image editors will allow you to select images, or a folder of images, and build a contact sheet without you having to place each image. The settings are customizable, so your contact sheet can be made to your specifications!

# CHAPTER 4

## Types of Wedding Coverage

**In this chapter:**

- Posed images
- Candid images
- Interview video

In this chapter, we'll consider the different types of shooting that you may be expected to do throughout the wedding day. There are certain techniques that are likely to come in handy at a given point in the day that we'll get to in Part II, "The Marriage"; more generally, here we'll review the different types of shots and footage common to wedding shooting and develop some skills for each type. We'll consider posed, candid, and interview shooting. Posed and candid shots are relevant to both still and video shooting; interview techniques are of course just for video.

# Posed Shots

One might argue that posed shots are the easy ones because you've got everyone looking at you and you have time to set up your camera with the right settings. Although that is relatively true, the furious speed at which these opportunities will come hurling toward you require preparation. In other words, the way things move at a wedding, even the posed shots can feel candid sometimes.

Some couples will request all posed shots, with the idea that they'd prefer to have less footage or pictures, but more carefully set up ones. Often, a couple will give a list of posed "formal" shots they know they want to capture, such as a shot with both grandmothers or with all the siblings together. These are usually taken in a predetermined place and symbolize the families being united. (Lots of information on formal shots can be found in Chapter 7, "Formal Shots and Cocktails.")

Formal shots are by definition posed shots, but not all posed shots are formal. For example, when you stop two bridesmaids on the dance floor and ask them to smile for you, that is a posed shot, but not a formal one. Posed shots can include video as well as photo, and there are lots of fun ways to incorporate posed, or blocked, action shots into your work. If your couple is looking for more of a posed style, it's good to have some ideas up your sleeve. (See Figure 4.1. and Figure 4.2)

**Figure 4.1** It is a combination of skill and luck that elicits such emotion from a posed setup. Encourage that spirit by keeping things light and fun while you shoot posed shots. Your subjects will feel confident and enjoy themselves—and it will show. (Image courtesy of Rick Collins; www.rickcollinsphotography.com.)

**Figure 4.2**
Perfect, even light helps make this posed shot elegant. Look for the right setting before you move your subjects! (Image courtesy of Christian Maike; www.christianmaike.com.)

A key—and totally underrated—skill for getting posed shots is the ability to take control in a crowd. Lots of parts of the wedding are chaotic, and being willing and able to ask people to "Please move here" or "Wait for a moment there" is crucial. Wedding shooters must be polite but forceful. When a photographer is hired, dressed all in black and unrelated to people in the scene, they are naturally given some authority. As a friend of the couple, you must assume that responsibility and tactfully—but firmly—ask people to help you get the best images possible.

As you are moving people around–whether it is one person or 30—to collect posed shots, here are a few things to consider:

- Don't start herding a group, only to reshuffle everyone into different light. Decide where you want people to pose *before* you start setting up the shot. As discussed in Chapter 2, "Understanding Your Camera Options," you ideally want light to be shining on your subjects or hitting them at a slight angle, but a duller, more even light will also work well. As you are getting ready to take posed shots in any given setting (the church, under an awning, on a dance floor), figure out the exact place that will give the best light and then move your subjects into it. An assistant (someone willing to help you for a few minutes) might be very useful to test different locations.

- If you have a large group, make your subjects get close to each other. In fact, have them get uncomfortably close to each other. The amount of personal space people tend to take up winds up being much more than looks good on camera; they will look awkwardly spread out, with strange light, spaces, and backgrounds peeking through from behind them. By squeezing people together for group shots, you will create a sense of warmth as well as avoid strange negative spaces (see Figure 4.3). Smaller groups can use space in a way that is visually compelling and interesting, especially with some consideration of their placement with regard to each other and the light.

- With your subjects in the camera viewfinder (whether photo or video), spend just a moment eyeing the scene before you start shooting. Once you have them there and well-positioned, you've got them there until you've pressed the shutter button or stopped taping, so wait until you have the shot well-framed to shoot. Remember to pay attention to headroom, the edges of the frame, the rule of thirds, and the background of your image.

- Make your subjects look their best. Asking them to button their jackets, take off their sunglasses, or straighten their hemline is totally appropriate. If your requests are made politely, in fact, your subjects will likely be grateful. Of course, in order for you to ask, you have to notice, so make sure to pay attention to these details as best you can!

- Use your surroundings for framing. While you are deciding where your subject should stand for posed photos, and while considering the focal length you want to use, make sure to look at the scenery. Trees, fences, shorelines, trellises, and altars are all part of the shot, so try to consider the lines and features they form in the body of your picture.

■ Shoot in burst mode. As discussed in Chapter 3, "Basic Production," burst mode is helpful because your subjects will tend to slightly relax their posed face after the first shot; the later shots in a burst series tend to be more natural. With groups, burst mode gives you several chances to get everyone's eyes open and facing the camera!

### Tip

There is often a lot of setup for group shots. This is a great time for you to play with different looks; to make an interesting montage out of the formal images, it really helps to have lots of different shots to cut with. Try using your camera zoom to get different shots, move yourself for different angles and framing, and generally use this time to show off your camera moves. If you are shooting video on a tripod, a close-up pan of a long line of family members can be a lot more entertaining than a static medium or wide shot of all of them.

**Figure 4.3** A slight low and sideways angle showcases the bride and her siblings well. Their tight positioning adds to the warmth and joy of the shot. (Image courtesy of Brant Bender; www.brantbender.com.)

# Candid Shots

When done well, candid photography and videography can capture the mood of the event in a way that posed pictures sometimes can't. Candid shooting—for both photo and video—is generally less invasive and obtrusive than more rigorously styled shooting.

One would think it would be easier to shoot candids—I mean, hey, no setup required, right? Actually, the skills involved in good wedding candid shooting are not insignificant. You have the pressure of getting the elements of a well-composed shot (good light, good framing, flattering positions, and so on) without the benefit of an especially participatory subject.

People tend to either pose vigorously or shy slyly away from the camera when a photographer is present, so, not surprisingly, you will be a better candid shooter if you are less obviously present. There are a number of ways to be subtler in your approach without resorting to wearing camouflage or hiding inside the cake. The following ideas will help you shoot with the low-key and inoffensive style that helps generate the candids you are looking for.

- **Use a camera with as long a zoom lens as possible.** This goes for both still photography and video. Being far away and shooting close up will improve your ability to shoot somewhat stealthily. Very few brides can have a camera in their face without displaying some self-consciousness, but a close-up from partway across the room can capture a genuine expression. When you are shooting stills from a distance, consider the quality of your lens, how quickly you will be able to shoot, and whether your lens has built-in image stabilization. If you are shooting video from a distance, remember that even the smallest camera shake can induce motion sickness when zoomed close up. Make sure to stabilize yourself and/or your camera to shoot zoomed in for either photo or video.

## Tip

High-end telephoto lenses allow you to shoot quickly at a long distance. An average consumer telephoto lens (or the zoom on your point and shoot), however, will have trouble zooming in close and shooting especially quickly. That means you should strategize at which points on the event timeline you want to shoot slowly from a distance and when you might use a prime lens (or a less fancy zoom) and move yourself closer to shoot faster. For example, when you want to get a lot of shots in succession (the first kiss or the entrance to the reception), you might want to get up close to allow your lens to function at peak speed. When you have time to watch for the right emotional moment (say, during the toasts), staying far away from the action can help you optimize for emotion over speed of shooting. See Part II for the types of shooting common in each section of the wedding.

■ **Shoot without flash.** It is easy for a videographer to shoot without a flash; it is the default. In darker situations, that of course means you have to pay pretty close attention to the light hitting your subjects and really work to make sure there is enough of it. As discussed earlier, you can certainly add more light, but that works against shooting stealthily; the lights attached to a video camera can be quite offensive to couples who want lower-key coverage of the event. Still photography is another story; most cameras have an automatic flash that will go off when lighting is low enough that the sensor requires it. As discussed in the Chapter 3, there are a lot of reasons to disable your automatic flash; you can add stealthy shooting to that list. Of course, you have to compensate for the light lost in other ways; automatic mode will help with that, as will boosting ISO. Refer to Chapter 3 for an extensive discussion of low-light shooting. (See Figure 4.4.)

**Figure 4.4**
By blowing out the background in this shot, the girls are perfectly exposed without using a flash—and their attention never has to leave the bride! (Image courtesy of Christian Maike; www.christianmaike.com.)

- **Position yourself strategically.** Professional wedding photographers are constantly on the move to get a good angle and a new perspective on the images unfolding. Considering where to place yourself will contribute quite a bit to how low profile you can be while shooting—a boost to your candid shots. Consider balconies or stairways for shooting down on the action, move to the side and capture from a unique angle, or shoot from farther back, framing your subjects with other people in the foreground.

- **Don't bring your camera to eye level.** Lifting your camera to your eye is the universal sign transmitting to all that shooting is about to begin. It couldn't be clearer without a siren, in fact. So? Don't lift your camera to your eye. Though it can be risky to shoot without looking at the viewfinder, digital photography has opened up a lot of room to shoot experimentally at little cost. Shooting candids is a great time to experiment; try shooting from your hip (literally), with your arm out to the side, or with the camera tilted up from your stomach or chest. Yes, you might wind up with some weird shots of arms and hairdos and torsos—which is why I don't recommend this as an exclusive shooting strategy. With practice, patience, and the right moment, though, you'll find yourself with gorgeous shots of a genuine, natural expression from a unique angle.

> ## Tip
>
> For both photo and video, if you aren't looking at the viewfinder to make fine adjustments, make sure to put your camera in autofocus mode. If you are using a DSLR with a number of lenses, pick one that will focus quickly, like a prime lens.

Despite the occasional difficulties, shooting candids is really fun. You get to roam a scene that is chock full of beautiful and fun moments looking for the best ways to capture them. You will be inundated with potential shots; playing with the possibilities is an exciting creative challenge. Now that you know the tricks for shooting in stealth mode, here are a few other things to consider while lurking about shooting candids.

- **Shoot action.** Despite the rigorous timeline, at any given point in a wedding, there will be guests standing around talking, eating, watching. That can make for some good shots, especially if you can capture a good smile or laugh. In general, however, you will have more luck if you find people doing things—that is, people in action. Within the crowd of people smiling and talking, look for kids playing with the rose petals, the guest showing off his napkin origami skills, or the bridesmaid reapplying lipstick on the bride or bustling her dress. Those moments tend to have momentum and show off the spirit of the day, without you having to wait to catch the perfect expression in a crowd of people. (See Figure 4.5.)

**Figure 4.5** This cocktail-party performer had way better things to do than worry about a photographer—and his concentrated action makes for a compelling visual.

- **Unusual angles and framing.** Using stealth positioning and shooting, you might accidentally wind up with unusual angles and framing, but candids are actually a great time to try for that, too. Unusual framing can change the tone of an image, creating playfulness or depth. One way to arrange framing is to use foreground elements to frame your background subject. This creates depth to your shot—a layer between the viewer and the subject that you are allowing the viewer to peek through. Breaking the rule of thirds can highlight expressions and details that otherwise might not get the same attention. (See Figure 4.6.)

- **Don't forget lighting.** Just because you are shooting without posing your subjects doesn't mean you can forget to pay attention to lighting. It is easy to roam around a reception room with the camera getting all the fun stuff, forgetting all the while that you are shooting directly into windows and all your subjects are silhouetted by the backlight. Roam strategically; pick places where the light is good. Since you always want the light on the subjects, put the windows behind you, look for places where the candlelight is warming the guests' faces, and shoot the guests who are drinking in the sunshine instead of the ones standing under an umbrella.

- **Shoot lots.** I mentioned this before (and it isn't entirely unique to shooting candid), but digital cameras—both photo and video—lend themselves to experimenting and shooting lots. Shoot lots, and that perfect, well-lit expression will come to you, even if it takes awhile. (See Figure 4.7.)

**Figure 4.6** The subject is in the background, framed by the man in the foreground. This untraditional framing highlights the subject beautifully. (Image courtesy of Rick Collins; www. rickcollinsphotography.com.)

**Figure 4.7** It isn't easy to capture pure joy, but at least at a wedding you have plenty of it to look for. A keen eye and lots of shooting will help you capture it. (Image courtesy of Remy Hathaway.)

## Shooting Kids

Kids are naturally photogenic—their smooth skin, big eyes, and unfettered emotions make them wonderful subjects. (See Figure 4.8.) There are always a few at weddings, and you should make sure that you capture them, too—with photo and video both. While there is nothing especially different about shooting kids in terms of composition or lighting, there are certainly a few things you can do to make sure you find good shots of kids.

■ **Get at their level.** Be ready to get down low to best capture a child's expression. Looking down on them can be stylistic and cool (assuming you are shooting more than the top of their head), but to see the child from his or her own eye level will make for more engaging shots. The viewer can more easily interact in the child's world, as opposed to superimposing their own, tall, adult world on the children.

**Figure 4.8**
You have to be pretty cute to look good shoving cake in your own mouth. Luckily, this flower girl has what it takes. (Image courtesy of Christian Maike; www.christianmaike.com.)

## Shooting Kids (continued)

- **Pose the kids who will be posed.** Not every child will put up with the camera, but some live for it. These days, with digital photography and videography, children are more used to the camera; take advantage of that!

- **Capture kids acting like adults.** Kids acting like adults are always fun to see—and at an adult event, there are so many opportunities for that. They are already dressed up for the event, which makes those moments where they are imitating adults even more precious. Watch for kids trying on make-up, going crazy on the dance floor, or applauding with the other guests. Or, in the case of Figure 4.9, simply being themselves.

- **Document tired, moody kids.** We all wish we could have a temper tantrum or fall asleep in the corner sometimes. Footage of an adult doing that could be grounds for blackmail, but kids doing that is pure gold. A wedding can be a long day; enjoy the range of expressions you get from the kids, from angry to overjoyed. (See Figure 4.10.)

- **Shoot lots.** Just because kids are cute doesn't mean they always take cute pictures. Like adults, capturing them well takes skill, practice, and luck. The more you shoot, the more chances you have of coming up with the best combination of those three things!

**Figure 4.9** The body language and expressions of these two children are very grown up, which isn't especially surprising if you know them! (Image courtesy of Aaron Hathaway.)

**Figure 4.10** Is this posed or is this outrage? It's hard to tell—but the expression suits Cora adorably well. (Image courtesy of Paul Taggart; www.paultaggart.com.)

# Interview Footage

Using a video camera to interview guests can be a powerful, personal, and emotional way to document the event. Interview footage inevitably uncovers funny stories and heartfelt expressions to the bridal couple, and is always a fun surprise for the couple on first viewing; of course, the comments and anecdotes are unscripted and generally flattering. It is a warm way for the couple to connect with guests that they may not have had enough time with during the wedding itself.

Before I go into detail about interview techniques, it's important to know that some couples don't like interviews, typically because they are perceived as invasive. As a videographer myself, and editor of other people's footage, I find that it isn't so much interviewing *per se* that is obtrusive, but how the interviews are conducted. In fact, interviewing *can* be done subtly and simply without losing out on any emotion. But make sure you go over the possibilities with your bridal couple and understand their preferences—they might prefer the camera to be on them all night instead of on their guests!

If you decide to do some guest interviews, there are some important things to keep in mind about both your setup and your interviewing technique. Let's take a close look at some ways you can make the most out of the footage devoted to interviews:

- **Find a quiet space.** To get any interview audio worth using, it's pretty important to shoot in a relatively quiet area. Even a really nice microphone will have trouble competing with the DJ, the other guests, and the clattering of dishes and glassware. Moving the interview location out of the main reception area will make a dramatic difference in the audio quality, as well as lending some privacy to the interview itself. Your subject will likely feel more comfortable to open up on camera without the din and pressure from guests around. Find a hallway or a room that is decently lit; if it is an outdoor wedding, it should be pretty easy to move away from the central action.

- **Find willing candidates.** Make sure to only interview guests who are interested in saying their piece on camera. If you force people into talking to the camera, not only will you be playing that obnoxiously intrusive role that bridal couples dislike, but you are less likely to get a good interview. Unwilling candidates appear nervous and uncomfortable on camera, while people who genuinely want to express something to the couple appear relaxed and enthusiastic.

## Tip

Some of a guest's willingness to appear on camera comes from how the idea is presented to him or her. If you request an "interview on camera," it sounds pretty daunting. If, however, you tell people you want to record some greetings for the couple, they tend to be enthusiastic and supportive. Once you've got the camera running, you can ask fun questions and request stories from guests who seem comfortable on camera.

- **Get good audio.** There is nothing more frustrating than recording the perfect sound bite, only to find it is barely intelligible due to poor audio quality. If interviewing is especially important to the content of your piece, invest in a camera (or rent one) that will take an external audio feed so you can mic your guests. Alternatively, get a separate audio recorder and sync the audio and video while editing. If you are using a lower-quality consumer camcorder and you don't have any external audio equipment, make sure you know the limits of the (non-directional, presumably) microphone so you know how close you need to be to your subject to get good audio.

■ **Don't forget about lighting and framing.** Just because you're concentrating on the audio content in an interview, it doesn't mean you can forget your lighting and framing guidelines. Find a well-lit area and take a moment to set up the shot nicely. That might mean smoothing hairstyles, straightening jackets, nudging the camera to a better spot to make sure the fire extinguisher is out of frame—all the things that make for a clean image. While you can always use good audio without the video by separating the audio and video tracks in post production, you will have more flexibility in editing if you set up the shot as if you are planning to use both the audio and the video.

Once you've got your interview set up, there are a number of things you can do to get good, usable footage from your guest interviewees:

■ Ask open-ended questions that invite guests to talk about the bridal couple. Yes and no answers or brief one-word answers won't give color to your story.

■ Ask (and remind!) your interviewees to speak in full sentences so the interview will be easy to edit. For example, if you ask a bridesmaid, "What was the bride most nervous about this morning?" and she replies, "Tripping at the ceremony!" it is a significantly less usable sound bite than if she says, "Rachel was terrified of tripping at the ceremony this morning!" If you need to, ask the interviewee to rephrase something in a full sentence.

■ Leave awkward pauses while your interviewee is talking. It is natural to want to respond immediately while conversing, but try to leave an unnaturally long pause as your interviewee finishes his or her sentences. The pause serves a dual purpose. First, it will be easier to edit sound bites if you have a little silence around them. Second, the interviewee will often rush in to fill the space and elaborate on his or her answer, which is often the best part of the interview. In the aforementioned example, given the space, the bridesmaid might go on to say, "In fact, Rachel was *so* nervous she dragged all of us on 15 practice laps up and down the aisle." That would be a fun bit of audio to place over Rachel actually walking up the aisle (that is, assuming Rachel has a sense of humor about herself).

■ Don't be afraid to ask an interviewee to repeat something or say it more concisely to make it usable in the final piece.

■ Be willing to cut off your interviewees. Long, drunken, storytelling is common near the end of the wedding reception. That can result in priceless, personal footage—or boring, rambling, and inarticulate blather. Don't waste your time and your media on the latter!

■ If you spend a little time planning the questions you ask, you can edit fun sequences. For example, if you ask all your interviewees the same question ("What makes Rachel and Dennis such a good couple?"), their responses can be edited together in a fun montage.

---

### Tip

With deft editing, interview sound bites can serve as wonderful transitions between sections. If you are organized about it, you can even have the interviews reference different parts of the day to serve as introductions. For example, ask one guest what their favorite part of the ceremony was, and use that video clip to start the ceremony video section. Ask another guest about the bride's dress to introduce the footage of her getting ready.

---

# Next Up

You've got your gear, you know how to use it, and you are familiar with the types of shooting that will occur on the day of the event. What's next? Don't be silly! You're now ready for the big day. We're going to go through the specific techniques and considerations of a typical wedding timeline, starting with the preparations.

# DIY Idea: Interview the Bridal Couple Before or After the Event

While there will likely be some fun sound bites from your bride and groom during the event, and you might even get the chance for a brief interview while they are getting ready for the day, it is very unlikely that you will get the time for a lot of thoughtful commentary from them during the beautiful chaos of the wedding. One way DIY video can be more personal and emotional than some professional videos is that you can interview your couple before and after the actual event and mingle that footage into your wedding video. (See Figure 4.11.)

The interview footage—or even just the audio—of the couple talking about what they are most excited for during the day ("We ordered the most beautiful cake ever!" or "I don't have the vaguest idea what her dress looks like!") will be extremely powerful and intimate when placed over those events actually unfolding on video. Similarly, an interview after the fact might elicit hilarious commentary, sweet memories, and a whole new take on some of the events. ("I was secretly aiming for Kaley to catch the bouquet," or "My dad gave me the nicest card—I almost lost all my eye makeup to the tears.") You could use the sound bites to introduce new scenes or mingle them into the footage—almost like a director's cut of the event. Either way, the additional commentary will raise the level of personality and warmth of your video immensely.

**Figure 4.11** As well as delivering some great sound bites for the video, the time spent with this couple before their marriage showed that as well as all the romance of the wedding day, they are indeed best friends. (Images courtesy Ronen Kinouri.)

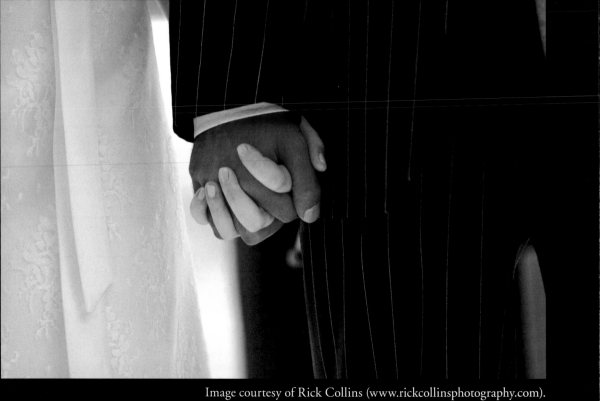

# PART II

# *The Marriage*

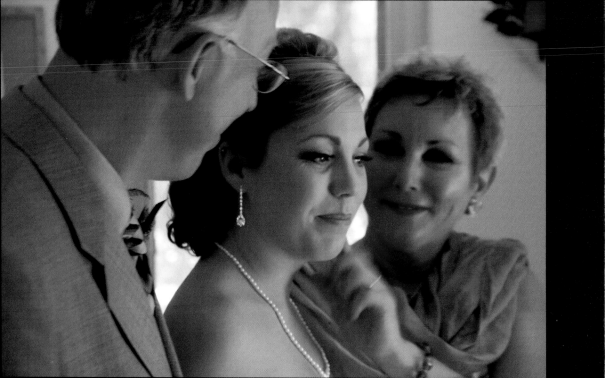

# CHAPTER 5

## Wedding Preparations

**In this chapter:**

- Focus on what's important
- Bride preparations
- Groom preparations
- First sight
- The venue
- Especially for videographers
- Shot list

In this chapter, we'll begin our walk through the events of the wedding day, starting just where the couple does—getting ready. Normally, this is a pretty exciting and happy time, although it can be tense, too. It is a wonderful time to be a friend of the couple; you will have access to the moments and emotion that can be harder for the professional shooter to capture.

# Focus on What's Important

As discussed in this book's introduction, a benefit to a DIY historian is the additional access to the bridal couple—a more intimate and personal knowledge of them and the spirit of their wedding. That is especially true during the preparations portion of the day; close friends and family are gathered and emotions are high. Unlike other parts of the day, the preparations generally have some breathing room; there is bound to be some totally unscripted and unscheduled fun.

"Wedding preparations" is an awfully vague term to describe the chaos that can occur during the two hours before the wedding begins. The seating chart might be under reconstruction, dresses might get rogue lipstick on them, and wedding rings might be accidentally left at home. Even in that rare wedding where everything moves perfectly smoothly, there is still an awful lot going on. It's important for you to know where to be and when.

There are typically three different scenes of preparation that you might want to shoot:

- The bride getting ready
- The groom getting ready
- The wedding location before the guests arrive

If all of those events are happening in the same place where the couple will be getting married, you're in luck; you can capture all of it by bobbing back and forth down the hall! More often, however, these things will occur in two or three different locations. In this situation, a professional wedding shooter will often cover the bride and send an assistant to shoot the groom and the location. As a DIY shooter, you are going to have to be a bit more strategic.

First, find out what the couple cares about the most. In most cases, the bride is anxious to get her own preparations captured: the buttoning of the dress and the placing of the veil will take precedence over the groom's preparations. There will of course be situations where that is different, depending on the couple and your relationship with them. Furthermore, you should find out if they want you to stay in one place and shoot everything you can or move around trying to get a few different scenes.

## Tip

If you have other responsibilities in the wedding, such as serving as a bridesmaid or groomsman, make sure to clarify these with the bride and groom. Some brides might want you to focus on shooting while others might prefer you to be with her all day, shooting only as a second task. If you have overlapping tasks, make sure to have a plan and some priorities established. It won't hurt to have another person on hand who can use your camera, too!

Second, work out your logistics carefully and realistically. Even if you are able to move between one place and another, that only helps if you are at the right place at the right time. For example, your bride is unlikely to want too many shots before she has her makeup and hair done, and your groom might want you there only for the moment where he presents a thank-you to his groomsmen. It's no use to get to the empty church to shoot it, if it is too early to be let in. When trying to split your time to cover multiple locations, make sure your couple has given you a timeline of events and you have strategized the best places to be *at the right time*. (See Figure 5.1.)

**Figure 5.1** While you certainly want an exterior establishing shot of the ceremony site, make sure you plan your shoot so you can get all the shots you need. If you get to the ceremony site too early, it might not be open or set up.

## Documenting Items of Particular Importance

Usually, the items used in a wedding are selected or made very carefully—the place cards, flower arrangements, table markers, jewelry, garter belt, and such. Often, those items come with stories attached—they're family heirlooms, they were obtained in a romantic or sentimental manner, or they're the result of friends pitching in their creativity. Understanding the significance of these items will translate into the details and emotional quality of your images.

Concentrating on the back story of these wedding elements is important for both photo and video. In photo, you'll want to shoot close-ups and from various angles to make sure you're capturing the important details. A shot of the flask used during the groom's bachelor party might bring up all sorts of memories for him. That's true for video, too, but you will also have the opportunity to include family members or friends talking about the items of important sentiment. For example, if you ask the mother of the bride about the veil, you might get a wonderful story about the veil being passed down through generations that you can edit over the visuals of the bride putting on the veil during video post production. It's helpful to know these elements before you go into the day; ask the couple ahead of time! (See Figure 5.2.)

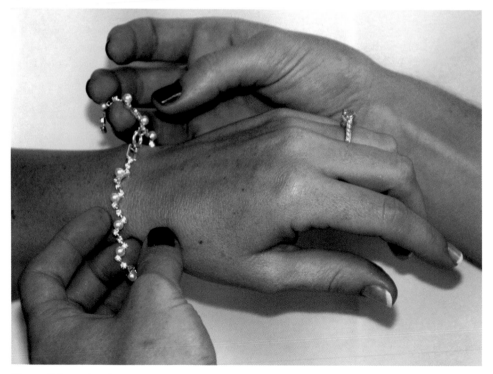

**Figure 5.2** In this shot, the older sister of the bride is putting her own bracelet on the bride. It was an heirloom and a gift from their grandmother to the bride's sister, and is the "something borrowed" for the day—an important moment I couldn't have known about without being told.

# Bride Preparations

As a DIY shooter, it is likely you will know a lot of the people involved in the wedding preparations. If you don't know everyone, however, the first thing you should do upon entering the preparations area is introduce yourself. You will get much better shots if your subjects are relaxed and comfortable with you—especially with the intimate moments you're about to be shooting. Take a moment to go around the room and learn the names and roles of all the people helping the bride get ready. After establishing yourself as the shooter, get right to work! There is always something to watch or shoot while the girls are getting ready.

# Details

You'll want to get a shot of all the significant items that make up the wedding outfit, as well as the rings and flowers. If you arrive at the preparations early enough, you will have time to style those items for your shots, before the bride actually needs them! Consider hanging the dress up or laying it on the bed to get a good shot of it before it is worn. If possible, shoot the back of it, too.

> **Tip**
>
> This probably goes without saying, but be very careful with the dress. No one wants to be responsible for mussing a wedding gown with champagne, make-up, or outdoor dirt!

Step back or use a wide angle lens to shoot the whole dress, top to bottom. This can be tricky—and for videographers is an excellent time to use a tilt camera move or to pan up and down. Once you have the whole dress, move in and get shots of the detailing on it—the buttons, the lace, the bows. If the dress is lying down, try folding the fabric on top of itself to capture the depth of shadow and help show off the richness of the dress material. (See Figure 5.3.)

With the dress out of the way, capture everything the bride might be wearing, before she wears it: shoes, earrings, necklace, garter belt—even the ring that she will be wearing once the ceremony is complete. This is a very fun part of the shoot; you get to be a stylist. Place these items artfully using coffee tables, end tables, doorknobs, pillows, chairs, balcony railings (careful!), mirrors, or whatever else your room has to offer. Even shoes can be a good stand for jewelry! This is a great time to shoot with a macro lens or in macro mode on your semi-automatic camera to get a narrow depth of field. Your subject will be focused, but you will get that wedding-quality softness around your images. (See Figure 5.4 and Figure 5.5.)

**Figure 5.3**  This is a tricky shot, capturing the hem of the bridal gown with gorgeous light coming in from the window behind where it is hung. Wedding preparations have more breathing room than the wedding events themselves, so give yourself a little time to play around and experiment to find these beautiful shots. (Image courtesy of Rick Collins; www.rickcollinsphotography.com.)

**Figure 5.4**
A macro mode on your camera works best when the subject fills up most of the shot.

**Figure 5.5** Don't take yourself too seriously when shooting details. Playfulness with the shot setup will add color and spirit to your images. (First image courtesy of Rick Collins; www.rickcollinsphotography.com.)

> **Tip**
>
> Try to use different setups for each of your detail shots. This is especially important for video because you will want visual variety as you cut images together in the editing process, but unique backgrounds and setups will make for a richer collection of photo images, too.

## Candids

While you are shooting the details of the bridal preparations, keep a very keen eye and ear on what's going on as the girls get ready. Here is a perfect time to shoot candids and collect great video. In the discussion of candids in Chapter 4, "Types of Wedding Coverage," it was noted that action makes for good candid shooting. The bridal prep is brimming with action. Actions can be as small as applying lipstick, zipping a dress, pouring champagne, or putting on a bracelet. If you show the action instead of just the end result—for example, the bride putting on an earring instead of just showing the earring on—the images you capture will showcase the building excitement of the bridal preparation.

Some additional considerations when shooting the girls:

- Don't shoot too much photo or video before the girls have most of their make-up and hair done. While a few at the beginning of the prep might be fun, the "after" is going to be much more compelling than the "before." No need to make anyone self-conscious with less-than-gorgeous pictures! (See Figure 5.6.)

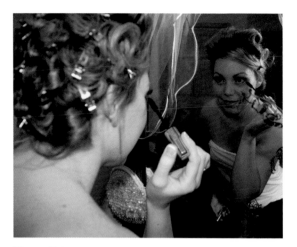

**Figure 5.6** There is a tendency to overshoot in the beginning of the day. While these early shots are pretty and fun, the bride won't want the preparation shots to overpower the ones where she is all done up. Shoot the "half done" shots selectively and save your energy, batteries, and media for her final look. (Second image courtesy of Rick Collins; www.rickcollinsphotography.com.)

- Many brides will feel self-conscious about getting undressed in front of their photographer; others won't care a whit. Just because you are a friend doesn't mean you are exempt from common courtesy, however. Ask the bride if she minds if you shoot her as she puts on her gown.

### Tip

If your bride is uncomfortable with you watching her get dressed, ask if you can stage some of the final moments of her putting on her dress. Having someone zipping up the dress the final inch or pulling the final ribbon of a corset-backed dress is all the action you need to imply getting dressed—even for video. Shots of her putting on her shoes are always fun and help build the momentum of getting ready.

- If you are shooting video, this is a great time to capture off-the-cuff comments and the general buzz and activity that showcases the mood of the room—whether it is tense or calm. You can also use this time to set up casual interviews (or just ask a few questions as the girls go about their business), which could give you fun sound bites to use throughout the video.

# Bridal Portraits

Make sure to get a few images of the bride when she is finished getting dressed, but before she leaves to meet her groom or go to the ceremony. This is the moment when her make-up and hair are perfect, her dress still entirely unmussed, and the crowds of guests aren't around her.

As soon as you get to the preparations room, you should be scouting for a number of good places to shoot your bride fully dressed. (The time for that always feels crammed, even when it is worked into the timeline of the day.) Look for pretty places, with visual elements to frame her—think doorways, fences, and trellises—and that have room behind her so you can shoot with a depth of field that softens the background. And of course, look for soft, even light.

You'll want to get some wide shots to showcase the bride's dress and some close-ups of both her face and her dress. Standing in a garden, in a doorway, or on a pretty staircase are all nice ways to show off the bride and her dress in a wide shot. Medium and wide shots of the bride lying on a bed, propped up on her elbows, will show off both her dress and her sex appeal. If she has a bouquet, make sure she is holding it for the portrait session; it will make a good prop and give her a place to naturally put her hands and eyes in some shots. Try different angles while you are shooting: a high angle (shooting down on the bride from higher up) tends to be a very flattering angle. Extreme close-ups can work really well here, too—showing off her jewelry and eyes. Also get the back of her dress; you can set that up playfully or elegantly and serenely. (See Figure 5.7.)

---

### Tip

If you are shooting video with a tripod, a bridal portrait session is a great time to do some camera moves. Try picking one detail of her outfit and zooming out until you have a wide shot of her whole outfit.

---

If you have time, get some portraits of the bridesmaids, too. (See Figure 5.8.) A shot of each bridesmaid with the bride will make a wonderful gift for the bride to present to her attendants later.

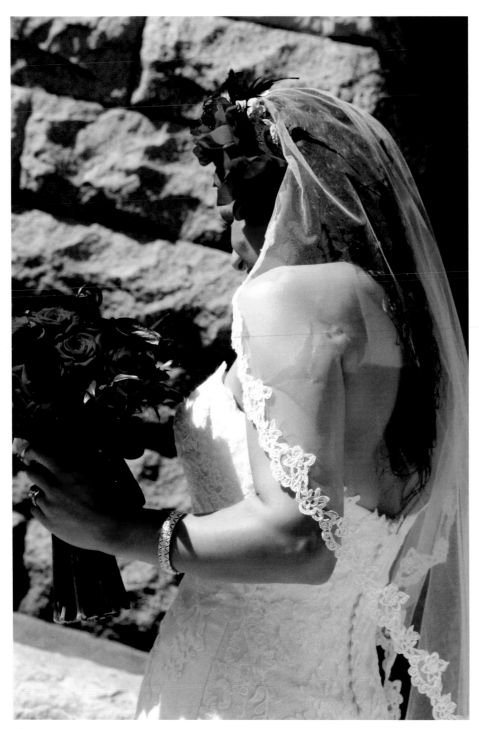

**Figure 5.7** This middle shot of the bride as she approaches the church showcases several of the important details of her outfit: her old veil, engagement ring, heirloom bracelet, and flowers.

**Figure 5.8** I always try to get at least one posed and one candid shot of each bridesmaid. In this case, it was the candid of the maid of honor watching her friend that made the final album.

# Groom Preparations

If a professional wedding photographer or videographer is shooting solo, he or she will tend to spend a fraction of the time with the groom and his groomsmen compared to the bride and her bridesmaids. Indeed, it is not uncommon for a professional to spend two hours getting ready with the girls and just 20 minutes with the guys. If you are dividing your time yourself, it's pretty safe to give yourself double for the bridal prep.

It's possible, though, that you were asked to shoot because you are a friend of the groom, and that the couple wants you to hang out with the guys exclusively during the preparations. Maybe they have a pro shooting the bride and you are only shooting the groom; maybe you have a shy bride and a hammy groom. Whatever the reason, and however long you are there, let's look at what to shoot while the groom is getting ready; as you'll see, it is quite similar to bridal prep. (See Figure 5.9.)

## Details

While there are fewer accessories and details associated with the groom getting ready, shots of his shoes, cufflinks, flask, handkerchief, and tie can be artfully arranged. Use the same techniques mentioned in the bridal preparation section to shoot these details. Pretty setups and macro lens settings tend to flatter the objects. (See Figure 5.10.)

**Figure 5.9**  This groom didn't enjoy modeling, but spending the morning with him before the marriage service led to a lot of fun candid moments.

**Figure 5.10** Just like with the bride, finding the back story of the details that go into the groom's outfit will influence your shots. (Image courtesy of Christian Maike; www.christianmaike.com.)

# Candids

Groom candids are a blast to shoot. If you are looking for action, you can always find it with the boys! With the slightest prompting, you can create it, too. On the smaller scale, look for ties being tied, shoes being put on, boutonnières being affixed (don't be afraid to stage or restage that one!), and toasts being made. On a larger scale, groom hijinks are fun to stage with willing participants. I've seen groomsmen write messages on the bottom of the groom's shoes (so that they show when kneeling in church), hide the groom's tie, and fake throwing the groom in the swimming pool fully dressed. You can't plan for the mood of your crowd, but as a shooter, you should be ready to go with it if fun is in the air. (See Figure 5.11.)

## Tip

Although grooms tend to be less rushed than brides getting ready, make sure to keep an eye on the clock. Get that groom to the church on time!

**Figure 5.11**   This shot is a combination of location and personalities. Work with what you are given, and have fun! (Image courtesy of Rick Collins; www.rickcollinsphotography.com.)

# Portraits

Most often, the bride will take center stage as soon as the couple is together, so make sure to get a few really good shots of the groom by himself first, with both photo and video. Like the bridal portraits, you want to pick a well-lit spot that will frame him well for a wide shot. Depth behind him will allow for you to get some softer close-ups. Your portraits may be formal, candid, or a combination of posed and playful; make sure you know the preferences of your groom ahead of time. (See Figure 5.12 and Figure 5.13.)

**Figure 5.12**
A full-length shot will show off just how dapper the groom might be—as well as showcasing some of his nervousness about the day.

**Figure 5.13** Portraits do not have to be formal, as shown in this casual and playful shot. Playing with depth of field is flattering to brides and grooms alike. The softening of the background in this shot accentuates the groom's eyes and expression.

# First Sight

In a professional setting, the photographer or videographer not only captures the events, but often has some responsibility for directing them. After all, most wedding vendors have been to a lot more weddings than the couple getting married!

As the bride and groom get ready, most of your shots are likely to be posed portraits and candids. There is not a whole lot to stage or direct; you will mostly be documenting the events as they unfold. However, if the bride and groom are going to see each other prior to the ceremony (usually for the purpose of taking pictures without wasting reception time), it is often left to the photographer and videographer to choose an appropriate place and move the parties into it. This is very handy; you get to choose a place based on how pretty it is, and more importantly, whether it offers the best light.

The typical stage direction in this scenario is to place the groom somewhere photogenic such as a garden or hotel lobby and allow your bride to walk up to him. Often, he will have his back to her, turning around to see her only as she is next to him. You can develop fancier schemes, with elevators, blindfolds, or cars, or you can simplify

everything by having the two of them walk toward the same place. Whatever scenario you choose, there are a few important things to keep in mind from a documentarian's perspective:

- If, in addition to you, there is another photographer and/or videographer shooting, make sure you are not in each other's shots. This might take some coordination, but it is worth it. Romantic reunion shots will be somewhat dulled by the presence of other cameras.

- Often, the bride's perspective is deferred to more frequently than the groom's. However, the initial meeting is one case when the emotion of the groom generally dictates the scene. You will want to catch his anticipation and his initial reaction to his bride as she walks up. In nearly 15 years of wedding videography, I have never seen a groom look anything but thrilled. From there, the groom will often go through a photogenic emotional spree: shock, tears, smiles, and laughter. Of course, you want to capture the bride, too, but position yourself to follow the groom initially. (See Figure 5.14.)

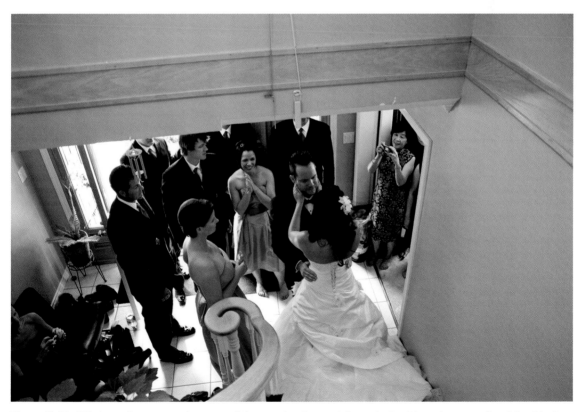

**Figure 5.14** While catching some close-ups of the emotion is certainly a priority, I love the scene that this wide shot captures because of all the action, witnesses, and chaos—none of which distracts the groom from his bride. (Image courtesy of Rick Collins; www.rickcollinsphotography.com.)

- Make sure your camera has the right settings before the bride walks up. Which settings you choose will, of course, depend on whether you are indoors or outdoors, and the light in which you have placed the couple. Do ready yourself to capture those tears, smiles, and kisses up close, however. Try for some wide shots as well—this is the first time the couple will be together in their wedding finery! (See Figure 5.15.)

- If you are shooting video, be ready to move. This is not a great time to be on tripod. You'll want to change your position to move away from other shooters, to get lots of angles, and to get details like the groom's hands on the back of the bride's dress.

- Also for videographers: It is very tempting to swing the camera between the waiting groom and the approaching bride. Be careful of doing that too much; you'll wind up with a jumble of moving footage. Make sure to stay on each of them long enough to have usable video clips that you can edit together.

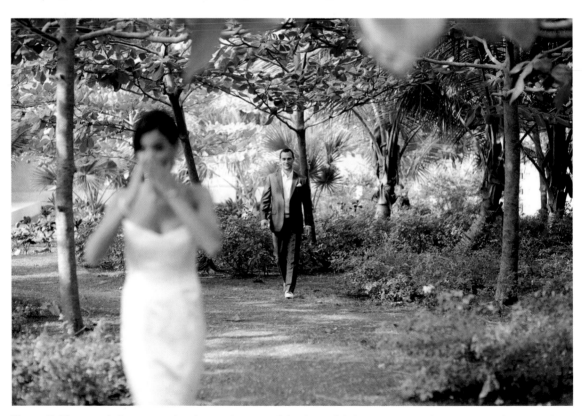

**Figure 5.15**  Being light on your feet during this part of the day will help you capture the excitement shown in this wide shot, without missing any of the beauty of the close-up details. In this case, the photographer played with depth of field to focus on the groom as he approaches his bride. (Image courtesy of Rick Collins; www.rickcollinsphotography.com.)

# Ceremony Site

If you have time to record it, the ceremony site before the guests have arrived can be incredibly photogenic, and capturing it well will give you elegant establishing shots. The emptiness of the site highlights the sense of anticipation that characterizes the general mood at that point in the day—not to mention the couple's anticipation of this event, which might be months or even years in the making! Assuming you have time for this, you will want to get an establishing shot that includes the empty seats. Try to get this shot from an interesting angle—shooting from a balcony behind an outdoor setting or on the altar facing the seats in a religious setting are two ways to capture the breadth of the scene.

Shooting your subject from a low angle can often be rather unflattering to people, as it can distort their features. That said, it can be a wonderful perspective for shooting scenery. Try shooting low from the aisle looking up toward the ceremony site, and the site will appear appropriately imposing and grand! Rows of chairs are fun to shoot birds-eye or at eye level to the seats. (See Figure 5.16.)

As well as playing with angles to capture the whole scene, use your detail techniques previously discussed to showcase the flowers, program, ribbons, candles, and signage that the couple spent time designing. These shots are especially appreciated, as the couple is always too nervous and too busy to notice these details at the time. (See Figure 5.17.)

**Figure 5.16**
There is a calm but palpable anticipation in the empty ceremony site.

**Tip**

If you aren't required elsewhere, it is great to get shots (photo and video) of the guests entering the ceremony venue. This helps build the excitement and anticipation, and provides an excellent introductory sequence for video of the ceremony.

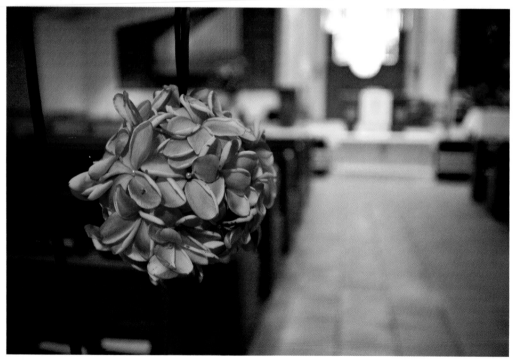

**Figure 5.17** The bride and groom are the people who care the most about the ceremony details. Of course, they are also the least likely to notice those details on the actual day. Good coverage will help the couple appreciate the elements they lost in their nerves and excitement. (Third image courtesy of Brant Bender; www.brantbender.com.)

# Especially for Videographers

During the wedding preparations is the best—and worst—time to be a videographer. The miniature dramas, the funny commentary, and the constant movement can make for wonderful video storytelling; often, it includes material that a still camera can't catch. That being said, catching that material can be quite difficult. You never know when the video-worthy material will happen! Which bridesmaid is going to start the hilarious conversation about the bride's ex-boyfriends? When will she do it? To get a few sequences of pure video gold, you either have to be incredibly lucky or shoot lots and lots of footage in the hopes you get something good.

How do you maximize your chances for catching those fun moments? You have to assess the situation. As soon as you walk into the chaos of the wedding preparations—whether it is the guys figuring out how to tie their ties or the girls looking for the bride's necklace, which might have been left at home—start assessing the situation. You are looking for the following:

- **Natural light.** You can capture a lot of the preparation material from any angle, so make sure to play to your advantage by using the light as best you can.

- **Stars of the show.** Some people like the camera better than others, and the camera likes some people better than others. By quickly learning who might be the bridesmaid most likely to tell amusing stories or ham for the camera, you can help yourself get good footage. Don't let your initial impressions blind you completely, though; some comfort in front of the camera, some champagne, or the perfect comment might change the wallflower to the star of the show in a matter of moments!

- **Moments of action.** There is lots of downtime during the wedding preparations. For example, you can only get so much footage of hair being curled, even though it might take 20 minutes. Then again, certain things will happen quickly, like the dress being zipped up or Dad's first reaction to seeing his little girl as a bride. You want to make sure you capture them. Use your shot list (see the next section) to figure out in advance when the particularly important actions will be happening so you aren't caught flat-footed!

In addition, you'll want to keep these points in mind:

- **Keep your camera poised, but not on.** Shooting too much can waste batteries and media, leaving you with hours of boring footage to wade through. Avoid shooting constantly. Don't be afraid to turn off your camera and simply observe the action. That being said, you should never be more than a few moments away from being ready to start, either. Make sure your camera is nearby, lens cap off, on or off tripod (depending), and settings correct. You want to be able to get rolling as soon as that impromptu toast begins!

- **Track audio.** Some of the most memorable pre-wedding moments are audio: the bridesmaids chatting, the bride with her parents, the groom with his best guy friends. Sometimes, just catching the audio can be fun; if you are planning on editing, you can overlay the audio with images. One idea to capture good moments is to let your audio recorder run continuously—the media storage and batteries required is much less than with video—and jot notes of the time when noteworthy audio occurs. That way, you don't have to listen to the whole thing in editing, but can cut immediately to the few moments that are worth it.

# Specific Shot List

As discussed in the introduction, professional shooters will go into each section of the wedding with a shot list. This helps them stay on track and reassures them that one way or another, certain key items were hit. Ideally, the bridal couple will contribute to your list so you know you are covering the moments they want. Regardless, you should develop one of your own.

A shot list should not be at all prohibitive; you should shoot the fun stuff as it comes. A shot list is to simply help you cover the basics. Following is a comprehensive list of important and fun moments to capture during the wedding preparations to help you build your own prioritized shot list:

- **Bridal Prep**
    - Dress
    - Dress details
    - Shoes
    - Veil
    - Jewelry
    - Bouquet
    - Wedding rings
    - Bride getting made up/hair done
    - Bride putting dress on
    - Bride putting shoes on
    - Bride putting veil on
    - Bridal portrait(s)—wide
    - Bridal portrait(s)—close and medium
    - Bride with parents
    - Bride with siblings
    - Bride with bridesmaids (individually)
    - Bride with bridesmaids (group)

- **Groom Prep**
    - Cufflinks
    - Boutonnière
    - Groom tying tie
    - Groom putting on jacket
    - Groom putting on cufflinks
    - Groom putting on boutonniére
    - Groom portrait(s)—wide
    - Groom portrait(s)—close and medium
    - Groom with parents
    - Groom with siblings
    - Groom with groomsmen (individually)
    - Groom with groomsmen (group)

- ■ **First Sight**
  - ■ Groom waiting
  - ■ Bride approaching
  - ■ Groom expression

  - ■ Bride expression
  - ■ Bride and groom together (wide)
  - ■ Bride and groom walking away

- ■ **Ceremony Site**
  - ■ Establishing shot
  - ■ Signage
  - ■ Flowers

  - ■ Podium
  - ■ Musicians
  - ■ Guests entering

# Next Up

The excitement of the day is building. The next part, the ceremony, is often what the couple is most nervous about. Not surprisingly, it is often what the shooters are most nervous about, too, as tricky lighting, poor audio, and shooting restrictions can regularly factor into this all-important part of the day. The next chapter looks at exactly what is going on and how you can dive in and get the best shots possible.

# DIY Idea: Time Lapse of Reception Setup

Video displays images at roughly 30 frames per second. If you capture images more slowly than that—such as one frame per second, one frame per minute, or one frame every five minutes—but play them back at 30 frames per second, there will be jumps between the consecutive images (lapses), and it will appear that time is moving faster. This is a fun way to capture long, slow processes; you will often see time-lapse images in nature photography, such as a sunset or a flower opening.

The reception setup is ideal for time-lapse photography. (See Figure 5.18.) A steady, wide shot of the room will show it going from empty and bland to all dolled up, with servers, DJs, caterers, and florists going in and out of frame. It is a more complicated setup than some other projects you might try, but it can be awfully fun. (Of course, the reception setup isn't the only time lapse you could do; the cake cutting would be fun, as would the bouquet and garter toss.)

There are a number of ways to capture time-lapse sequences. The method you choose will depend on the gear and software you have. Certain cameras (both still and video) enable you to shoot time lapse by setting the interval at which the camera automatically captures an image. You can also get an *intervalometer*, which programs a DSLR camera to shoot at certain intervals. Alternatively, you can shoot video continuously at 30 fps but attach your camera to a software program such as Video Velocity (PC) or iMovie (Mac) that will record images only at specified intervals. In addition, many webcams

can be set to record images at specific intervals. Finally, you can shoot video normally at 30 fps and then remove frames from it in post production, keeping only one frame every minute or so.

Whichever way you shoot time lapse, there are a few things to keep in mind before you decide to embark on the project:

■ A time-lapse sequence is easily set up if you are near the reception while it is being set up. If the ceremony and reception are far away from each other, you might need an assistant to oversee the time lapse or be willing to leave an unmanned camera on a tripod for the duration. (See the upcoming point about security.)

**Figure 5.18** A bird's eye view of the reception area is a great way to shoot a time lapse. Since that isn't always available, look for places where you can set up a wide angle, where the light won't change too dramatically in the span of the setup. (First image courtesy of Remy Hathaway; second image courtesy of Katie Clark.)

- Your time-lapse camera should be a spare, not the one you need for more pressing things like shooting the ceremony. (Often, the reception is being set up during the ceremony.)

- Make sure your equipment will be secure if you are leaving it unattended for an hour or two. No one wants to think of a wedding as a theft target, but I have certainly heard of it happening on more than one occasion.

Once you are ready to go, here are some considerations for getting the sequence right:

- Determine the interval that you want ahead of time. When you come up with the number, you should be thinking about how long the setup will take, how long you want the final time-lapse sequence to be, and how jumpy you want the images to look. The equation is as follows:

$$\text{Interval} = \frac{\text{Length of Event (in Seconds)}}{\text{Number of Frames in the Time-Lapse Sequence}}$$

For example, if the setup will take 90 minutes, and you want a 90-second time lapse, you would figure it out as follows:

Length of Event
(in Seconds) = 90 Minutes × 60 Seconds = 5,400 Seconds

Number of Frames in
Time-Lapse Sequence = 90 Seconds × 30 fps = 2,700 Frames

5,400 Seconds / 2,700 Frames = 2-Second Intervals Between Shots

- A smoother image sequence requires a longer time lapse and a shorter shooting interval; a jumpier sequence needs a longer interval and a shorter time lapse.

- Stabilize your camera so that your framing remains constant. You want the action jumping within the shot, not the shot jumping!

- Put your camera on manual settings so that all your images stay roughly constant in exposure.

- If you are shooting still, make sure to capture lower-resolution image files (JPEGs) to save space.

- Make sure you have enough media and battery life for the length of the event.

- If you are recording still frames, be prepared to spend a little time in post production putting your images onto a video timeline. There are lots of software utilities available to help you handle this process, including Video Velocity (PC) and Time Lapse Assembler (Mac).

Image courtesy of Katie Clark.

# CHAPTER 6

## The Ceremony

**In this chapter:**

- Focus on what's important
- Schedule the shoot
- Especially for videographers
- Shot list

In this chapter, we'll cover the most important part of the day: the ceremony. Although sometimes overshadowed by the excitement and creativity surrounding the reception, the ceremony is usually the part couples will single out to be documented in photo or video, even if nothing else is. It is, after all, the precise moment that two individuals officially become one married couple. From a shooter's perspective, that moment is awfully hard to re-create; you'll want to get it right the first time!

# Focus on What's Important

Ceremonies can range from a five-minute recital of vows to a full day parade and feast. Most often, of course, they fall somewhere in between. It would be impossible to find two ceremonies that are identical in format, content, and tone. Religion, group participation, the venue, the officiant, the music, and the emotions of the couple will all contribute to the feel of the ceremony. All these elements are important to the couple and should be reflected in your images.

# Ceremonial Elements

Having been to one wedding does not actually mean you have been to them all. It is crucial to understand the important ceremonial elements of the wedding you are shooting; otherwise, you could innocently make a big error.

For example, in a Jewish wedding, the bride and groom see each other prior to the wedding service in order to sign the *ketubah* (marriage contract). With the contract in place, the couple is technically married; the rest of the service is a customary and detail-rich embellishment of the deed already done. If you as the shooter were to show up simply for the service that the guests attend, the most important element would be lost.

Naturally, these critical elements vary culturally. A Jewish wedding differs significantly from a Chinese wedding, which looks nothing like an Indian wedding or a Catholic Mass. Make sure you know the meaningful parts of the ceremony for the culture of the bride and groom whose wedding you are recording. Ask about the order of events and the important customs. You will need to place yourself appropriately to catch them. (See Figure 6.1.)

---

**Tip**

While the most obvious way to learn about the cultural aspects of a wedding ceremony is to ask the bride or groom, it is entirely possible they are participating in the ceremony for the first time and don't know themselves. (This is especially true in mixed marriages.) On the other hand, they might be so overly familiar with the traditions, they forget to mention them as anything notable. A quick Internet search often proves to be a very valuable resource.

---

**Figure 6.1** A tea ceremony is often performed before Chinese weddings as a way to honor the bride and groom's ancestors. Generally, only family will be present at the tea ceremony, which will often be held at home. (Image courtesy of Rick Collins; www.rickcollinsphotography.com.)

## Know Where (Not) to Shoot

The ceremony location is likely to be the single biggest factor in your ceremony shooting decisions. Dimly lit churches, the harsh sunlight or backlighting of outdoor weddings, poor acoustics, and shooting restrictions are common obstacles to simple shooting. It would be hard for me to overstate how helpful it is to look at the site ahead of time; a pre-wedding visit will enable you to assess the lighting, determine where to stand to get the best angles (and where you aren't allowed to stand!), and how to move through the room without interrupting the event too much.

> **Tip**
>
> Many bridal couples have a rehearsal the day before the actual event. If you haven't seen the site already, that might be a perfect opportunity to gain access to the site and rehearse your shots.

Start your preliminary site research by finding out whether the site (or the officiant) has any shooting restrictions. It is extremely common for religious buildings to allow you to shoot only from certain areas, such as balconies (see Figure 6.2) or the sides of the room. While these rules are of course frustrating to the shooter, under no circumstances should you break them. *Always* work within them. More lenient churches allow shooters on or behind the altar and in the aisle; this is wonderful for flexible shooting, though occasionally at the expense of the solemnity of the occasion.

> ### Tip
>
> The site contact, usually the wedding officiant or administrative personnel, will let you know the rules associated with shooting. Often, the same person is an excellent resource for determining where to best shoot. He or she is likely to know how professionals work in the space, and is likely to help you get the best images possible from the areas where you are allowed to shoot.

**Figure 6.2** While being forced to shoot from the wings or the balcony will limit you in some ways, it can open up other stunning views of the scene.

**Figure 6.3** Even if the venue will allow you to shoot from anywhere, check with the couple. They might prefer you to maintain a low profile on the sides of the ceremony. A little creativity when it comes to maintaining some distance from the ceremony itself can take you a long way—literally and figuratively! (Image courtesy of Rick Collins; www. rickcollinsphotography.com.)

In an outdoor setting (or a lenient indoor setting), don't assume you should shoot from just anywhere. Make sure to check with the couple to see how much of the ceremony they want covered. Some couples want every moment covered, paparazzi-style; other couples want a few shots as keepsakes, but prefer a more uninterrupted feel to their ceremony. Get specific instructions. Is it okay to block the aisle? Do they want shots from behind them (facing the guests)? Can you move around the area where they are standing? (See Figure 6.3.)

## Consider the Light

Understanding the natural light in the location you are shooting will change how you approach your subjects. Of course the basics of lighting your subjects won't change; you will still want fairly even light to hit your subjects at a very slight angle. What differentiates ceremonial shooting is that you won't be able to move your subjects, and you can't usually move the light either. Your only option is to move yourself. For this reason, light is integral to consider when determining where you want to be.

Shooting on the beach? Consider your position relative to the hour of day so that the couple isn't backlit. Shooting in a dark church? Consider aperture size, think about using a tripod to allow for a longer exposure, and decide whether you need to use an external light or flash. Shooting in a room with a window creating splotchy light? Find ways to avoid it, shooting in the more neutral parts of the room. Or try playing with the light; make the dappled light a part of your image. A site assessment, combined with the time of day and the equipment you have available, will help you determine the best places from which to shoot.

# Schedule the Shoot

Not only should you know the important events and the best places to capture them, ideally, you will also have a plan of where to stand for each of the relevant moments, which will likely require some movement on your part. Having your shots mapped out will prevent you from missing the bride walking down the aisle because you are already set up and waiting for the vows.

Follow a general outline of places to stand. Your plan will of course depend on the specific customs, timeline, shooting restrictions, and preferences of your particular wedding shoot; use these basic considerations as you build your own ceremony schedule. Following are some common elements to many ceremonies, and some considerations to keep in mind when positioning yourself.

# Processional

The seating area or aisle is a great place to capture the processional. Take an aisle seat, and move between the aisle and your seat so as not to block the processional itself. This should allow a clear line of vision to capture the awaiting groom, turning quickly to get the bride's walk toward him (not to mention the bridesmaids and family members who may walk the aisle first). Once everyone has reached their destination, you will be well-positioned to shoot the beginning of the ceremony from the front. (See Figure 6.4.)

If you need to take a side position for the entrance, make sure to pick a side where you will be able to see the bride's expression. Keep in mind that she is unlikely to walk down the aisle alone; she will probably have an escort. Stand on the side of the room that will give you best exposure to her, without her escort blocking your view. (See Figure 6.5.)

If your bride and groom have not seen each other yet, try to get a shot of the groom's expression as he sees his bride for the first time. This can be tricky with a short aisle; longer aisles give you more time to shoot both the approaching bride and the awaiting groom.

If you are using a tripod to capture the ceremony, remember that the guests usually stand up when the bride begins her walk down the aisle. Be sure to set your tripod position and height so that you will be able to see her over the standing crowd. (See Figure 6.6.)

**Figure 6.4** If you're given access to a straight shot of the bride walking down the aisle, make sure to take it! Using your camera's burst mode will help you get a lot of pictures to pick from. (Image courtesy of Rick Collins; www.rickcollinsphotography.com.)

**Figure 6.5** I was frustrated to have picked the wrong side to catch the bride during the processional, but thrilled that her ring bearer gave me such expressive material in exchange. The bride loved what she called his "angry bird" look.

**Figure 6.6** Standing crowds can make capturing the bride walking down the aisle difficult. Make sure you find yourself a good spot. Focusing on the bride and playing with your depth of field can differentiate her from the standing crowd. (Image courtesy of Remy Hathaway.)

# Service

The rules of the ceremony venue and your couple's preferences will dictate from where you shoot during the ceremony itself. Make sure you are positioned to catch the vows, the ring exchange, and the first kiss. You will also likely want to capture friends and relatives who are participating in the service with readings or musical performances.

The moment when the rings are slipped on the bride and groom's respective fingers is packed with meaning. If you can, zoom in and capture that moment with an extreme close-up. You should figure out ahead of time (or at the beginning of the service) whether your lens and positioning will allow such a tight shot. If not, find a pretty way to capture it medium or wide to display the action of the moment. (See Figure 6.7 and Figure 6.8.)

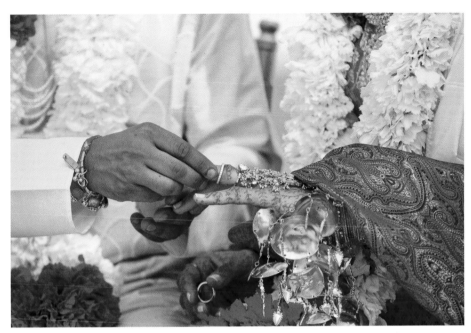

**Figure 6.7** The ring exchange is especially important to catch close up in an Indian wedding, where henna-decorated hands are part of the tradition. (Image courtesy of Rick Collins; www.rickcollinsphotography.com.)

**Figure 6.8**
If you miss the ring exchange in the wedding itself, you can re-create the moment with the couple later on, when you have a little more control over positioning and light. (Image courtesy of Christian Maike; www.christianmaike.com.)

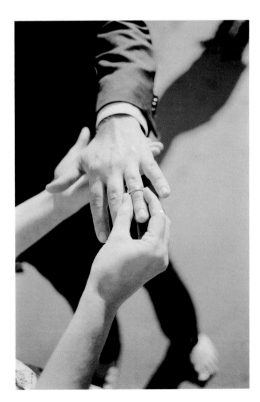

> ## Tip
>
> It helps photographers to move around a lot during the ceremony. In contrast, videographers might move a bit to get different shots or stay in one place to get a single, master take. (See the upcoming section "Especially for Videographers" for further discussion of capturing the ceremony on video.) Ideally, you will move within your acceptable bounds, experimenting to catch different angles while making sure you are in predetermined, chosen spots for the key moments.

Facial expressions and emotions are what make photographs of the ceremony so compelling. Regularly check in on your couple and their parents. Capturing their joy, their tears, and their love for one another is the cornerstone of wedding photography, and these emotions will be on wild display during the ceremony. If you aren't given a straightforward view of the couple (from the front or the back) and you have to choose a side, most professional shooters will aim to capture the bride and her expressions during the ceremony as opposed to the groom. Ideally, of course, you will get some of each. (See Figure 6.9.)

**Figure 6.9** Obviously, it is not just brides who cry at weddings. Close attention to emotions will help inform you where to stand to get the right shot. (Image courtesy of Rick Collins; www.rickcollinsphotography.com.)

# Recessional

Usually, right after the first kiss, there will be an official pronouncement and the couple will walk up the aisle together followed by their attendants and family and the rest of the guests. This can be a very fun and playful time to capture shots; position yourself carefully, as it will happen quickly!

If you are in front of the couple shooting the first kiss, you can walk backward, shooting them going down the aisle. In the background of wider shots, you will have joyful guests, which makes for a wonderful scene. (See Figure 6.10.) If you aren't comfortable walking (usually quickly) backward and shooting, or if you aren't allowed in the aisle, try standing where the couple was married and capturing them from behind as they leave arm and arm. For both photographers and videographers, this shot beautifully symbolizes the couples walking into their new life together. (See Figure 6.11.)

Some situations will allow you a birds-eye view of the ceremony—a balcony in a church or a patio overlooking an outdoor garden. If you can easily get there, a wide shot of the whole scene is a gorgeous way to capture the joyful walk of the couple and the supporting crowd looking on.

**Figure 6.10** The balancing act is worth it when you can capture the joy of the couple and the guests in the same shot! (Image courtesy of Rick Collins; www.rickcollinsphotography.com.)

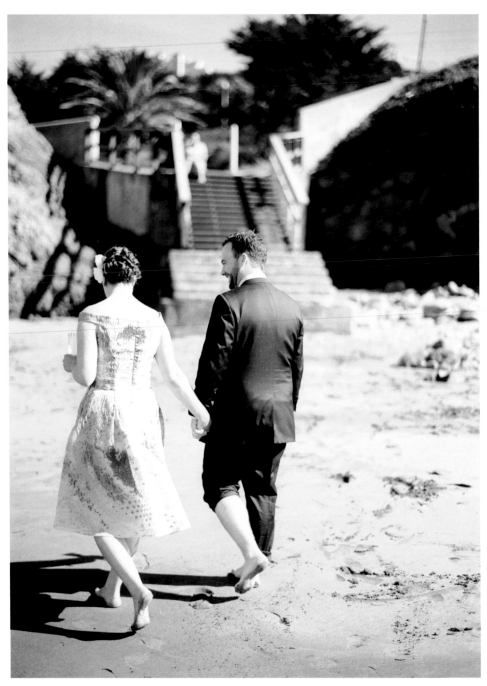

**Figure 6.11** I always aim for a shot of the couple walking together. It is symbolic of the steps they are taking through marriage. If the shot is walking from the ceremony itself, it tends to be especially loaded with meaning. (Image courtesy of Christian Maike; www.christianmaike.com.)

# Especially for Videographers

As a videographer, I am never more jealous of photographers as during the ceremony. Photographers have the ability to be quick and light, not worrying about such complications as continual shots and clean sound.

Of course, your wedding video shoot can be as simple or as complicated as you choose. The crucial element is to know, in vague terms, how much of the event you are trying to cover in video. Here are some possibilities:

- **Images only.** If you are just looking to get images that you will use with different audio during editing, you can move just like a still photographer. Get the best shots of the action: the processional, the father of the bride giving his daughter away, the vows, the ring exchange, the kiss. This method is an especially good strategy if you don't have great sound equipment but will rely somewhat heavily on your post-production editing skills to sew the images together with music or other natural audio. (See Figure 6.12.)

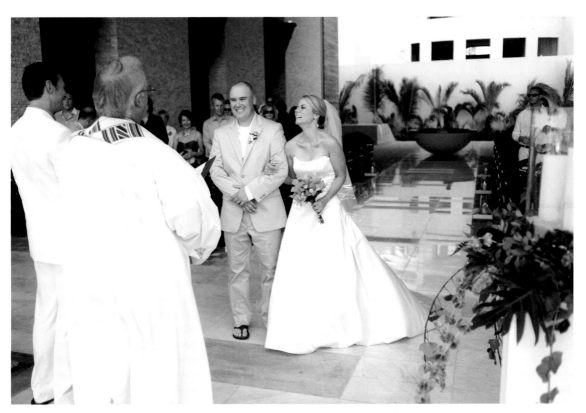

**Figure 6.12** The acoustics in this setting make for poor, echo-y audio that would be a challenge even for professional equipment, but the image of the bride being escorted toward her groom will be beautiful when shown with music. (Image courtesy of Rick Collins; www.rickcollinsphotography.com.)

■ **Edited with audio.** You might want to capture bits of the ceremony using natural audio, but not the whole ceremony. This is a fun and liberating way to shoot because you can turn the camera off and move around to get different angles, anchoring yourself somewhere to capture the parts of the ceremony that have been designated as important. Keep in mind that unless you have a separate audio feed, your on-camera microphone will capture sound differently in different places. And of course, you need to be close enough to the action to capture audio at all. This method won't work if you are trying to capture audio and a distant bird-eye shot at the same time.

■ **Single take, no editing.** A single take of the wedding ceremony is a very common request from couples. To do this, set up a camera on a tripod and find a wide, master shot that gets a good look at the whole scene. Usually, you will get this view from the back of the ceremony site or from one side. If you are manning the camera, you can zoom in and zoom out or reposition slightly to avoid disturbances. If you have another role in the wedding, such as serving as a member of the bridal party, this might be the only way for you to capture the ceremony. Simply hit Record and go on to your other duties. Make sure your on-camera microphone will capture the audio from where you are. While this version might not be as creative or compelling as an edited version with lots of different angles and the boring bits removed, it is an excellent way to make sure events have been recorded thoroughly and completely. As it requires almost no editing, it can be a quick and easy method to cover that part of the wedding day.

## Tip

If you are planning to use an unmanned camera to capture a section of the ceremony, make sure you have enough blank media and battery life to get you through.

■ **Multiple cameras.** If you have two cameras running, you can edit between them. The options this presents often make for extremely visually compelling and beautiful storytelling; for this reason, most professionals shoot with two cameras. Of course, it is also the most difficult from both a production and editing standpoint.

## Shooting with Multiple Cameras

Want to shoot with multiple cameras? There are a few different ways you can go about it. If you have one operator and two cameras, set one camera up on a tripod and find a wide, master shot that gets a good look at the whole scene. Use the other camera as a roving camera, aiming for details and close-ups. If you have two operators, divide the shoot in a logical way for your setting. That might mean one shooter goes wide and one goes close, one shooter focuses on the bride and one on the groom, or one shooter follows the action while the other follows reactions.

Regardless of how you set up a dual-camera shoot, there are two things to watch for. First, if using two shooters, make sure your shooting responsibilities are carefully meted out so you don't get in each other's way. In other words, be sure the close-up shooter stands in places where he or she isn't constantly landing in the wide shot. Second, it is a good idea to leave both cameras continually running. Don't turn either of them off. If the ceremony is recorded as one long, continual take, you only have to sync the two different cameras' footage once while editing. If you have lots and lots of short takes, however, syncing the footage becomes much more of a challenge. This might mean that you leave the camera on while you walk across the room or run down a flight of stairs. It will feel odd, but is certainly worth it in the time saved editing.

- **Extra audio recorder.** You have much more shooting freedom if you have an extra audio recording running. As well as serving as insurance that you have audio captured at all, this will enable you to move to places where the on-camera microphone might not capture very well or will pick up a lot of the room noise in between. An extra audio recorder could be a wireless microphone with an audio feed to your camera (although not every camera will allow a separate audio input; in fact, most will not), an old camera with the lens cap on, or a small, inexpensive digital audio recorder. Any one of these can be placed near the officiant to give you an extra track of sound that you can edit in during post production. If you use an extra audio recorder, keep it running continually. This will enable you to easily sync your audio recording with your video track(s).

# Shot List

As mentioned in Chapter 4, "Types of Wedding Coverage," a shot list should neither be prohibitive nor a task master. It's simply a way to keep on track—a reminder of the important moments and people to watch for. A shot list is an excellent way to stay organized, but make sure to look up from your list and catch all the unanticipated moments, too. Of course, the wedding you shoot may require you to incorporate

different cultural and personal elements, but following is a general shot list for a ceremony from which to build your customized version:

- Wide shot of entire site

- Grandparents arriving/walking down aisle

- Parents arriving/walking down aisle

- Groom and groomsmen taking their places

- Bridesmaids walking down aisle

- Doors opening for bride

- Bride walking down aisle

- Groom seeing bride

- Father giving daughter to groom

- Bride and groom meeting at site

- Friends or relatives speaking or performing

- Recitation of vows

- Exchange of rings

- Official pronouncement of husband and wife

- First kiss

- Recessional

# Next Up

Phew! The stress of the ceremony is behind you—congratulations! Often, couples will take a few shots of themselves and of their newly joined families right after the ceremony. During this time, most of the guests will be mingling and having drinks, getting ready to enter the reception. If you want to capture everything happening, you'll have to move quickly. Luckily, these shots are always joyful and fun. Chapter 7, "Formal Shots and Cocktails," will give you some ideas on how to best manage them.

# DIY Idea: Group Shot of Two!

It is common for wedding shooters to cram all the wedding guests into one shot—a big group shot of everyone at the wedding. One very fun DIY idea is a twist on the traditional group shot: having a group shot...of the couple. Almost all the guests have cameras or camera phones with them; with a little bit of effort, you can maximize that photo-taking power and create a fun and beautiful piece for your couple.

To begin, create a small printout—maybe just business-card size—asking each of your guests to take a picture of the couple just as they give each other their first kiss; then place the printout on every seat at the ceremony. Make sure the printout provides your email address so that participating guests can send you a picture file. (See Figure 6.13.) You'll get dozens of different shots of the same moment—different angles, different framing, different color tones. Print out all the images and put them in a collage of that exact moment for your couple. Using post-production tools (or simply a pen and paper), include the guest photographer's names on their photo as a way to make the project even more intimate.

This project would work at moments besides the first kiss, too. The entrance to the reception, the first dance, or the cake cutting are all times when you could gather a variety of shots of a specific, beautiful moment. Make sure to pick a moment when flash photography is allowed and when the guests are likely to have a good view of the couple.

**Figure 6.13**
Written instructions will ensure that your guests understand your project and will help out. Because so many phones have cameras and email capability, you'll likely get a lot of images before the recessional is over!

*I Do!*

*If you do, indeed, want to help me make a beautiful collage for Mary and Brad...*

*Please take a picture of their first kiss and email it to me at:*
*mb1stkiss@gmail.com*

high resolution appreciated! videos welcome!

# CHAPTER 7

## Formal Shots and Cocktails

**In this chapter:**

- Focus on what's important
- Formal shots
- The couple
- Cocktail hour
- Especially for videographers
- Shot list

Every bridal couple has a slightly different timeline, but it is very common to have some time between the end of the ceremony and the beginning of the reception. During that period, guests might be driving to a different venue or enjoying some cocktails, appetizers, and a pretty setting. At the same time, the wedding photographer and videographer will be busy shooting formal shots, romantic shots, detail shots, and action shots. This is a fast-paced part of the wedding day for the shooter, and you will want to be able to have a good time with it—without losing your cool. That can be hard, even for a seasoned professional; let's take a look at exactly what is going on and how you can best be prepared.

# Focus on What's Important

*Formal shots* are the posed pictures that generally occur after the ceremony. They formally join the couple and their families in portraiture. True, some couples choose not to do formal portraits at all, citing a preference for journalistic or candid photography over the posed nature of the portrait shots. For those couples who do want formal shots, many choose to sit for them after the ceremony, as it is relatively easy to gather everyone together in daylight, before too much drinking and dancing occurs. (See Figure 7.1.)

> **Note**
>
> Not all couples wait until after the ceremony to sit for their formal shots. Some couples choose to do all the formal shots prior to the event to save precious reception time for pure enjoyment.

**Figure 7.1** Couples have different opinions on the value of formal shots versus candid or journalistic ones. I like them because they serve as a historical record of the family as well as of the event. (Image courtesy of Remy Hathaway.)

It's important to learn from your couple what kind of emphasis they want on the posed shots (if at all) and how much time they want to designate for them. Similarly, find out if they want a series of shots of themselves together or with their attendants. Make sure this is information you cover well before the event itself so you can have a list of shots ready, the correct equipment on hand, a shared and realistic vision of the timeline, and—if needed—a helper.

## Tip

Brides and grooms (or their parents) often want formal pictures, but don't want to spend the time taking them. This is especially true with couples who seek the services of a DIY photographer. Often, they want the ease, unobtrusiveness, and casual style of the DIY shooter, but the posed images shot by a pro. The fact is, however, that formal shots require some time and guest-wrangling, no matter who is doing the shooting. Make sure the couple's expectations are realistic.

As discussed in detail in Chapter 4, "Types of Wedding Coverage," knowing how and where to place your subjects is very important. Ideally, you will have the opportunity to visit the site ahead of time and determine the best place for your posed shots. Often, this will occur in the exact same place where the couple got married—the altar, stage, beach, or trellis. Alternatively, you might find that the reception site offers a place that is even more photogenic. Have a number of locations for these shots in mind; keep an eye out for visually interesting places throughout the day. You are looking for places that offer some combination of depth of field, pretty background, interesting framing elements, and elegant details. Your bride and groom might have some opinions on this; be sure to ask.

## Formal Shots

Chapter 4 gives lots of pointers for setting up posed shots. Formal shots are, by definition, posed, so the advice there is worth reviewing. As well as posing the shot, however, you have the additional considerations involved with shooting a group, which can be slightly trickier than posing just one or two individuals.

Here are some ways to make the formal shots go as smoothly as possible:

- **Work from a shot list.** While I recommend a shot list for every portion of the wedding, your list for formal pictures should be especially detailed and organized. Find out from the couple ahead of time who should be pictured with whom. Also learn whether there are people who *shouldn't* be asked to pose together to avoid awkward moments. Once you have the list from the couple, organize it in a way that makes sense. The goal is to avoid shuffling people around too much and to move through your list efficiently so that those who are finished can retire to the reception instead of waiting around for further appearances. You might want to shoot largest group to smallest group, bride's side and then groom's side, or family and then attendants. Make special accommodations for elderly relatives; you don't want to keep them waiting too long, especially if you are shooting in the heat or rain.

---

**Tip**

Make sure everyone who is expected to pose in formal shots after the ceremony knows about it ahead of time. You can accomplish this with an announcement from the officiant, a note in the ceremony program or on the ceremony seats, or instructions issued from ushers to guests.

---

- **Use a chair or stepladder.** Using a chair or stepladder is an effective way to shoot an especially large group. For one thing, you will be able to fit more people in the shot. Looking down on a crowd gives a clearer view of the people in the back row; you can capture everyone, without having to arrange people by height. Additionally, by having your subjects look up at you, you are likely to get a flattering view of their faces; shooting down on your subjects tends to be very kind to their features. Finally, by elevating yourself, you will be able to take charge more easily—a skill whose importance can't be overstated for a group photographer. (See Figure 7.2.)

- **Use a tripod.** Generally, tripods are used for long exposures, and are typically stowed until later in the evening, when the sun goes down. But even with relatively shorter exposure photography, a tripod can be a wonderful advantage when dealing with a group. Mounting your camera on a tripod enables you to move between the group (repositioning people, straightening suit jackets) and your camera viewfinder without losing any of the framing, focusing, or exposure settings that you have set up. Like a chair, a tripod will also help augment your authority.

**Figure 7.2** This took a little more than a stepladder—actually, it was shot from a second-story window across the street—but it is an excellent illustration of how getting higher than your subjects allows you to capture more of them. The higher the better; if there are balconies, windows, hills, or ladders at your disposal, try them out! (Image courtesy of Rick Collins; www.rickcollinsphotography.com.)

- **Use a strong voice.** Yes, I'm officially repeating myself, but I can't overstate this: You need to be able to take charge of the group. However, while you certainly need a strong voice, it doesn't have to be your own. Consider getting a friend of the couple—ideally someone who knows a lot of the people who are expected to pose—to help you out. Your temporary assistant can make sure everyone is present and ready to be photographed, freeing you to move swiftly from group to group.

- **Develop a keen eye.** The time you take asking people to take off their sunglasses, straighten their dresses, adjust their footing, and change their spacing can make all the difference in your shot. (See Figure 7.3.) While that's easy to do when you have a posed shot of two people, it is trickier with 20—but no less important. A tripod, an assistant, and several reminders to yourself to slow down and pay attention will help you accomplish that.

**Figure 7.3** Though I normally suggest positioning people in group shots close together, the spacing here was careful and intentional to separate the couple from their siblings. Despite being a posed formal shot, having the subjects look slightly over my shoulder (instead of directly in the camera) resulted in a less formal feel, which is a handy trick for couples who want more casual formal shots.

- **Select the right camera mode.** Make sure your camera is ready to go. If you have a wide angle lens, this might be the time to use it. Landscape mode might be good, too, as it will give you a longer depth of field for your shot; this is particularly helpful when you have a line of guests that extends across the whole image. If you find you are losing the attention of your group, try putting your camera in burst mode—not necessarily because you need the shutter speed, but because if you fire a bunch of shoots at once, your subjects will stay on the task of modeling. You won't have to constantly remind them to look at you and smile.

- **Exude a sense of joy.** It sounds terribly cheesy, but if you have fun shooting, your subjects will have fun being shot. If you feel harried and stressed, they will feel put upon and just want to get to the party already. This is a pretty good time to stop and remind yourself that the whole point of a wedding is to celebrate love, new beginnings, and families; camera exposure settings can take a back seat to that if necessary. Your attitude will affect your subjects' attitudes, so cheerlead the joy right into your images. (See Figure 7.4.)

■ **Try some fun ideas.** You may or may not have the chance to plan fun shots with elderly relatives, but there are lots of ways to add spice and action to your posed formal shots. As a friend of the couple, you are especially qualified to add in some fun, as you are likely to know their tastes, quirks, and friends. Use that insider knowledge to come up with some ideas that will help make their shots especially intimate. Let your creativity shine. The more fun you have, the more joy you will capture in your shooting!

**Figure 7.4**
This is a formal shot that turned into a candid with the injection of a little enthusiasm. (Image courtesy of Christian Maike; www.christianmaike.com.)

On the subject of trying out fun ideas, here are a few for big group shots:

- Make some signs with the date or the couple's names for guests to hold.

- Pose the couple on the steps of the church or in the middle of the grass, with a space immediately around them. Then place their friends and family in a circle around. This works even better if the subjects are tiered or if you shoot them from above.

- Ask the group to sing or chant while you shoot. This results in fun action-oriented stills and fabulous video.

For smaller groups, consider the following ideas:

- Use props or actions such as walking or jumping to make your posed shots more fun.

- Get the bridesmaids and groomsmen involved with shot planning. With a little encouragement, they will come up with some great ideas of their own. (See Figure 7.5.) I've seen groomsmen initiate heartfelt and sentimental toasts, throw the groom up in the air, and treat the groom like a bride—pretending to apply his lipstick and help him put on high heels. And a group of bridesmaids I worked with once posed a shot where it looked like they were all going to dive in the pool, like a swim team. (The bride actually did at the end of the evening!)

**Figure 7.5** This shot came with some effort, but everyone had a great time setting it up. The right participants will be your allies in thinking up and creating fun shots! (Image courtesy of Rick Collins; www.rickcollinsphotography.com.)

■ Use some old favorites, like the groomsmen picking up the bride, the bridal party jumping in the air, or all the bridesmaids tossing their flowers at the groom. Research wedding photography online for fun ideas.

# The Couple

Formal couple shots can be an absolute joy to shoot, for photo and video both—especially if the shots are after the ceremony. The stress of wedding planning and the nervousness surrounding the ceremony is gone; indeed, this might be the first time the couple has relaxed in days. That unworried joy in each other and in their day can be felt on camera; make the most of it! (See Figure 7.6.)

**Figure 7.6**
A small beach wedding is no less scary than a huge church wedding; after all, it represents the same commitment! Chris and Corinne's ease and joy once the ceremony was done was visible in this shot. (Image courtesy of Christian Maike; www.christianmaike.com.)

There are some challenges to shooting couples. You want to capture emotion, but you don't want it to be overdone or cheesy. One of the best ways to do that is to allow the couple some time and space to hang out together without too much direction. (See Figure 7.7.) Chances are, they will be affectionate and loving when the presence of the camera is subtle. Furthermore, your stage directions can make a couple feel self-conscious, which will look unnatural on camera.

Another way to make your couple feel comfortable is to shoot them in a place that is fun. There is nothing to do against a wall except pose, but if you are at the beach or in a park or in the empty reception hall, there will be more for them to play with and react to, and you will get livelier, more natural expressions.

With that in mind, you'll probably still want to get a few careful, posed shots. Have some ideas up your sleeve and don't be afraid to offer direction. Tell them where to put their hands, how to sit, and when to kiss, if you need to. If a shot isn't working, drop it and move on to the next idea. Make sure to get a variety of shots: wide and close-up,

**Figure 7.7** By playing with depth of field, this shot gives the couple a romantic and dreamy look, without requiring them to model—a handy trick between other, more rigorous poses! (Image courtesy of Rick Collins; www.rickcollinsphotography.com.)

serious and playful. Mostly, though, have fun. This is such an exciting moment for the couple! You are there to capture their joy, but that shouldn't stop you from adding to it and even basking in it yourself. Your pictures will be better for it. (See Figure 7.8.)

While I certainly encourage you to use your setting and your couple's personalities to dictate your shots, here are some simple poses to try. These will work anywhere!

- Groom behind bride, kissing her shoulder
- Groom dipping bride (or bride dipping groom!)
- A close-up of their wedding bands or a wide shot of the couple looking at their wedding bands
- The couple walking together (this works walking toward or away from the camera)
- Groom's arms circling the bride, his hands on the back of her dress
- Bride's head rested on the groom's shoulder
- A kiss (old-fashioned still works!)

**Figure 7.8** Playful indeed! The couple's preferences and personality will be the best resource for fun shots. (Image courtesy of Rick Collins; www,rickcollinsphotography.com.)

# Cocktail Hour

The cocktail hour enables you to capture a fun mix of candids and posed shots, with plenty of room for details in between. Often, the time between the ceremony and dinner falls as the sun is getting low in the sky, creating wonderful light if you happen to be outdoors. Very few things can go wrong during the cocktail party shoot: There are no first kisses to overexpose, no cake cutting to be in the wrong room for. It is simply *fun*.

If the couple is being photographed, often they will miss a lot of the cocktail hour and especially appreciate this coverage. Look for shots of guests talking, drinking, and laughing; shots of kids running around; and close-ups of appetizers being served and drinks being poured. Often, the cocktail area will be decorated with personal items from the couple: pictures, a guestbook, or a place to write a sentiment to the couple. Be sure to shoot those, too. (See Figure 7.9 and Figure 7.10.)

---

**Tip**

Remember to look for action shots. For example, instead of shooting a tray of appetizers, shoot a close-up of a guest's hand selecting an appetizer. Other ideas: drinks being poured, guests toasting each other or laughing, the guestbook being signed. Small actions give life to the party footage; make it as lively and fun as you can!

---

**Figure 7.9** This thirsty guest didn't mind posing on her way back to the bar!

**Figure 7.10** Catching joy always improves a shot. There is lots of joy to be found right after a wedding ceremony! (Image courtesy of Remy Hathaway.)

# Especially for Videographers

If you are shooting video while someone else (professional or DIY) is shooting still photography, you have a lot of options during the formal photography session. It's worth checking in with a couple to see if they have preferences. Some couples want the cameras on them at all times. In this case, you can shoot the formal shots with the still photographer. You have an advantage here in that you can do pans, zooms, and tilts, which will add some zest to the shots that will prove useful in a montage of family and friends. Although it is usually the still photographer's job to call the shots (literally!) and organize the guests into groups and poses, don't be afraid to step in with adjustments or ideas that will work better for video.

If you know the formal shots are being covered extensively enough for the couple by the still photographer, you have a lot more wiggle room. You could do one of the following:

- **Shoot "behind the scenes."** For example, you might film the bridesmaids bustling the bride's dress, kids running around and refusing to pose, or the uncles having their own toast while they wait for their turn in front of the camera.

- **Get some interview footage.** This is a great time to gather comments from guests waiting to have their photo taken or to record informal toasts from guests enjoying a drink during the cocktail hour.

- **Get really good coverage of the cocktail party.** These are some of the people with whom your bridal couple will be spending less time throughout the day. The couple will likely appreciate the extra footage.

- **Sneak into the reception venue to shoot the empty room.** The possibilities are extensive here, and are discussed more thoroughly in the next chapter.

# Shot List

As with previous chapters, this shot list is presented to help you think about what you need to cover during this portion of the event. You will likely need to personalize this list somewhat, depending on the wishes of your bride and groom. Ask them about special friends and relatives who should be singled out for photos. Remember that for formal shots, a list isn't enough; you also need an efficient and organized way to get through the list, without wasting too much precious reception time!

- **Formal Shots**
  - Bride and groom with officiant
  - Bride and groom with ceremony readers/performers
  - Bride and groom with grandparents
  - Bride and groom with both families (extended)

- Bride and groom with bride's family (extended)
- Bride and groom with groom's family (extended)
- Bride and groom with both families (immediate)
- Bride and groom with bride's family (immediate)
- Bride and groom with groom's family (immediate)
- Bride and groom with all siblings
- Bride and groom with attendants
- Bride with groomsmen
- Groom with bridesmaids

- **Couple Shots**
  - Portrait (wide)
  - Portrait (close)
  - Romantic (wide)
  - Romantic (close)
  - Fun

- **Cocktail Reception**
  - Guests (candid)
  - Guests (posed)
  - Appetizers
  - Drinks
  - Guestbook
  - Decoration details

# Next Up

You're formal duties are finished. From here on out, it's a party! That doesn't mean there isn't still a lot to capture, though. The reception is coming up, and no matter how informal or low key your bridal couple is, there will surely be some moments you can't miss. The next chapter covers how to best prepare yourself for the important moments of the reception.

# DIY Idea: That's What He Said!

Often, a couple will leave a place for guests to express a wish or a comment in writing. This might be a book to sign, a jar with cards to drop in (see Figure 7.11), or something more elaborate. Ask if you can borrow those quotes to weave them into your documentation. Videographers can use the graphics feature of the editing software to create subtitles that show a guest's wishes under his or her image. (See Figure 7.12.) Photographers can use the comments underneath guest pictures when compiling the images in an album.

If the couple doesn't have a place to collect guest comments, ask if you can set that up yourself by handing out decorated index cards for guests to write on. Alternatively, collect those sentiments on video, which you can later transcribe or use as interview footage.

**Figure 7.11**
You'll have a blast going through the comments that guests leave for the couple. There will likely be lots of sweet comments as well as several funny ones.

**Figure 7.12** The text graphics add a distinct flavor to the video. This particular quote makes the father-daughter dance more personal and warm, if a little less serious. The comments and graphics style you choose will contribute to the tone you create.

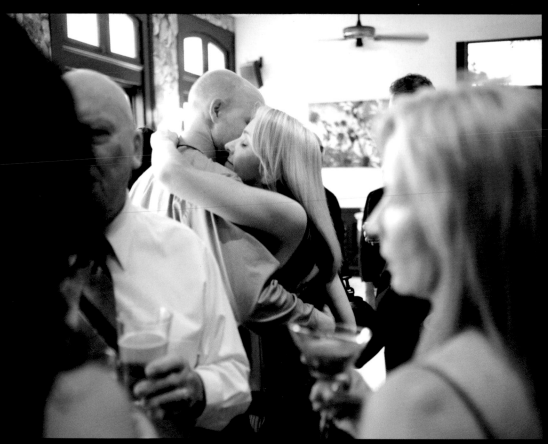

Image courtesy of Rick Collins (www.rickcollinsphotography.com).

# CHAPTER 8

## *The Reception*

**In this chapter:**

- Focus on what's important
- The setup
- Formal dances
- Toasts
- Cake cutting
- Working the room
- Especially for video
- Shot list

It's party time! There is lots of freedom in how you cover the reception. There might be certain points you will want to catch, such as the bouquet toss or the cake cutting, but there is also a lot of time for creativity and fun with your shooting. Receptions can vary from a single champagne toast following the ceremony to an all-night dancing affair. A wedding reception might be described as elegant, cozy, intimate, glamorous, chaotic, sweet, or extravagant (among other adjectives); as the documentarian, it is your job to understand and capture the mood that the couple has created with their event. As well as figuring out all of your shooting goals, make sure you figure out when you can relax and enjoy the party, too!

# Focus on What's Important

Like the other parts of the day, you should strategize how to cover the reception ahead of time. This will require consideration of the couple's preferences, the events taking place, and the venue lighting, all of which contribute to the overall feel of the event.

Capturing the mood of the reception will bring the event back to life for your couple as they review your pictures and video. It is important to use their stylistic clues when you strategize how you want to shoot the event. For example, if they have a small and simple garden wedding featuring a string quartet, it's unlikely they want an MTV-style wedding video with color effects and strobes; on the other hand, a dance party that goes late into the night might not need six hours of continual journalistic coverage. Think about a realistic piece for the event you are covering.

The agenda for the reception will tell you what to cover, often in extremely explicit terms. Typical reception events include an entrance, formal welcomes, toasts, the couple's first dance, a father-daughter and mother-son dance, and a cake cutting. Your couple may eschew some or all of these traditions or incorporate other ones, such as a money dance, a chair dance, or various newlywed games. Find out ahead of time so that—as with the ceremony—you can plan where to be for each one.

Of course, you need to solicit the opinions of the couple as you make your plan for shooting the reception. Here are some things to ask that will help you develop your reception strategy:

- Can the couple provide a schedule of the evening events (photo and video)?

- Will there be a DJ or MC announcing events as they happen (photo and video)?

- How much coverage does the couple want (photo and video)?

- Does the couple want pictures of particular tables or groups (photo)?

- Is it important to capture the toasts in entirety (video)?

- Is it important to capture the dances in entirety (video)?

- Should you interview guests (video)?

- Is it okay to use a flash (photo)?

- Is it okay to use a light (video)?

- Are there any special events (games, dances, performances, etc.) that the couple wants you to cover (photo and video)?

By the time you are at the reception, chances are the lighting will be low (see Figure 8.1). You might be shooting outside, but the sun is going to be heavier in the sky than it was during the ceremony, if not down entirely. If you are shooting indoors, it is likely that the lights will be dimmed. Low-light shooting will require some combination of longer exposure time, higher ISO, boosted gain, flashes, or external lights. You may or may not have all these options available to you, so make sure you know which you can employ (and refer to Chapter 2 for further information about each). Remember the following points about low-light shooting:

- If you plan to use long exposures, make sure you have a tripod.

- If you are using a light for your video camera, make sure you have extra batteries and the go-ahead from your couple.

- If you are boosting your gain or ISO, make sure you know when your camera images tend toward noisy and what is acceptable to you.

- Remember that a flash is often a poor way to create light; it is, however, a good way to augment existing light. Look at the ceilings and the walls of the room to see if you can bounce a flash for more even distribution.

**Figure 8.1** This reception was lit entirely by candles and torches. To get this wide shot, an exposure time of $1/15$ second was used—as was a tripod!

> **Caution**
>
> If you have a brightly painted wall in the room, be careful when bouncing light, as you will bounce a color cast too. Bouncing light off the walls or the ceiling works best with white or neutral-colored surfaces.

# The Setup

Shooting the reception venue before the guests arrive will give you a clean view of the room for an establishing shot, as well as some peace, calm, and space to set up detail shots of the centerpieces, table numbers, place settings, candles, and cake, which is usually on the side of the room for guests to look at before it is cut. (See Figure 8.2, Figure 8.3, and Figure 8.4.) It's also a really good time to assess lighting so you can best position yourself to maximize the natural light of the room.

**Figure 8.2** Shooting reception pieces will benefit from macro mode for close-ups with a lot of crisp details; use portrait mode for a softer look. (Image courtesy of Rick Collins; www.rickcollinsphotography.com.)

**Figure 8.3** The soft elements in the foreground do a beautiful job of framing the place card, a lovely depth of field trick for shooting details. (Image courtesy of Christian Maike; www.christianmaike.com.)

**Figure 8.4**  Ideally, you will have time to get shots of the cake intact.

## Tip

A shot of the couple's place cards next to each other at their seats is always fun. If the bride has changed her name with marriage, this might be the first time it is written out for her to see.

Ideally, you will arrive at the reception venue before the guests do. When you arrive, start by grabbing some wide shots followed by some table shots; then move to the details and the cake if you have time. (You can do those after the guests arrive if necessary.) Find out when and from where the guests and the bridal party will enter; you might want to catch that moment. If the couple is announced by the DJ or bandleader as they arrive, remember that it is likely the guests will stand up, so make sure your view won't be obstructed. A grand entrance is a wonderful time to shoot down on the scene if the room allows it.

Sometimes, the bridal couple will sneak into the reception room to check it out before the official entrance. They have typically spent hours and hours designing the space, so catching their excitement and joy at this moment makes for good video footage. If you are shooting still, a wide shot of the decorated room with only the couple in it can be very dramatic.

> **Tip**
>
> A few shots of guests entering the room or mingling before the festivities really amp up will be useful as an opening to the reception section of the video. (See Figure 8.5.)

**Figure 8.5** It is useful for the videographer to get some transition shots to move the video between sections—in this case, from the cocktail hour to the reception dinner.

# Dancing

The couple's first dance together and any dances they might do with their parents are fun to shoot. When you are shooting photo, look primarily for the subjects' expressions, but go for some fun shots, too: feet, hands on back, guests watching. If your shutter speed is high, you can shoot in bursts and get clear shots—especially handy for the nuanced changes in expression. Experiment with a slightly lower shutter speed, too, for some intentionally blurred motion. Dances tend to end with a big hug, so position yourself to catch expressions there, too. Remember, you'll probably have to pick one person to focus on and get the shoulder of the other one. I usually aim to get the bride's face during her dance with her husband, but her father's face after the father-daughter dance. Pay attention to who is expressive, and use your skills to capture the mood of the dance. (See Figure 8.6.)

If you are shooting video, decide ahead of time if you will shoot the whole dance to show unedited or if you want to cut the dance up in post production. If you don't plan to do much editing, leave the camera running so you get a continuous audio track and pick a relatively safe wide shot so you can cover a lot of the action without having to move too much. If you are on a tripod, or are steady (using a wall or your elbows), you can try zooming to get more interesting coverage, but be careful of too much movement. It can become quite distracting if you aren't cutting between shots.

## Video Tip

If you are in a medium-wide or tighter shot, don't feel you have to follow the dancing couple too closely. Allowing them to move partially in and out of frame can give a sense of action without the dizziness associated with too much camera movement.

As I mentioned, dancing shots can be fun—but they're also difficult. Luckily, you usually have lots of time to shoot and to practice under whatever conditions you might be facing. (See Figure 8.7.) Vary your shots—everything from bird's-eye shots of the scene (see Figure 8.8) to eye-level shots of dancing feet can make for exciting images. If you want sharp shots, try for a very fast shutter speed. A slower shutter speed will give you some motion blur, but that could be stylistic and fun—especially if there are candles or colored lights in the mix. If it is dark in the dancing area, consider trying night mode, which will briefly flash the subject in the foreground but leave exposure settings and shutter speed that consider the background as well.

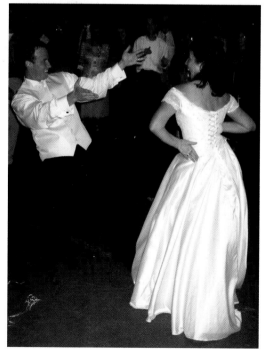

**Figure 8.6** The style of photography you use might depend on the mood of dance: upbeat, romantic, or comedic. (First image courtesy of Rick Collins, www.rickcollinsphotography.com; second image courtesy of Christian Maike, www.christianmaike.com; third image courtesy of Pete Laub.)

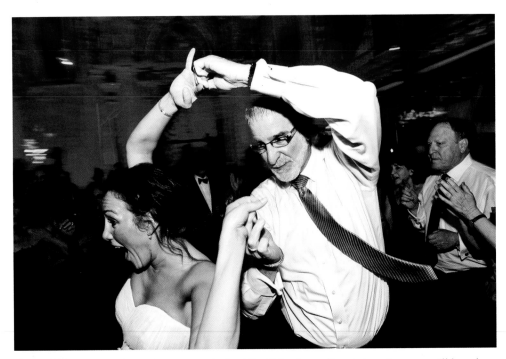

**Figure 8.7** Dancing shots take some work. Luckily, if the dance floor is hopping, you will have lots of chance to practice! (Image courtesy of Rick Collins; www.rickcollins.com.)

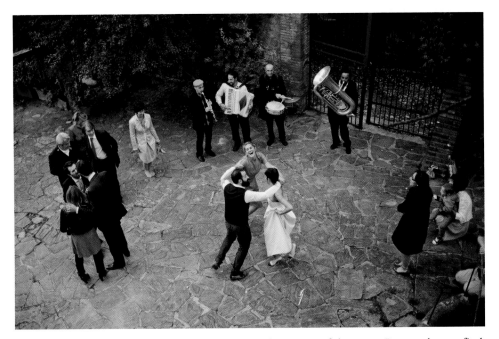

**Figure 8.8** This shot beautifully captures the joy and intimacy of the event. Do your best to find angles besides eye level when you are shooting dancing! (Image courtesy of Rick Collins; www. rickcollins.com.)

# Toasts

The toasts are another part of the day when videographers are envious of the relative mobility of still photographers. As a photographer, you want to make sure to get at least one good shot of each of the toasters and the couple reacting to their comments. Moments of laughter and tears are always a good time to be shooting, but you can also get great images whenever the speaker looks up from his or her notes, smiles, or pauses. These shots are portraits, so consider your depth of field accordingly; a short depth of field tends to be flattering to your subject, and will soften the background, over which you have very little control. At the end of the toast, get ready to shoot in action mode or burst mode. Laughter, raised glasses, and applause make for spirited action shots. (See Figure 8.9.)

**Figure 8.9** The photographer's keen eye on the couple proved that the reaction shot was better than the action shot! As well as attention to what was going on, the photographer had a tough technical challenge with the couple against the backlit window. By exposing for the subjects and allowing the background to be blown out (overexposed), the shot catches the detail in the couple beautifully. (Image courtesy of Rick Collins; www.rickcollinsphotography.com.)

> **Tip**
>
> If there isn't a designated space for the toaster, request one yourself. That way, you can choose a spot that is well lit and enables you to move between shooting the speaker and the reactions of the couple being toasted.

Video of the toasts is more complicated because of the audio, of course. Like the vows themselves, the toasts are one of the main reasons your couple might choose to have a video at all. An important thing to consider when shooting toasts is getting close enough to capture audio on your on-camera mic or placing a separate audio recorder on or near the speaker. Be careful with shooting too tightly, too, because a lot of people pace as they toast.

# Cake Cutting

Hundreds of weddings later, I still love the cake cutting. (See Figure 8.10.) As well as being pretty, and the excitement of eating that first slice, the couple will often make a little speech when they cut the cake. Inevitably, they are thrilled to be surrounded by friends and family and, of course, their new partners. I find their joy contagious!

Another thing I love about the cake cutting is how the couple often has no idea on Earth how it is done. Here is another place where the photographer often steps in with more wedding experience than the couple. If that job falls to you, position the couple next to each other, in the best light possible. Make sure your camera is in burst mode because you will want shots of the couple and their expressions, which will change quickly. You also want to get close-ups of their hands on the cake knife, the cake on the plate, and the first bites. Be prepared to move quickly for a few minutes; you might want to shoot from behind the couple or off to one side, as well. If they are the type of couple who might wind up in a cake fight, that burst mode will become especially handy.

For videographers, my advice is the same: Stay flexible (off-tripod), ready to shoot both tight and wide. If you are planning on minimal editing, leave the camera rolling and make your camera moves and zooms as smoothly as possible. If you plan to cut up your footage later, you can move between your shots less jaggedly.

> **Tip**
>
> If you don't have time to shoot the cake before it is sliced, you can always shoot another side of it after the cake cutting. Alternatively, shoot it with the first slice taken out.

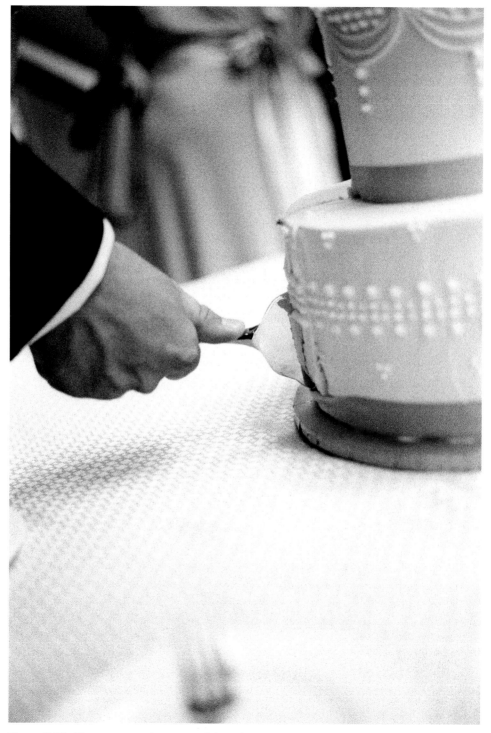

**Figure 8.10** Try to capture the action of the cake cutting. (Image courtesy of Christian Maike; www.christianmaike.com.)

# Working the Room

Not every part of the reception involves an event, such as the toasting or cake cutting. There is lots of time dedicated to eating, mingling, and dancing—simply enjoying the party. Here you can show off your skills as a candid shooter, catch the action on the dance floor, or set up a place to conduct interviews. (Refer to Chapter 4, "Types of Wedding Coverage," for information about interview footage.) You might also shoot table shots, which are posed pictures of every guest sitting at a given table. Often, the bridal couple will make rounds, greeting every table, which will help you get group shots. (See Figure 8.11.) This is also a fun time to get a wide shot of the room full of people, details you might have missed before, and shots of children, the band, and the building exterior. Remember, though, that as a DIY wedding documentarian, you are also a guest. This is also a wonderful time to relax and enjoy!

**Figure 8.11** Not every couple will do table shots, but it is something you should clarify beforehand. It is a nice way to ensure that the couple sees every guest, and that there is some footage of every guest. (Image courtesy of Rick Collins; www.rickcollinsphotography.com.)

## Turning the Camera Off

Until I had been working weddings for some time, I got nervous every time I put down my video camera—as if all the fun stuff would happen the exact moment I relaxed. It took a while to realize that not only are you a better documentarian when you stop and watch the scenery (No, really! It helps!), but certain things are not especially photogenic. Here are some things that *don't* look especially terrific on camera:

■ **People eating.** I love shots of buffet lines, servers placing meals in front of guests, and glamorous catered dinners, but the act of eating is not especially attractive to record. (See Figure 8.12.) Mealtime is traditionally when the professionals take a break. The bride is unlikely to want to see herself chewing.

■ **People doing nothing.** I'll be honest: There is a lot of time at a wedding when people are just sitting at their tables, chit-chatting and watching each other. A few candids of the individuals and the mood of the room are fun, but don't go overboard here; it is simply not highly compelling material.

■ **People dancing…again.** Dancing shots are such fun; they show action and movement and energy, and speak volumes about the fun that the guests are having. But there is a strong tendency to shoot dancing *all night long*—and three hours of the same thing simply is not needed (especially when you realize it is the same guests dancing all night). Work on getting a few good dancing shots: a bird's-eye view of the crowded dance floor, the bride and groom in a circle with their friends, that couple who are awesome swing dancers (they are there, somewhere), and whatever other great moments pop up, but don't feel a need to capture every second. Put the camera down and enjoy the dance floor yourself!

**Figure 8.12** Alluding to dinner is much more photogenic than showing it actually being eaten. (First image courtesy of Christian Maike; www.christianmaike.com.)

# Especially for Videographers

How much editing you want to do will play a big role in your shooting decisions during the reception. If you plan to edit a lot, you can free yourself up with the shooting and be more experimental with angles and shots; you can then cut out the bits that don't work and sew together a piece from the shots you like. If, however, you prefer more traditional coverage, be more conservative with your shooting. Use a tripod, don't make too many camera movements, and leave the camera running from the start to the end of a particular event. Like other parts of the evening, be conscious of audio collection and make sure to position yourself or an additional sound recorder when natural audio is important. Also, pay attention to the music playing during the reception. If you will be adding songs to your edited video, use some of the songs that the couple chose to hear at their event.

Getting a final video shot is also important. If the couple leaves before their guests, make sure to capture the send-off. If the guests trickle out and leave the couple, make sure you have a final scene to end your piece. It doesn't need to be chronological—it could be a full dance floor, the couple hugging their parents, a shot of a candle, a shot of the couple looking at their rings, or an exterior shot of the reception building all lit up. It could even be a funny interview quote. The point is, make sure you have something with which to conclude your piece—or a few closing shots to pick from—before you turn off your camera and start dancing!

# Shot List

Receptions vary so much that your shot list will undoubtedly be different from mine. As with other portions of the day, use what you know about the event timeline and the list that follows to help you formulate your own shot list. As always, the list you make should serve as a reminder and a guideline, but not hold you back in any way.

- **The Setup**
  - Wide angle of empty room
  - Place settings
  - Place cards
  - Centerpieces
  - Cake (wide)
  - Cake (details)
- **Formal Dances**
  - First dance (wide)
  - First dance (close)
  - First dance (hands on back)
  - First dance (feet)
  - First dance (ending)
  - Father-daughter dance
  - Mother-son dance

- **Toasts**
  - Each toaster (wide)
  - Each toaster (close up)
  - Reaction shots (bride and groom)
  - Reaction shots (guests)
- **Cake Cutting**
  - Couple with knife (wide)
  - Hands on knife
  - First slice
  - First bite
  - Champagne toast
  - Couple's speech
  - Cake with slice taken out
- **Working the Room**
  - Wide angle of full room
  - Dancing (bird's eye)
  - Dancing (individuals)
  - Dancing (feet)
  - Table shots
  - Kids
  - Interviews
  - Food shots

# Next Up

Congratulations! You made it through the event! You deserve a glass of champagne and a big slice of wedding cake. Once you've recovered from the party, it's time to take a look at all your shooting, and do any post-production corrections, enhancements, and editing. The next chapters guide you through getting your images from raw to polished.

# DIY Idea: That Was at My Wedding?!

Remember when couples used to put disposable film cameras on every table at the reception? The guests would take pictures and leave the cameras for the couple to have developed. It became the rage in part because couples often missed much of their own party; it was a wonderful way to be in all parts of the room at once (well, more of them anyway).

An iPhone app called the Hipstamatic has given that concept a makeover; if you have even a few iPhone users at the wedding, this application is a fun and inexpensive way to get great shots from your guests. Here's how it works: One person downloads the free Hipstamatic disposable camera application from the Apple iTunes store. Then he or she buys a roll of film from the store. That costs money—it's a few dollars per roll. That person can then invite friends to join his or her roll of film. The roll of film will have a certain number of exposures—24 or 36. Whoever has accepted an invite to the roll of pictures can shoot pictures from the roll on their own camera (after downloading the free app). When the last picture in the roll has been taken, all the shots are immediately

sent to everyone in the group. Each person will have a full set of the exposures, even if they only shot a couple themselves.

Hipstamatic images are shot through the iPhone camera, but the images are square and have filters applied to make it look like they are old film-camera images. The application lets you choose certain looks that go with certain cameras, films, and flashes. The disposable Hipstamatic lets you pick from a number of "cameras" to get the filtering effect you want. Gather a few iPhone users together; it could be very easy to shoot a few Hipstamatic disposable film rolls that will showcase the reception from different perspectives and with a beautiful, stylized look! (See Figure 8.13.)

**Figure 8.13** Hipstamatic shots are a great way to share the love! (Images courtesy of Sage Romano.)

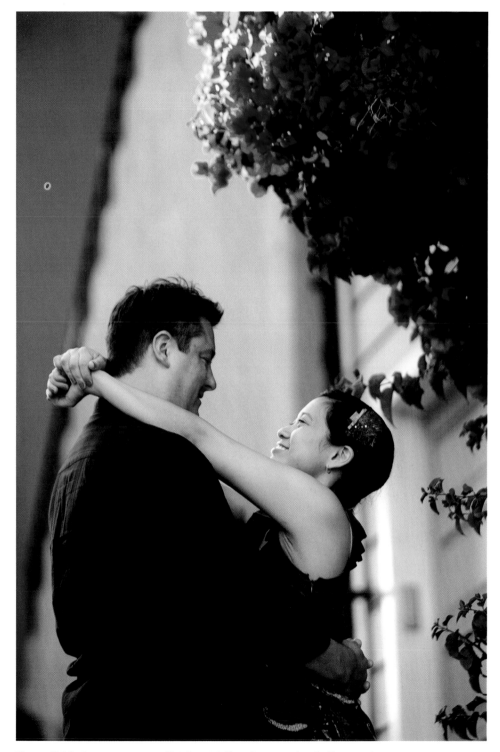

**Figure 8.14** Image courtesy of Myleen Hollero (www.myleenhollero.com).

# PART III

## The Honeymoon

Image courtesy of Myleen Hollero (www.myleenh

# CHAPTER 9

## Image Editing

**In this chapter:**

- Workflow
- Image adjustment
- Image effects
- Subject corrections
- Additional resources

Well done! You survived the wedding and undoubtedly collected lots of wonderful shots. Hopefully, you even managed to have a good time, too. You're done now, right? Well, not exactly. The beauty of digital photography is the ease with which you can take dozens of shots, aiming for an exact look. Indeed, it is not uncommon for a wedding photographer to leave a shoot with hundreds—even thousands—of shots. The price paid for all that shooting is the amount of work in culling, sorting, and perfecting the images.

This is wonderful work, though. In contrast to the wedding shoot itself, image editing is quiet, slow, and solitary. There is room to be methodical, experimental, emotive, and playful. It can be a long process, or you can speed through it. This chapter will give you some basic guidelines for the post-production process and some common corrections and effects used in wedding photography. If you find that image editing is up your alley, you can take these beginner lessons and expand on them; there are very few limits as to what you can do when you start playing with your digital images.

# Workflow

Facing a library of hundreds or thousands of images might seem a bit daunting. Your *workflow* is the way in which you move the images from your camera to the finished images you present, and there are a number of steps in between. With some method applied, you can dramatically reduce how overwhelming the project might feel.

Some computer applications are used to store your images, some are image editors, and some perform both functions together. You might use one application for each step, or a combination of applications. The image-editing portion of this chapter covers the use of Adobe Photoshop because it is a very common tool available on Mac and PC platforms. It's available in the Creative Suite, in which case it comes bundled with a lot of other related applications, or in the much more affordable Photoshop Elements, which has all the features most users need. Photoshop is not an especially good workflow management tool on its own, however; to help with that, the Creative Suite version comes with Adobe Bridge. Other applications to integrate the workflow management with the editorial process include Apple's Aperture and Adobe's Lightroom.

Let's look at an overview of the post-production process.

## Import Your Images

You can't do much with your images while they're still in your camera, so your first step is to transfer, or *import*, them from your camera to your computer. You can do that with a card reader or a cable connected directly to your camera. If you choose the latter option, remember it will drain your camera battery.

Your camera will likely give you the option to erase your images from the camera at this point. I choose *not* to erase at this point. Instead, I reformat my memory cards only after I have made sure all my images were correctly transferred and backed up. In addition to providing the assurance that everything is completely and safely imported, waiting to erase a memory card is preferable because erasing a memory card can occasionally lead to a scrambled directory structure on the card. This can complicate or damage later images. A post-import, complete reformatting of the card will help avoid that problem.

## Back Up Your Library

With all the images imported, make a copy of every single picture you shot—an entire backup digital library. Then put that backup library in a separate place from the library you will be working with—a separate drive or burned to DVDs.

Many hobbyist photographers skip this step, preferring to archive only the important, keeper shots. Most wedding photographers, however, are diligent about backing up the

whole library. Is it overkill to duplicate every picture when you know only a fraction of the shots will make your final collection of finished images? Arguably, yes. But the last thing you want is a drive failure before or while you are editing the images; you could lose everything. With their reputation on the line, some professionals duplicate or even triplicate their media before they even leave the wedding site on the night of the ceremony. Many will go an additional step and leave a set of backup images in a separate location in case of fire or flood.

Besides fear of losing the collection, there are a few other reasons to keep a backup library of every shot. One is that your selections might differ from the couples' choices, and they may wish to refer to the originals. Also, as you start tossing and changing images from your working library, it is a good idea to have a set of originals in case you make a mistake, accidentally throwing away or changing an image without intending to, especially if you aren't working in a *non-destructive* environment (discussed later in this chapter).

## Cull the Images

Once you are in your working library (as opposed to your backup library), perform an initial sweep of the pictures to take out the ones that clearly won't work. This is not a delicate process or one fraught with difficult decisions or comparisons; simply look at every image and eliminate the shots that are obviously bad. There will be lots. If a shot is too blurry, too dark, or isn't flattering, it goes. You can eliminate these shots by deleting them (assuming you have another copy in your backup library) or placing them in a folder of unusable shots.

> **Note**
>
> Some photographers might choose to back up their library *after* this initial culling of the images, which is fine—especially if the time between shooting and the beginning of post-production is not long. Because I often have a good amount of time between shooting and the post production (read: I'm usually running behind), I want to make sure I am covered in the event of a drive failure or disaster—hence, my insistence on backing up the whole library.

## Divide and Categorize

Just as your shooting day was divided into sections (the preparations, the ceremony, the reception), your final product will likely be, too. I recommend dividing the pictures categorically before you start making difficult decisions. This will help you ensure you

have shots from every point in the day—or at least all the parts you were responsible for shooting. At this stage, using more granular categories than simply "prep" and "reception" can be a useful tool, as you might have sections of a category that have more images than other sections. Within the reception, for example, if you only have one decently exposed cake shot, you will be likely to spend a little more time on it in post production; if you have dozens of well-lit dancing shots, however, you can pick and choose the ones that flatter everyone.

Your individual workflow and image management system will determine how you divide your pictures. You might rank pictures within an image manager, move images to a new folder on your hard drive, or create a new album of images for each category. Like most parts of your workflow, it is less important what system you use than it is to have a consistent and maintainable system in place.

Of course, every wedding is different. But here are some basic categories that might help you form your own list to somewhat equally divide your pictures:

- Bride preparation
- Groom preparation
- Ceremony site
- Processional
- Ceremony
- Recessional
- Formal shots
- Cocktail hour
- Reception room and details

- Reception entrance
- First dance
- Father/daughter and mother/son dance
- Toasts
- Food
- Cake cutting
- Dancing
- Departure

If you want to rename pictures or add *metadata tags* and *keywords,* this would be a good time in the workflow to do it—after some images are gone, but while you still are sifting and sorting. For example, you might apply tags or keywords like "bridal party," "detail," or "rehearsal," which will help you search for images later. Renaming the files themselves will also help your filing system be more intuitive; you will be able to work more quickly when your shots are called Recept_DadToast_3 and Prep_Groom_14 rather than IMG_8932 and IMG_6771. The naming convention itself is not especially important; however, consistency within the convention you pick is. It will make things much easier if you pick one system and stick to it. Additionally, any metadata and keyword information you add will help you move around your shots; you will be able to search by more than just the image title.

## Metadata Basics

*Metadata* is data about data. If pixels are data that compose the image, the metadata (data about the data) describes the conditions surrounding the pixels themselves, such as the type, size, resolution, and exposure variables of the image. (See Figure 9.1.)

Despite its utility and straightforward purpose, metadata can be quite daunting to amateur photographers, as the standards around metadata range from complicated to nonexistent. We'll focus on the relevant and helpful parts of this exhaustive topic.

Using metadata is a great way to become a better shooter. With metadata, you can assess which settings work under what conditions, when your ISO starts to produce noise in low light, whether you should use a flash or bounce light, and more. Your metadata is a handy way to get the details about a shot; combined with your own critical eye, you can use this data to make decisions about how to shoot in the future. Look at your metadata as you reject shots to determine what *doesn't* work; look at your metadata as you keep shots to pinpoint what *does* work! You can also sort your images by certain pieces of metadata such as the date photos were taken and file size.

**Figure 9.1**

Looking at a shot's metadata will tell you all the exposure variables you chose or, in the case of automatic mode, the exposure variables your camera chose for you.

## Metadata Basics (continued)

Within your metadata, you have an option to add *keywords*, which are a type of additional information related to the content of the image itself. This feature is extremely useful if you are managing a large collection and want to be able to search by image subject matter—for example, if you need an additional shot of the cake or you want to find all the pictures that feature Granny. Keywords in wedding shooting might include the event (ceremony, reception, prep), the type of shot (detail, portrait, establishing), or the people involved (bridal party, couple, parents). There is no correct way to develop your keyword scheme, but keywords are valuable only if you are consistent and thorough in your tagging. If you decide to use keywords, spend some time planning your method. (See Figure 9.2.)

**Figure 9.2**

A consistent keyword system, with categories and subcategories, will make your images much easier to find later on.

# Make Selections

Sometimes, you will only have one usable shot in a category—and it will require some editing. Often, however, you will have dozens of good pictures of the same thing, and you will be forced to choose. After all, the bride doesn't actually need 16 pictures of her shoes, even if they are all perfect shots. This is called making *picks* or *selects*—choosing the best of the best.

**Note**

When I am at this level of decision-making, I often don't delete but simply promote the ones I'll keep to a new folder. If you prefer a more cut-down, minimalist approach, delete the ones that don't make the cut (but make sure you have them in a backup library first).

The difficult decisions that I said you *didn't* have to do when you were culling? Now you have to make them. Here are some things to look for when you are deciding between usable images. While some images are correctable with image editing, ideally you'll use as many images as you can that require as little processing as possible.

- **Framing.** Look around the subject to see what's around it. Does the framing push your eye to the subject or away from it? Is there accidental clutter in the frame? Is the subject well-positioned?

- **Contrast.** The *contrast* of an image refers to the amount of light as opposed to the amount of dark—whites versus blacks. Images with high contrast, or lots of range, tend to be more visually compelling than the midtones of a less-contrasted image.

- **Softness.** Look carefully to see which parts of your image are in full, sharp focus and which parts are softer. Although soft focus is very useful, it should be applied with intention. Also, you want to make sure the images you use are crisp and focused in the right places. (See Figure 9.3.) Make sure to do comparisons at a full- or almost full-size level. You might not be able to tell whether something is out of focus if you are looking at a smaller view.

- **Flattering to subjects.** Make sure your subjects look good in all the pictures that make the final cut. It sounds obvious, but sometimes photographers get so wrapped up in the lighting and contrast and such, they forget that what a bride is often *actually* worried about: herself. Ask yourself, is the shot at a flattering angle to her features? Is her hair smooth? Is her expression pleasant? Does the photograph accidentally highlight figure flaws or blemishes? Brides are notoriously self-conscious; humor them and help them out with your decisions.

- **Nuances of expression.** When you are shooting in burst mode, or shooting formal pictures, you might have a lot of shots of the same setup with slightly different expressions on the subjects' faces. Those subtle differences can change the feel of the image; look at the eyes and smiles of all your subjects to help pick between shots.

**Figure 9.3** These two images were shot in burst mode. As thumbnails, they look similar and passable. On closer inspection, though, it is clear that the bride isn't in proper focus in the first image, but is much crisper in the second one. Furthermore, the framing in the first image highlights the negative space between the two subjects, whereas their subtle movement toward each other makes the framing in the second image much warmer and pleasing to look at.

## Edit and Adjust

Once you have your basic collection of images, you might want to make some changes to them. The rest of this chapter is devoted to some of the ways you can clean up and improve your final shots—if they need it, or if you envision it. This can range from simple adjustments like cropping and adding contrast to more complicated *compositing*, or using multiple stacked layers of an image to create one complete image.

Although you have a wealth of tools available to correct images, because of the time and technical skills involved, you will want to minimize this step if your bridal couple is expecting images back quickly. If you are in a rush, make sure to look for images that don't require too much editing. If, on the other hand, you love this process, there is almost no limit to what you can do to play with the look of your work. Additional resources for advanced photo editing are included at the end of the chapter.

## Output

Files on your computer aren't much good to anyone. Chapter 11, "Outputting," discusses different ways to output your images so they can be viewed and appreciated by the wedding couple and their guests. Output methods might include posting digital collections on the Internet or burning them a DVD, generating a set of prints, or putting together an album.

The steps in your personal workflow might vary a little. For example, you might output a big collection of images to the couple before the selects have been made in order to solicit their opinion. Then come back to the selection, editing, and output (again) steps with a more refined set of images. Whatever your workflow is, make sure it is defined in your own mind before you begin. Otherwise, you might get lost in the details of the project without an eye for the overall scheme. The big picture is indispensable for getting a complete wedding photo shoot out the door!

### Workflow for RAW Shooters

As discussed in Chapter 2, "Understanding Your Camera Options," there are some advantages to shooting RAW images over shooting JPEG images. Most of these advantages relate to the flexibility you have with image adjustments, as you have so much more pixel data to work with. If you are working in RAW, however, it will slightly change your workflow.

Importing your RAW images will be the same as importing JPEGs: A card reader or cable attached to your camera will enable you to bring your images directly into your image editor (or into your operating system for later import into an image editor). Making your initial selects is a bit harder, however, because all your files will look a bit

## Workflow for RAW Shooters (continued)

dull compared to the JPEG-processed versions. If you shot RAW plus JPEG, obviously this is a non-issue. If you only shot RAW, however, your camera will have a thumbnail JPEG image that you can use to help you make initial selects.

Often, your camera will come with bundled software that enables you to view, edit, and convert your RAW files. If you are using a camera that shoots a RAW format incompatible with your image editor, this might be your only option.

With your initial selections made, you can bring the files into your image editor. The RAW image editor in Aperture, Lightroom, and iPhoto is straightforward; these applications treat RAW files like JPEGs, enabling you to get straight to work with post processing. Photoshop uses a free bundled plug-in called Camera RAW, which lets you process RAW images in the Photoshop environment. For output, you will want to save the images as TIFFs or JPEGs.

The basic strategy for adjusting RAW images is similar to that of JPEG images: Straighten and crop, adjust for exposure and colors, and change details. However, with RAW images, there are a number of techniques and adjustments that will enable you to get the most out of the pixel data you collect—working more closely with shadows, highlights, and brightness of the image. If you are working in RAW, I encourage you to learn about specialized techniques to help you maximize these options, which are beyond of the scope of this book.

# Image Adjustment

There are a number of ways to adjust an image to make it more pleasing—many of which correct for things that didn't happen in shooting, such as framing or exposure. In this section, I will use Adobe Photoshop to make image changes, but there are a number of applications you could use to accomplish the same tasks with varying degrees of control. As mentioned, some image editors are also image-storage and image-management systems; Photoshop is not, although Adobe Bridge, a bundled application in the Creative Suite, is.

It is important to understand that some image editors are *non-destructive*. (More on that in the following sidebar.) If you are working in a regular image editor, be sure to duplicate the image in your working library (not just the backup library) before you begin so you can easily compare the originals with the edited versions—or more importantly, revert to the original. You can duplicate a whole folder of images or simply duplicate any given image before you start post-processing it. If you are working in a non-destructive application, that step isn't necessary.

## Non-Destructive Image Editors

A photo image is a collection of pixel data. When you adjust an image, you are by definition changing that pixel data. Most image editors, including Photoshop, record the changes you make and the image is altered accordingly. In a *non-destructive* editor, however, the original image is kept as it was brought in from the camera. The alterations you make to the pixel data are recorded as a list of instructions, which the software processes in real time to adjust your images. However, the original pixel data isn't altered; it is used as a reference for the changes and left intact. The advantage of a non-destructive editing application is the ease with which you can go back a few steps to a previous look as you are making changes. Adobe's Lightroom and Apple's Aperture are non-destructive editors; Photoshop is not.

I will not go into great length about all the image-editing techniques possible with Photoshop—or any other application, as that would be a book (several books, in fact!) in itself. This section is intended to give you some basic vocabulary and ideas for the ways you can enhance your images, which are certainly adequate to complete a wedding shoot. If you are interested in additional techniques and ways to advance your skills, further resources for image-editing tutorials are listed near the end of this chapter.

# Cropping

What if you caught a perfect romantic gesture, but you also captured the bride's new mother-in-law's awkward expression? Or you simply captured too much sky, which dwarfed your subject? Or maybe you overexposed one side of the image? Bad framing is one of the most common mistakes—and one of the easiest to correct. You might choose to crop even without a "mistake," so to speak; creatively reproportioning your image can make it look more interesting. Sometimes, a little cropping is all the editing you need to do.

Most cropping tools are extremely easy to use. You simply nudge and adjust the crop boundaries until the image looks right. If you accept the crop and it isn't right, simply undo it and try again. You can perform a *free-form crop*, or you can constrain your crop tool to a certain aspect ratio, or the relative sizes of the width and height of an image. Free-form crops are really fun and can accentuate the shape of the church, the length of a table, or a wide panoramic view of the scene. Be careful, though, if your output requires certain formats. For example, if you are making an album with precut mattes, you might need to stay within standard crop sizes, such as 4×6, 5×7, or 8×10 inches. (See Figure 9.4.)

If you need to straighten your image, a combination of rotating (so your image is straight), enlarging (to get rid of the blank space created by the rotation), and cropping will do the trick.

**Figure 9.4**  By taking the car out of the bottom of the image and cropping so the three church doorways fill the image frame, the free-form cropped image on the bottom is much more compelling than the original image on the top.

# Tone

*Tone* is the amount of brightness in a pixel. Digital tones range from 0 (pure black) to 255 (pure white). *Tonal range* is another term for contrast: the range between black and white tones in an image, and the grays in between. Like cropping, tonal adjustment can make a huge difference with a little bit of effort. By darkening blacks and brightening whites, dull and flat images get new life. The contrast makes them more exciting; more detail makes them livelier on the page. Colors have tones, so correcting the tones will affect your colors.

There are lots of different tools for adjusting tone. The most obvious is an *auto tone*, offered by many image editors. This analyzes the image, darkens the black, and brightens the whites of your image. Although this is more crude than some of the other tools, it might be the exact fix you need to add a little pep to your shot—without adding a lot of time to your process. By auto-adjusting contrast, you can change the tonal range, which will appear similar in some images and different in others.

A *levels slider* is a more nuanced way of performing tonal adjustments. Most image editors have a level slider. To use a level slider, you must understand histograms. A *histogram* is a graphical representation of the dark tones, midtones, and highlights (blacks, mids, and whites) in your image. The X axis of the graph represents tonal value and the Y axis represents the concentration of that value. If your histogram is skewed to the left, your image will be very dark; a histogram that is skewed to the right means the image will have lots of highlights and whites. If you have lots of values in the middle, but not on the sides, your image will lack range, or contrast. (See Figure 9.5.)

**Figure 9.5**

The image represented by this histogram has decent contrast but is missing some range on the right. There are more dark tones than white, as shown by the histogram distribution.

A feature of some nicer cameras is the ability to look at the histogram of your image on the camera's LCD screen; that way, you can adjust exposure while shooting. You can't adjust the histogram there, only the exposure of the image, which will in turn change the histogram. In post production, you can get right to work on the histogram, no matter what camera it was shot on.

Underneath the histogram are input sliders, which indicate where 100% black, 100% white, and the *gamma point*, or midpoint of the tonal range, lie. Flat, hazy images might not reach the maximum point for white or black, which is why they are flat. (See Figure 9.6.) By dragging the slider, you can tell the lightest point of the image to be 100% white (the value will be 0) and the darkest part of the image to be 100% black (the value will be 255); the rest of the levels will adjust accordingly while maintaining their basic shape. You can also adjust the gamma, which will change the midtones to be more dark or more light. (See Figure 9.7.) When you reopen the adjusted image, the new histogram will have image data across the whole range, as you have reset the scale. (See Figure 9.8.)

**Figure 9.6** The histogram on the bottom reflects the unfortunate truth of the photograph on right: The contrast is dull, and neither the whites nor the blacks have enough maximum value to make a well-contrasted image.

**Figure 9.7**

By resetting the maximum and minimum whites, as shown on the histogram, you add contrast to a flat image.

**Figure 9.8**

The new histogram for the image will have data spread over the whole X axis, but notice the basic shape of the histogram remains constant.

The advantage of using a slider over an auto-correct function is that you can adjust different parts of the image individually. You can brighten the whites while leaving the blacks intact, and vice versa. You also have precise control over how much to adjust.

Note that when you change the black-to-white scale, you lose a little image data. Consider it this way: By spreading the values over a wider range of tones than they naturally appear, they become thinner, so to speak. Fortunately, most images will give you plenty of room for this kind of adjustment before they look grainy. Keep in mind, however, that adjusting in post production will generally cause some data loss, so multiple operations can have unintended results: grain, noise, and artifacts. Getting it right in the camera will save all your pixel data!

## Color Adjustments

Like contrast, you will ideally get color right when you are shooting. It is pretty typical for it to be off, though, considering the number of settings you will be using—and how quickly you will change them—over the course of a busy wedding day. Also, like contrast, many applications will give you a default setting to correct for color before you get too deep into the nitty-gritty of it. While it's important to know how to adjust color with precision for the images that require it, I encourage testing the default settings first. If they work for your shot, it can be a real time saver!

Correcting for color is not unlike setting the white balance as you shoot. If you determine the reference white (and the reference black), the rest of the color spectrum will fall in naturally around it. In Photoshop, the adjustments are done within the levels slider; other applications might call it *color correction* or *white-balance selection.*

Color adjustments are done with the three droppers on the right side of the Levels dialog box. The dropper on the right is your white-point dropper. Select it and then click a pixel in the image that should be white; that value will become "true" white (the value will be 0), and the other colors will adjust accordingly. The dropper on the left will set your black point. Use the dropper in the middle to correct your midtones by clicking something that should be middle gray, or neutral. Often, you will only need to adjust one or two of the droppers. (See Figure 9.9.)

It is crucial that you choose exact pixels when you are selecting your colors with the dropper. You can't pick an area that is white (like a wedding dress); you must look for the exact point that is fully white. If you pick a part of the dress that actually has some shadow or detail on it, you will either blow out the entire image or set an incorrect reference white. When picking colors at this level of precision, make sure to scale your image way up so you can see individual pixels.

## Figure 9.9

By using the droppers on the levels slider to reset white and black points, the cathedral loses its slightly greenish overtone, shown in the first image, and looks much more balanced.

# Image Effects

Image effects can be added to change the feel of your shots. Some pros eschew effects, aiming for a more natural look; other pros depend on effects to create a certain look that can't be otherwise achieved. Regardless of philosophy, effects are fun—and can be helpful in making an image more compelling or enhancing the mood of a particular shot. Playing with effects will also help you notice subtle changes in your images, which will improve your eye as a photographer and image editor.

Skilled image editors use tools and *compositing* to affect parts of an image. Image editing tools such as croppers, cloning stamps, selection wands, and paint brushes enable you to choose and make changes to certain pixel data in your image—for example, to remove blemishes, add softness, adjust light or colors, and eliminate or replace portions of a picture. Some tools, such as tools for auto-adjusting or red-eye removal, are extremely straightforward and require the simple click of a button. Others are more complicated, requiring a number of layers and steps.

More complicated compositing techniques are usually based on the notion that images are composed of a stack of layers, and the image on the top layer of a stack is the one that will show. For example, if you have text on top of a picture, the text will show, but if the image is over the text, the text will not show.

With a set of stacked or composited images, lowering the opacity of the top-level layer or removing part of it will allow the image underneath it to show. Why would you do that? Imagine creating a duplicate of a color image and putting the duplicate on top of the original. Now imagine converting the original (bottom) image to a black-and-white image. If the bottom image is black and white, the top image is color, and both images are at full opacity, all you would see would be the color image. (See Figure 9.10.) But if you were to swap the order of the layers, putting the black-and-white image on the top, then all you would see would be the black-and-white image. (See Figure 9.11.) If the top image were at half opacity, you would see some of the color from the bottom image

**Figure 9.10**
With two duplicated layers on top of each other, only the top layer shows.

peeking through. (See Figure 9.12.) By using another layer to mask, or block, parts of an image from view, you can manipulate portions of an image while leaving the rest intact. (See Figure 9.13.)

**Figure 9.11**
Switching the positions of the first and second layers will display only the black-and-white top layer.

**Figure 9.12**
If you bring the top layer to 50% opacity, some color from the bottom layer peeks out from under the black-and-white top layer.

**Figure 9.13**
Adding a mask to the top layer enables you to remove part of it completely, showing more of the color from the bottom layer.

Different image-editing programs offer different effects; advanced editors will offer numerous ways to accomplish the same end. In the following sections, I have listed some common editorial techniques that wedding photographers use.

# Black and White

Black-and-white imagery packs a lot of emotion, and offers a sense of timelessness. Bridal portraits and detail shots are usually good candidates for black and white, but shots from any part of the day might benefit from a black-and-white effect.

All images have color data. Every color has an associated number that reflects the *saturation*—or amount—of that color. If you bring the saturation of all the colors to zero, you will have a black and white image. However, there are more nuanced ways of removing color that enable you remove saturation at different levels for different colors. This can increase contrast and change the look of an image.

A robust program such as Photoshop will offer dozens of ways to make an image black and white—and with plug-ins, you have even more options. It is worth experimenting with your application to see the different black-and-white looks you can achieve.

Here are a few of the simpler and more common options to make an image black and white:

- **Grayscale.** *Grayscale* simply removes the color information from the image. It is easy to use, but doesn't offer any control. (See Figure 9.14.)

- **Hue/Saturation tools.** Dragging the Hue and Saturation sliders all the way to the left effectively removes all color information from the image—which is the same as the grayscale method. However, the sliders offer additional control—and the ability to leave selected color data in the shot—which can be a fun way to highlight parts of an image. (See Figure 9.15.)

- **Channel mixing.** Photoshop's Channel Mixer, shown in Figure 9.16, gives even more control over the black-and-white process. By selecting the Monochrome check box, you can remove color data from the image. You can also decide at what percent to remove data from each color. The general rule is that the sum of your colors should equal 100 percent; however, experimentation with a given image will show you what combination you like best—and it might be a little more or less than 100 percent. If the tool feels overwhelming, try some of the preset options. Figure 9.17 shows the same image as Figures 9.14 and 9.15, with a custom channel mix.

**Figure 9.14** A grayscale image.

**Figure 9.15** In this version of the image, the Hue and Saturation sliders were adjusted so that all of the color—save a bit of green—was removed.

**Figure 9.16** The Channel Mixer.

**Figure 9.17** Here, a custom configuration of the channel mix was made.

## Vignette

A *vignette* is an effect that darkens the outside of an image in order to highlight the interior, or subject, of an image. It has a soft and romantic feel, and is therefore common in wedding photography. As with black-and-white effects, there are a number of ways to create a vignette, as well as dozens of plug-ins that offer preset and customizable vignettes. Figure 9.18 shows a vignetted image alongside the original version.

**Figure 9.18** Sometimes subtle and sometimes dramatic, a vignette can highlight your subject by darkening the area around it.

In Photoshop, an easy and customizable way to vignette an image is to use the Lens Correction filter. In the filter's Custom tab, you will see Vignette settings, including an Amount slider and a Midpoint slider. (See Figure 9.19.) The Amount setting establishes how light or dark you make the vignette; the Midpoint setting indicates how much area of the photograph is vignetted.

**Figure 9.19**
The Lens Correction filter in Photoshop makes vignetting easy; almost every application will have a similar function.

## Soft Focus

Soft-focus filters are popular in wedding photography because of the romantic feel they give and the way they tend to flatter the subject. (See Figure 9.20.) Not surprisingly, there are lots of ways to blur an image. We'll look at one method that uses *compositing*, or multiple layers of an image, to accomplish the task.

First duplicate your image so you have two layers of the same thing: the crisp original below and the image that will be blurred on top. Then add a blur filter to the top image. (See Figure 9.21.) There is an awful lot of customization available here: different types of blur, as well as different amounts. Only experimentation can dictate what to use, but I recommend starting with a Gaussian Blur. Once you have applied the blur, bring the opacity of the top layer down so that the crisp layer underneath can peek through. Again, the amount of opacity needed to create a pleasing image is found through trial and error, but start with about 60 percent opacity and move up and down from there.

**Figure 9.20** Using a soft-focus filter can give an image a romantic feel and flatter the subject.

**Figure 9.21**

To soften an image, duplicate it, add a Gaussian blur, and lower the opacity of the top, blurred layer. This simple two-layer compositing offers a lot of customization enabling you to achieve lots of different looks.

If you are working on a very close-up image, a soft blur can be very flattering to the skin, but you might not want the eyes to be blurred, as they are in Figure 9.20. Similarly, in a wider shot, you might want most of the subject to be blurred but not the face. In either case, you can add a layer mask to the top, blurred layer. A *layer mask* enables you to remove part of the image on the layer while keeping the rest intact—here, erasing a piece of the blurred layer to reveal the crisp image underneath. To use a layer mask, make sure black is your foreground color, select a brush tool (with soft edges), and paint directly on the blurred layer to remove those portions. (See Figure 9.22.)

**Figure 9.22**

By removing a portion of the blurred layer using an image mask, you get a crisp view of the bride's face while the rest of the image stays soft.

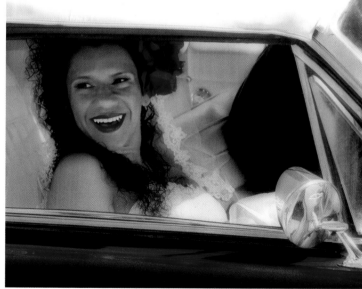

# Subject Corrections

As well as changing the overall look of your image, you might want to tweak small parts of it—especially to flatter your subjects. As with other adjustments, you can get incredibly refined and technical in your process, but here are some common ways that wedding images might be easily and quickly retouched. The names of tools will differ in different applications, of course, but the concepts will remain the same.

## Red-Eye Reduction

*Red eye* occurs when the flash from a camera bounces off the subject's retina and back into the camera lens, creating a demonic look to what might otherwise be a great image. Most applications offer a red-eye reduction tool to fix this problem. Often, it is as simple as clicking a button for red-eye removal. In Photoshop, it is a tool called the *Red Eye tool*, which you use by selecting the tool and then clicking the red eye itself. The tool can be adjusted to change the amount of darkening and the size of the area (pupil) affected. (See Figure 9.23.) Usually, that will be enough; if it isn't, simple compositing will often do the trick. Put a duplicated, desaturated layer of the image under the main image; then, with a layer mask on the top full image, delete the pesky red eyes to let the desaturated ones show through.

## Retouching

Photoshop has a wonderful feature called the *Spot Healing tool* to help smooth over blemishes and wrinkles in your images. By selecting the tool and "painting" over any troubled areas, you can smooth over spots that might make the bride self-conscious. The tool works by sampling the pixels around the spot you are removing and using those tones and textures to replace the selected blemish. Keep in mind that you can't approximate here; you need to select the pixels you are adjusting carefully. Be sure to enlarge your image so you can see it in great detail.

## Stray Hairs

In Photoshop, stray hairs can be removed from an image in a similar fashion to retouching. Instead of a Spot Healing tool, however, a *Healing Brush* is more effective. Rather than automatically defining the correction, like the Spot Healing tool does, the Healing Brush has you define the pixels you will use to cover the stray hairs—helpful when the background varies greatly from the hair you are covering. Using the *Clone tool* is another common way to eliminate stray hairs, by covering them with pixels similar (or cloned) to the background.

**Figure 9.23** More often than not, the preset red-eye reduction tool in your image editor will be enough to correct the red eye in all your images. In this case, three of the four wedding guests were good candidates for Photoshop's Red-Eye Removal tool; the second guest from the right needed a little compositing to show off her baby blues. (Image courtesy of Mary Tunnell.)

# Additional Resources

This chapter is not intended to be the definitive guide in image retouching, but instead to provide you with ideas and basic skills to improve your pictures. It is the initial changes that will make the most difference, so it is unlikely you will need to take your image editing too much further. However, in the event that you need or want to learn more about image editing—especially as it pertains to your image editor—here are some good resources:

■ www.completedigitalphotography.com

■ www.lynda.com

- www.adobe.com/designcenter.html
- www.apple.com/aperture/how-to/
- www.apple.com/findouthow/photos/

# Next Up

Well done! You have a set of images to show off, and you have very nearly completed your first wedding photo gig! If you also shot video of the wedding, you will want to take a look at Chapter 10, "Video Editing," which teaches workflow and basic editing for your video piece. If you only shot still photos, go right to Chapter 11 to learn how to best present the images to the bridal couple.

# DIY Idea: Plug It In!

Plug-ins are small applications that work within a larger software framework to accomplish a specific task. Plug-in developers (often separate entities from the larger software developer) make small, cool tools to increase the power of a program. Examples of plug-ins would be tools that add specific effects, such as looks to age an photo, retouch a subject, or colorize an image. Photoshop was a pioneer of the plug-in concept. By allowing smaller software companies to develop tools that work within the Adobe Photoshop framework, the Photoshop application gets additional user functionality that Adobe didn't have to work to produce.

There are literally thousands of plug-in effects that you can either download free or purchase that will provide fun filters and effects for your footage. I could not begin to describe them all here, but I will recommend—highly—that you Google around and take a look at a few. Simply Googling "Photoshop wedding plug-ins" will give you lots of options to look at, with demos provided. They are fun, and can add styles and twists to your work that would either be otherwise unachievable or would take days or weeks to complete.

Be careful, though. Some plug-ins scream, "I'm a loud, cheesy plug-in designed to cover up a bad shot!" But there are lots out there that will subtly highlight and accentuate the look you are building—for example, a retro or blown-out look. Some plug-ins will affect your images in ways you already know how to achieve—for example, blurring or vignetting—but with less work and experimentation on your end. (See Figure 9.24.)

> **Note**
>
> Many plug-ins have free trial demos; take advantage of that as you try out different looks. And watch out, hours might go by as you play and experiment. It's really fun!

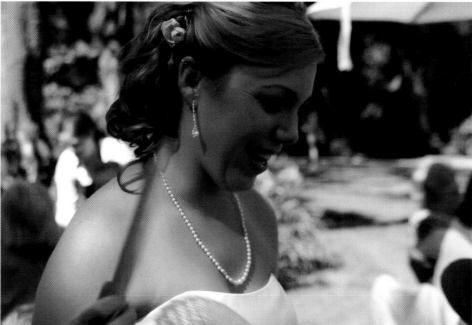

**Figure 9.24** Using a third-party plug-in, Portraiture by Imagenomic, on a default setting, I smoothed out the bride's skin tone from the original picture. I love the look, ease of use, and available customization of this plug-in. There are lots out there, though, so do some research!

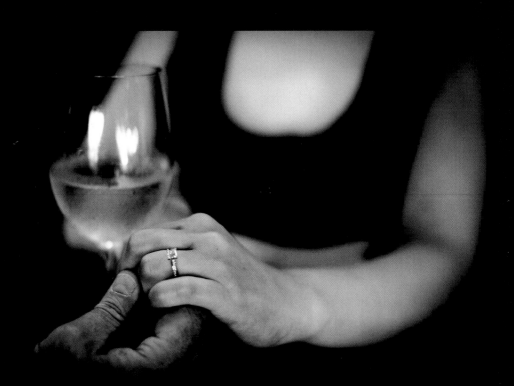

Image courtesy of Myleen Hollero (www.myleenhollero.com).

**In this Chapter:**

- Workflow

- Basic editing

- Advanced editing

Congratulations! You've finished shooting. Now it's time to assess what you have in your footage with which to make a finished piece. Your editing process might be as simple as choosing full clips to deliver to your couple straight from the camera, or as complex as piecing together a movie from the day, complete with voiceover, additional song tracks, and graphics. Unlike the hectic shooting, editing can be done at your own pace; I love the relative peacefulness of reviewing and cutting video. It can be quite overwhelming to start, though, because even if you are only shooting with one camera, you could easily end the day with three or four hours of footage—or more.

## Workflow

Diving into the video-editing process can be a bit overwhelming. In addition to having to go through lots of raw material, you might have different video formats to contend with and no clear ideas for the flow of the *sequence*, or edited video. Defining your workflow, breaking the process down into steps, will help when the task feels unmanageably large, as it often does to new editors. No single step is terribly daunting; if you consider your workflow in individual pieces, you can get the job done easily. Keeping your eye on the sequence of tasks will prevent you from getting swamped in the many

details associated with the job. Any given workflow will be a bit different due to the hardware, software, and style of the editor, but the basic idea will remain constant. Let's take a look at the basic workflow steps.

# Import Footage

Bringing all your clips onto the computer is the first step of your workflow. Before you can edit your footage, you need to get that footage from the camera onto your computer's hard drive. This is usually a relatively simple operation. In some applications, such as iPhoto, the computer will automatically detect your plugged-in camera and ask which files you want to import. Some applications, such as Final Cut Pro and Adobe Premiere Pro, have you open a capture utility to import or capture the video from the camera and bring it onto the hard drive.

After plugging in your camera or a card reader, you can bring your clips onto your hard drive, or directly into a nonlinear editing program such as Final Cut Pro, iMovie, Windows Live Movie Maker, or Adobe Premiere Pro. A nonlinear editing application is a program designed to look at and edit video footage non-destructively. When changes are made to the source footage during editing (such as a cut or an effect or a volume boost), the source footage remains intact, and a list of editorial changes are added on top of it and rendered (processed) to show the video in a new and altered way. Like the non-destructive photo editors described in Chapter 9, this means that the source footage is always intact, and you can start a new edit any time you want.

You don't need a nonlinear editing application to simply review your media; you can look at video clips in a viewing application such as QuickTime, Windows Media Player, or software that comes bundled with your video camera. Some of these applications will let you make basic editorial changes and all of them will allow you to watch your clips to decide which ones are keepers. If you aren't engaging in a long editing process and merely want good clips right out of the camera, this could be enough. You can watch clips in a viewer and then take them into a more robust nonlinear editor later on, too. By allowing the user to randomly access any part of the footage, both nonlinear editors and media viewers can display any single frame of footage as easily as any other, without having to rewind or fast forward to get to it.

Most nonlinear editors, will accept a wide variety of footage formats, although in a few cases, you will have to *transcode* your footage, or convert it from one format to another. In this book, I use Adobe Premiere Pro 5.5 as my video editor because it is available for Windows and Mac, it accepts nearly every video format, and it is available as a free trial download on the Adobe website. Keep in mind, however, that the basic concepts of nonlinear editing will be similar regardless of the application you are using.

Video files will vary in size depending on the format in which you shot and the length of the clips. They can get quite large when you are talking about full HD video and long wedding ceremonies! Make sure you have enough storage space available on your computer for the amount of footage you shot; and enough space on an external drive to duplicate your media for the purpose of backup. Table 10.1 is an approximate guide for storage space that you will need for common video formats, indicating how many gigabytes of storage you need per hour of video (GB/hour) and how many hours of video you can store on a terabyte of hard drive storage (hours/TB). If you know how many hours of footage you have and what format it is in, you can figure out how much hard drive space you will need. If you have to transcode footage, these numbers might have to be recalculated!

| Table 10.1  Hard Drive Storage Requirements for Video | | |
|---|---|---|
| **Format** | **GB/Hour** | **Hours/TB** |
| DV (standard definition) | 13 | 75 |
| HDV 720p | 11 | 90 |
| HDV 1080i | 13 | 75 |
| DVCPro HD | 60 | 17 |
| Uncompressed HD, 720p, 10-bit | 497 | 2 |
| Uncompressed HD 1080i, 10-bit | 558 | 1.8 |

AVCHD is another popular compression format for consumer cameras. It is an extremely high-quality compression that makes very small video files—meaning you can fit a lot of footage on your camera and your computer. Be wary, though; not all editing systems accept AVCHD files—and if you have to transcode them, you will find they expand extremely quickly.

Before you start the next step of the edit process, back up all of your video files and store them on a separate drive from the one you are working from. That will ensure you don't lose your original footage in the event of a drive failure.

# Log and Organize: A Review

After all my video is on my hard drive and I can view it in my editing application, I perform an initial screening of all the clips. During this phase, I *log* the useable clips, or make notes about them. I'll track what the content contains, whether the footage is good, and where I might use the clip in my piece. Most nonlinear editing applications enable you to log your clips within the program. You can also use external logging

applications that store your logging input as metadata when you bring your clips into an editor. Although lacking some of the convenience of logging onto a software program, a pencil and paper have the same functionality—jotting a few notes to yourself might be sufficient logging for smaller projects!

As I log footage, I do two other tasks simultaneously: I delete clips I can't use, and I organize the ones I want to keep. This initial pass is not a fine-toothed comb exercise; I only toss the truly unusable footage, like when the camera was accidentally left on while I walked across the room. I keep clips where the audio is good but the video isn't, and vice versa, because I can use one without the other. I also keep shots that are boring or not especially well set up because the couple might value the footage for other reasons, such as shots of a particular guest or moment. Most editing applications enable you to note when a clip is "good," which is a handy feature when you are keeping lots of mediocre footage in the mix.

As I go through the footage, I put video clips in *bins*, which helps me organize my material for editing. Bin structure looks just like file structure on your computer—a series of folders that hold your footage (also music, graphics, and still images). How you organize your bins is as personal as how you organize your closet; however, it's helpful to design a system that reflects the structure of your project. For example, if your piece will be edited chronologically, it would make sense to number your bins and label them according to the portion of the day. Or, if you were doing a "he said, she said" piece that switches back and forth from the bride's and the groom's point of view, it would help to divide your footage between "his" and "hers." (See Figure 10.1.)

## Build a Rough Cut

A *rough cut* in video editing is akin to a rough draft in writing: It is an assemblage of bits and pieces that creates a story. If your raw footage is the slab of stone and your finished piece is a glossy sculpture, your rough cut sits partway between the two: a distinct and recognizable shape that still needs some shaping, polishing, and detailed attention.

A rough cut doesn't have an exact point of completion. Different editors consider different levels of refinement "rough." In fact, one editor's rough cut might be another's finished product. However, as will be further explained in the upcoming section, "Basic Editing: Turning Your Footage into a Sequence," I have defined a rough cut as the point in the process when you have taken all the pieces you will use from the raw footage and put them in your newly edited sequence, but you haven't yet trimmed, added effects, or otherwise refined them on the timeline, which is the next step in the workflow.

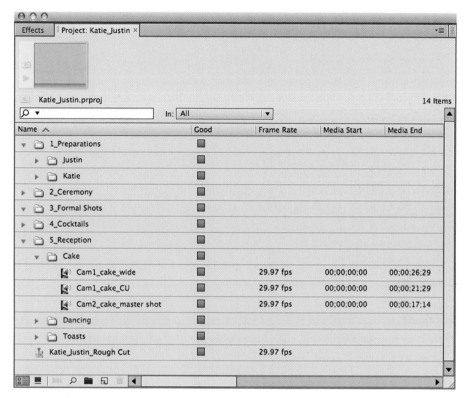

**Figure 10.1** Properly naming your media will make your process much easier, especially in long projects. Spend a little time devising a system that makes sense for your project. Considering your project in chunks or sections will help with that.

## Refine and Polish

Many editors (myself included!) find this part—the refining and polishing of the rough cut—to be the most fun part of the process. In my experience, it is the part of the workflow where time gets absolutely lost as I tweak, play, and experiment. Indeed, hours can go by before I look up from my work! As will be explained in the upcoming section, "Advanced Editing," it is the time to make more precise decisions about the sections of video you will use as well as adjust audio levels, add stylistic and corrective effects, and consider transitions between clips and scenes.

The refining part of the project can be addictive. Make sure to keep an eye on your entire workflow so that you can get the job out the door! It would be very easy to polish a bridal prep scene for days, while ignoring the rest of the video.

# Output

A finished video that sits on the hard drive of your computer won't do your bride and groom much good. The crucial last step of your process is to put your video into a format that can be easily viewed and shared by the couple, wedding guests, and friends and family who weren't at the wedding. Chapter 11, "Output and Sharing," discusses the ways in which you can showcase your video handiwork.

# Basic Editing: Turning Your Footage into a Sequence

At its most basic level, the editing process involves screening raw footage, making selections from it, and putting the selections into an edited sequence. Most applications have a similar interface, including a window to browse your video files, a window to screen raw footage, and a window for looking at your edited sequence. (See Figure 10.2.) The

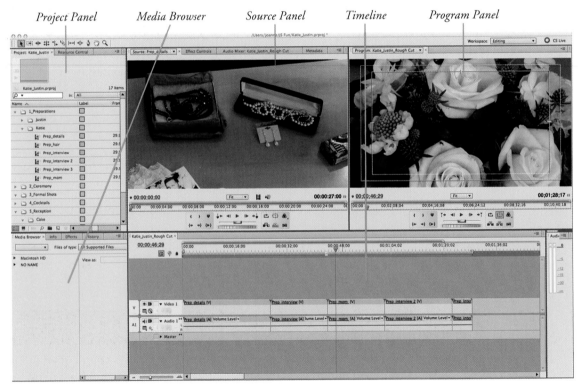

**Figure 10.2** Not every interface will have all the features of Adobe Premiere Pro, but this layout gives a clear representation of the editing process. Raw video files are retrievable from the Media browser (bottom left), organized in the Project panel (top left), and viewed in the Source panel (top middle). The edited piece being created is viewable in the Program panel (top right) and represented graphically on the timeline (bottom right).

edited sequence is also represented by a timeline, enabling you to see your piece being built graphically. Of course, not all interfaces are identical (iMovie lacks the graphical timeline, for example), and the vocabulary used is different (Adobe's Source window is Final Cut Pro's Viewer window, for example), but the overarching structure between applications remains constant: Look at a raw file, select some of it, and put it in a new sequence.

An integral concept of working in nonlinear editors is that when you are moving bits and pieces around the interface, you aren't moving the footage itself, but *pointers* to where the footage is actually stored on your hard drive. This is the nondestructive part: The pointers change but the footage does not. If you were moving actual footage, the applications would be clunky and slow because video files are so large. By working with pointers instead of the files, you can quickly rearrange chunks of video and see how your ideas look.

### Tip

Don't rename or move your files on your hard drive, or it will break the links you have established between the actual file and the pointers in your editing application.

## Making Selections

*Selections* are simply the bits of the footage that you want to use in your final piece. Selections are determined by an *in point* and an *out point*, which mark the first and last frames of your selected clip.

Once you have selected the exact footage you want to use, you can move it into your edited sequence. Your timeline will grow horizontally, reflecting the fact that the piece has gotten longer. Your editing application will have a number of ways to move a selection to your edited piece; typically, you can drag and drop from the source screen to the timeline or use a menu command or a keystroke.

### Tip

It is well worth spending the time learning the keystroke commands to navigate your footage quickly. Learn to use keystrokes to scroll through large sections of video quickly to find certain sections (like the joke near the end of the toast), and find out how to step through frames individually so you can find the best starting or ending frame.

# Inserting Versus Overwriting

The beauty of digital editing is that you can bring your selection to any point of your timeline—beginning, middle, or end. Where you put your selection will be determined by the location to which you drag it or the point you have selected on your timeline. If you are using menu commands or keystrokes, the clip will start at the point you have placed your *playhead*, or the *in point*.

If you want to add footage to the middle of a sequence (for example, if you found a shot of the flower girl that you missed), you have two options: *overwriting* and *inserting*. Overwriting the new selection on your timeline will cover up the old piece of footage, and the length of the entire sequence will stay the same. Inserting a new selection on your timeline will place the new footage between frames, and the entire sequence will get longer. (See Figure 10.3.)

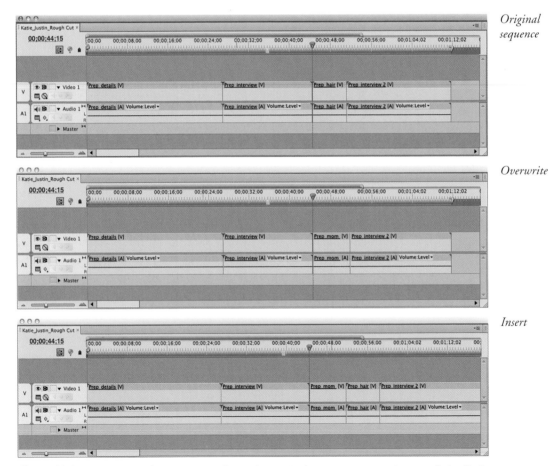

*Original sequence*

*Overwrite*

*Insert*

**Figure 10.3** Overwriting the prep_mom clip to the original sequence means the prep_hair clip is no longer visible and the sequence remains the same length. Inserting the prep_mom clip means the two clips after the inserted clip (prep_hair and prep_interview 2) move back to accommodate the new clip and the entire sequence becomes longer.

# Working with Multiple Tracks

On the timeline, your piece will grow horizontally as it gets longer. It can also grow vertically as you add, or *composite*, layers of video and audio. The level of complexity of your editing application will determine how many layers of audio and video you can have, but the concepts are the same whether you have two layers or 99 layers.

Audio is additive. As you add tracks, their sound combines, and you hear all of them. There are lots of times when you might want several audio tracks—for example, the natural audio of the scene, additional music, and the spoken voice of an interview clip might all be combined in one scene. When that is the case, you will want to adjust the volume of each track to create a mix that is balanced.

---

**Tip**

If you are using multiple layers of audio in your piece, designate tracks for each type of audio. For example, the first two tracks might be natural audio, the third and fourth tracks might be music, and the fifth and sixth tracks might be voiceover. This will help you stay organized, make global level changes, and preview certain tracks.

---

In contrast, video is not additive. It comes into your timeline at 100 percent opacity, so the top video layer on the stack will be the only one that shows in the output of your piece. If you lower the opacity of a video layer, the video track beneath it will show through, like a background layer.

There are a number of times you will bring in audio without video or video without audio. You might create a montage of preparation images that you cut to music instead of the natural audio or add natural audio (interviews, vows, ambient sound, etc.) to different images. Some applications will let you put only the video or audio from the source on the timeline. Otherwise, you can put the audio and video on the timeline together and delete whichever track you don't need (or lower the opacity or volume). (See Figure 10.4.)

Understanding basic ways in which your timeline expands—horizontally for length and vertically for complexity—is the cornerstone to editing. Once you know how to move clips from the raw footage to the sequence, the rest is bells and whistles.

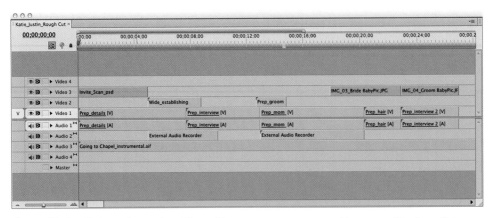

**Figure 10.4**  All the audio tracks will combine to create a master audio output. During editing, you can turn tracks on and off to listen closely to any one of them. When video is at full opacity, only the top track on the timeline will be visible in the final project.

## Adding Photos

It is likely that you will have elements in your piece that aren't video. You might add musical tracks, still photos, or graphical elements. Editing applications will have slight variations in the file formats they accept. Fortunately, it is generally quite easy to get your elements to align with the specifications needed for your particular software, which will be listed in the help menu. (See Figure 10.5.)

**Figure 10.5**

As a DIY videographer, you have the ability to add images from various aspects of the couple's lives—which can make for a personal and funny video. These two shots of the couple as six years olds have been composited into a split screen image, which will transition to two images of the couple as adults.

When importing still photos, make sure you bring them in using the highest resolution possible so the image doesn't look grainy or pixilated when brought up to match your video size. If you have a full-resolution picture from a nice camera, that won't be a problem; just don't use a version that has been shrunk a bunch of times to be sent around via email.

## Including Titles

A title tool enables you to add names, dates, or any other words to your piece. The lettering can appear on a separate screen or right over the video. Often, there are templates available for rolling credits or crawling text. Titles are a great way to personalize your work. Here are some different types of titles you can use to dress up your piece:

- **Title card.** This is a title that is not animated. That is, it does not move on the screen.

- **Opening/closing credits.** These are a series of credits that start or finish a movie. In the case of a wedding, such credits might include the couple's names, the date of the event, the locations of the various parts of the wedding, the parents' names, the names of the bridal party, the videography company, other vendors, etc.

- **Title roll.** This is a series of credits that scroll from the bottom of the screen to the top. A title roll is usually used for opening and closing credits because it is an efficient way to pack in a lot of information. (See Figure 10.6.)

**Figure 10.6**
If your title tool offers a rolling option, it is an easy way to create some funny credits for the opening or closing of your piece. If your title tool doesn't offer that option, create a still graphic in Photoshop and animate it to move across the screen vertically to create the same effect.

- **Title crawl.** This is a line of titles that moves horizontally across the screen, usually at the bottom. A crawl is often a technique to describe or editorialize video content.

- **Superimposed**. This is a title that is placed, or superimposed, over other video or graphics.

- **Lower thirds.** These are titles that fit in the lower third of the frame, usually used to identify a speaker.

- **Pad.** This is a box or stripe behind a title to make it more visible and legible. (See Figure 10.7.)

**Figure 10.7** The titles in your piece are another chance to customize your piece. Adding commentary, humor, and pointing out particular details of the day will lend charm and fun—a distinct advantage to DIY over the more reserved professionals.

Here are some considerations for making your text as legible as possible:

- **Font.** Avoid fonts that are too delicate or too small. Although it depends on the font style, a good rule of thumb is to stay above a 20-point font.

---

**Tip**

Your font decisions should reflect the feel of your piece, whether that is romantic, comic, slick, or sweet. Consider matching the font of the wedding invitation and program for a consistent feel.

- **Color.** Use a color that shows up well, either on a black background or on top of video. Drop shadows can help text legibility immensely.

- **Superimposition.** When putting titles over video, be careful of especially busy video screens. If your frame is too cluttered or the action is moving quickly, the title will be hard to read.

- **Position.** Don't place your titles too close to the edge of the frame; it can make them hard to read. Especially if you will output to DVD, you want to stay away from the edge of the frame because your visual information could get lost to the *overscan area*—that is, the area on the edges of a video frame that might not be seen on all television screens. If your editing application has a toggle for action safe and title safe guidelines, make sure it is on while you are creating titles. (See Figure 10.8.)

If your title tool can't handle the graphics you are trying to build (not an uncommon problem), you might want to build your graphics in an external graphics program such as Photoshop, After Effects, or Motion, and import them into your piece. The image-adjustment tools available in dedicated graphics applications are far superior. The size

**Figure 10.8**
Steer clear of the overscan area.

of the image you create should be the same pixel dimensions as your video frame size; that way, you won't have any problems with sizing when you bring your images in. The *pixel aspect ratio* (the ratio of a pixel's width to its height) should be consistent between video and graphic files, too. Video prefers a square pixel aspect ratio, meaning that graphics with rectangular pixel aspect ratios are likely to be distorted. Check the settings of both your video and your graphics program to make sure that the frame size and the pixel aspect ratio are consistent between them. (See the resources listed at the end of this chapter for help with your specific editing application.)

---

**Tip**

Scanning the wedding invitation and importing the image as a still photo is a nice way to start the piece.

---

# Advanced Editing

Editing is a process of refinement, like a sculpture. Chipping away at the footage and paring it down to the best bits will deliver the final, master video. Editing is an ongoing process—arguably, it only ends when you decide it ends.

As mentioned earlier, your *rough cut* is an intermediate step; with a rough cut, all your footage is on the timeline, ready to be crafted, shaped, and pared down a bit more. Depending on how carefully you bring the footage to the timeline, a rough cut could be extremely blocky, with lots of spaces and unfinished sections, or it might be incrementally close to the final version. The general idea, however, is that your story has been culled from the raw footage and is ready for polishing. Your refinements from this point on tend to happen on the timeline.

## Syncing Footage

Multiple cameras covering the same footage can be set up so that each camera, or audio source, gets its own track in editing. This will enable you to choose which track to use at any given point by looking at all your available options. With video, the clip on top is the one you'll see. (See Figure 10.9.)

A common approach is to choose one audio track (whichever is best) and line up all video clips so that you can see what is happening on any camera at any particular moment. To line your clips up, you will need to sync them. You can manually find the frame on which they match by using camera flashes or audio cues, or you can use an external application such as Pluralize to do the syncing for you. Some more advanced

**Figure 10.9**

If your editing application offers a multi-camera editing tool, it is an easy way to see what each of your cameras show at any given point in time. In this case, I had one camera wide, one camera on the side, and one shooting close up on the ceremony site. Here, all three cameras are waiting for the processional to begin.

applications also offer a multi-camera editing tool, which enables you to easily move between different camera angles and simultaneously make cuts between them in your sequence.

> **Tip**
>
> If you plan to use multi-camera editing, it will be much easier if you leave all your cameras running throughout the shoot so that you only have to sync them once. This might mean capturing some footage you don't need, but you'll be grateful in editing!

## Trimming on the Timeline

Normally, *trim* means to make something shorter or smaller. In editing, *trim* means changing the length of a clip. Counterintuitively, trimming a clip might make it longer—for example, to complete an audio phrase, to get a longer view of a particular shot, or to have enough footage to add a transition (discussed momentarily). Shortening, or tightening shots, is an excellent way to make your piece move faster and feel cleaner and snappier. I recommend trimming each clip to exactly what you need and no more. (See Figure 10.10.) By cleaning each clip, your overall piece will have a more professional feel.

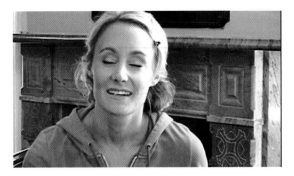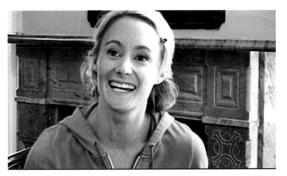

**Figure 10.10** Only a few frames apart, these two images will give a different feel when used to end the interview section of the video. Spending a little time making precise choices about frames is one way to add a cleaner and more professional look to your video.

There are various tools to trim on the timeline; if you spend a lot of time editing, I recommend learning them. Ripple and roll tools are examples of elegant features that condense trimming steps. However, less-refined methods (dragging the edges of your clips or using a razor tool to cut clips and delete pieces) will do the same job. The process of trimming is much more important than the methods you use.

Most applications will let you trim audio and video separately so you can extend the audio longer than the video on a given clip. This is called *softening a cut*; using audio in this manner is a nice way to lead the viewer into or out of a scene.

## Adding Transitions

A *transition* is a move from scene to scene or from clip to clip. You want to do both with some care so your piece flows smoothly. It is often said that the viewer never sees good editing; a viewer only sees bad editing. Transitions are a place where you can really tell the difference.

Scene-to-scene transitions are thematic and might be indicated by a pause, a music change, or a graphic. Transition effects (discussed momentarily) can help support the theme of your piece, as can the way you choose footage from one scene to the next. Establishing shots are helpful in scene transitions, to set the viewer up for a new location; interview footage can set the viewer up with the same type of contextual information. Jumping right to the action of a new scene without the establishing introduction can work in faster, slicker pieces.

A transition point is also where two different clips meet within a given scene. Like your scene-to-scene transitions, you will want to consider these points carefully as they fit in the general context of your overall piece.

Transitions should be carefully picked so that consecutive shots look good as one moves to the next. Here are things to be wary of in transitions:

- **Jump cuts.** *Jump cut* describes two shots of the same subject that vary only slightly in framing or camera position. Jumps cuts can be jarring to look at. Picture a word or sentence being edited out as someone talks; the resulting sequence is awkward and not believable as a continuous stream because the point where the two pieces meet is not smooth. Jump cuts are not always bad, however. They can also be used stylistically to create a fast-paced and cool feel. Like the rules of composition, use jump cuts with intention, not as a mistake.

- **Monotonous cuts.** If you constantly use shots that are similar—all close-up or all wide—the piece will be visually monotonous. Try to mix your cuts so that you change your shot type at each transition (or lots of them, anyway), incorporating wide, medium, and close shots as well as different angles.

- **Accidental spaces and frames.** Make sure you don't have spare frames between your cuts. A spare frame could be a blank space on your timeline (which is very hard to see if you are zoomed out) or a frame or two of footage left over from a different cut. Either one will create a messy transition and should be avoided. (See Figure 10.11.)

**Figure 10.11**

If you are looking at your timeline zoomed out (top), you won't see the single frames that might be missing. These are suddenly visible when you zoom in close (bottom). Get some practice manipulating the view of your timeline so you can catch the little bugs!

Your editing application is likely to come with a series of transition effects that you can add to edit points to smooth or highlight the change in footage. They are easy to apply and can give your project some extra sophistication. (See Figure 10.12.) Be careful with transitions, however. There is a tendency to go overboard that can lend itself to overdone and cheesy editorial. Deliberately campy styles can work well, but make sure your style is intentional, not accidental! Here are some common transitions used in wedding video:

- **Dissolve.** A *dissolve transition* fades out the opacity of the outgoing clip, while the opacity of the incoming clip fades in. For the duration of the transition, you will see both layers, as they are composited. This is a good transition to use for montages and to smooth jump cuts.

- **Fade to black.** A *fade to black* is exactly what it sounds like: The footage goes from full opacity to zero opacity and back up again. It is often used at the end of a sequence or between scenes, as it has a sense of finality to it. Used mid-scene, a fade to black can add drama.

- **Flash.** In a *flash transition*, the outgoing clip fades to a white screen and then back up to full opacity on the next clip. The transition will only be a few frames in length, mimicking a camera flash.

- **Zoom.** A *zoom transition* will briefly rescale your incoming clip so that it starts larger or smaller than full size and quickly scales to normal. Quick and quirky, a zoom lacks subtlety, but is rich in style and fun.

**Figure 10.12**
The style of your piece will dictate the transitions you might use. This campy 3D cube spin wouldn't work for a romantic piece, but it's perfect here, adding extra personality to the humorous interview that the parents of the groom gave me.

# Adding Effects

Most applications include effects, or *filters*, that you can apply to alter the look of your footage. Filters are applied to a single clip and affect every frame within the clip. Sometimes you will add a filter to a whole section—for example, to make an entire scene black and white. Advanced programs will enable you to customize some aspects of the effects by adjusting filter parameters and by compositing, or layering, filters. Learning your application's filter potential will help you to maximize the different looks and styles you can achieve in your video. Advanced use of effects would include applying *masks* or *mattes*, which block certain parts of an image from being affected by a filter, enabling you to selectively manipulate pieces of an image. In wedding videography, you might apply filters to correct footage or to add a certain look. Following are some examples of ways you would use both types of filters.

## Corrective Effects

Corrective filters include the following:

- **White balance.** If you forgot to set the white balance while you were shooting, a white-balance filter can be a handy way to make your footage match in color. A white-balance filter enables you to reset your reference white and rebuild the spectrum around it. There are also preset white-balance filters you can add to give your footage a different cast, such as tungsten or daylight. (See Figure 10.13.)

- **Contrast.** You can brighten flat and dull footage by boosting the contrast of the image, which effectively increases the dynamic range between the whites and blacks in the picture. On the other hand, decreasing contrast might be a way to find details in the darker tones that might have been lost due to overexposure.

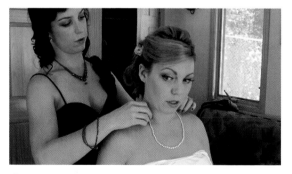

**Figure 10.13** Ideally, your white balance will be correct as you shoot. But there will undoubtedly be times when you will make some adjustments in post production. Quickly resetting the reference white in this shot gives a much warmer tone to the bride and her sister, and will also match later footage better.

## Stylistic Effects

Stylistic filters include the following:

- **Desaturate.** To *desaturate* an image is to take the color out of it, or make it black and white. This is a common filter for weddings, as black and white is considered timeless and is a good way to showcase emotion. I like to play with desaturation filters by applying them at less than 100 percent and by mixing them with sepia tones and other tints. (See Figure 10.14.)

- **Old film.** There are dozens of filters designed to make your footage look older by adding noise, grain, or dirt specks, or by saturating the color to look more like that generated by a Super 8 camera. Experimentation with these filters is a lot of fun; these filters also work well combined with speed changes, such as speeding up or slowing down your footage. For example, a dreamy, romantic sequence slowed down or a frantic preparation scene can both work well with old film effects. (See Figure 10.15.)

*Original*

*Black and white*

*Removing all the color except in the flower*

*60 percent desaturation*

**Figures 10.14** The original image has gorgeous bright color, which is removed entirely in the second, black-and-white image. A matte and some compositing enabled me to take the color out of all of the image except the flower in the third image; the same matte and compositing, plus a 60 percent desaturation (as opposed to 100 percent) left a little color in the background of the fourth image.

*Original*

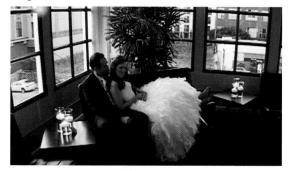

*Old Movie effect*

*Silent Movie effect*

*Brother effect*

**Figure 10.15** There are dozens of companies that make effect plug-ins for various editing applications. Showcased here are three filters by a company called Nattress: Old Movie, Silent Movie, and Brother.

- **Vignette.** A vignette in film or photography is an image that is darker around the edges and lighter in the center, highlighting the subject. (See Figure 10.16.)

- **Tint.** Tints can be used by themselves or in combination to give a color cast to a piece of footage.

The use of effects will help you determine your style as a film maker. Straightforward, journalistic wedding filmmakers use very few non-corrective effects. As genre, however, weddings tend to be very open to the use of the stylistic playfulness that effects encourage. I find they work especially well in places where there is less natural audio and the emphasis is on the imagery, such as montages of the bridal couple, scenes of the wedding reception venue before anyone is there, and detail shots of the bride and groom's preparations.

Much of wedding video is finding new and fun ways to showcase pretty images. After all, you know the plot of a wedding before the day even begins! Experimenting with effects is a fun way to show off your images. As with transitions, however, it is easy to overuse effects, leading to campy, heavy, or awkward imagery. So experiment, play, and ultimately use only the ones that highlight your footage, your storyline, and the mood you are creating in your video.

**Figure 10.16** The dim lighting in this image gave it a slightly natural vignetted look, which I enhanced by adding an effect. The vignette accentuates the couple in the center and provides a soft and romantic feel.

## Working with Speed and Motion Parameters

Lots of editing applications offer the ability to slow footage down, speed it up, or resize an image, which can be used with compositing to create split-screen images. Speed and motion changes might be used either stylistically or correctively. For example, split screen is a great way to show a toast and a reaction, or a bride and groom getting ready separately. Slowing a piece of footage down is a good way to cut out a camera move or bump that makes the footage jarring while leaving the clip long enough to fill an allotted space in your sequence, such as a piece of music.

## Sound Editing

Most editing applications enable you to mix several different audio sources in your final sequence. As mentioned, the sources will be mixed *additively*, meaning that you will hear all the sounds together, not just the top track.

Here are some of the audio tracks you might include at different points in your sequence:

- **Natural audio.** Natural audio is the audio attached to the video clip, such as the recital of vows as you watch them being performed.

- **Synced audio.** Sometimes, the best audio track of an event comes from a different source than the best video track. For example, a close-up camera (or a dedicated sound recorder) might get the best audio of the toasts, while a camera much farther back in the room might get a beautiful wide shot that shows the guests and their reactions. In this case, you could swap the natural audio for a better track of the same thing, matching it to the best video coverage. (Syncing footage was discussed earlier in this chapter.)

- **Music.** Using music either with or instead of your natural audio can add professionalism to your video. One good technique is to make edit points (the transition points between different clips) on the downbeat of the music. This makes watching the video feel smooth and relaxing, as your eye anticipates the changes it will encounter. Of course, you should choose music appropriate to the event. I always ask the bride and groom to suggest music they like, and I pay attention to the actual music at the event so I can use some recorded versions of their musical selections. (See the sidebar on music rights, which discusses when it is permissible to use copyrighted material in your work.)

- **Voiceover.** You might have pieces of interview footage that could work well over prettier footage than simply the talking head giving the interview. Say, for example, you have interview footage of a bridesmaid talking about making all the place cards and table centerpieces for the bride. You could separate that audio from the video of the bridesmaid's interview and lay the audio track over the shots of the empty, set-up reception room. That will enhance both the interview footage and the room shots. Interview audio, music, and pretty images can work well together in almost any scene of the wedding sequence. You can also add voice that is recorded after the fact to your sequence. Many editing applications have a voiceover tool that enables you to speak into a computer microphone and have your voice recording wind up as an audio clip right on the timeline. This is fun if you want to add some humorous narration or transitions.

- **Sound effects.** Sound effects are a fun way to make the audio richer and more robust. Sounds you might add include laughter, applause, a car honking (picture the couple driving away at the end of the night), a champagne bottle being opened, or glass being broken (a Jewish wedding custom). The events at your party will determine which sounds you might add. Many editing programs offer collections of sound effects you can add; there are also thousands of sound effects available for free download on the Internet.

As mentioned, it is a good idea to keep the types of audio you are using on separate tracks. For example, put all your natural stereo audio on tracks one and two, all your stereo music on tracks three and four, a mono voiceover on track five, and sound effects on track six. This allows you to easily increase the volume of one type of audio or temporarily turn certain tracks off so you can listen to your piece without, say, the music or the voiceover (or whatever track you want to temporarily eliminate).

Once you have all your audio tracks in, you will want to mix them so that the levels sound good together. Your editing application should have a digital output meter; make sure the output volume of all your tracks combined doesn't exceed 0 dB (decibels), as digital audio has the tendency to peak and distort above that level. (See Figure 10.17.)

---

**Tip**

Sound editing is an art. If you find you enjoy it, there are lots of applications that will enable you to do incredibly complex manipulations with filters and give you the ability to look at sound waves in fractions of frames. (Pro Tools, Soundtrack Pro, Garage Band, and Logic are a few.)

---

**Figure 10.17**

A mix tool enables you to see the output levels of each track as well as a combined master output. Not every application will offer the ability to see individual tracks, but you should always have a view of the master, combined output. Make sure that one stays below 0 dB!

## Music Rights

Music rights are a big issue among wedding videographers, who frequently use unlicensed materials in their work. While I do not at all support the illegal use of music, there is little to be concerned about if you are not making any money off your work. Creating a piece with unlicensed music for a small family audience does not constitute a copyright infringement. In this situation, DIY videographers are different from professionals, who by definition are making money and should not be using unlicensed tracks.

If you have the intention of making money off your work, or if you have visions of your video becoming the next Internet sensation viewed by millions, you should be careful about the music you choose. Do it right from the start, and don't use unauthorized tracks. Natural audio is fine; or, if you need some additional music to overlay, consider buying *royalty free* music, where a very low, one-time fee will enable you to use the music in any situation. There are dozens of royalty-free music sites; a quick Google search will give you an inexhaustible supply of options.

# Additional Resources

This chapter is not intended to be the definitive guide to wedding video editing, but instead to provide you with ideas and basic skills to get your video going. It is my experience that actually editing video is the best editing teacher, because you will come across questions to which you must figure out the answers. If they aren't provided here, following are some additional resources that can help you, especially as they pertain to your nonlinear editing system.

- www.lynda.com

- www.onetakedv.com

- www.adobe.com/support/premiere/

- www.apple.com/support/finalcutpro/

- http://documentation.apple.com/en/finalcutpro/

- http://windows.microsoft.com/en-US/windows-vista/
  Getting-started-with-Windows-Movie-Maker

# Next Up

With a finished video sequence on the timeline, all you have to do is make sure it is in a format everyone can view and enjoy! We'll talk about ways to export and present your video in the next chapter.

# DIY Idea: Credits Where Credits Are Due

In addition to recognizing the people who helped make the event happen, the credit sequence of your video is a great time to interject some humor and personality into your piece. As you are editing the raw video, watch for bloopers, questionable interview answers, and funny images. Did the minister say the wrong names? Did grandma do vodka shots? Moments that might not be appropriate for the actual video (or moments you want to feature again, because they are so good!) are perfect for the credit sequence.

*Split frame*, sometimes called *picture in picture*, is a great compositing tool to incorporate multiple images on one frame in your video. First, stack all the video you want on the timeline. You might have two title tracks and a video track, or a still frame, or two video tracks—whatever! Remember that when video is added at full opacity, you see only the top track. In split frame, we will change the size of the video image on each line so that they are smaller than 100 percent and the images below them are visible. Once smaller, we can move the timeline tracks around the frame like tiles to create the exact layout we want.

In Premiere, changing the size of the media on a given track requires selecting the clip on the timeline and opening the Motion Controls tab, where you will find the Motion properties. Under the Motion properties, you can change the scale, position, and rotation to make all the tracks fit in one video frame. (See Figure 10.18.)

*This panel references the motion characteristics of the Remy Horror image, which has been resized to fit the black matte on which it is sitting.*

*These are six layers of video, stacked on top of each other. Because some layers are resized and the font is superimposed, all the layers show.*

**Figure 10.18** In this point in the credit roll, six layers of media are composited on top of each other, a few of which have been shrunk to make room to see the others (some of the text remains at 100 percent). In this case, you can see the Motion parameters for the picture of the best man, the track that is highlighted in the timeline.

Image courtesy of istockphoto.com/mphotoi.

# CHAPTER 11

# Output and Sharing

**In this chapter:**

- Sharing your photos
- Sharing your videos

For a professional, the job isn't over until you've presented your work to the client. This can be done a number of ways. Presentation might happen in stages, with photo proofs and draft videos that come before the final versions. Alternatively, it might simply be a transfer of the raw media. It could be loose prints, an album of images, a hard drive, a DVD, or an email link to an online gallery. Regardless of the arrangement you have with the couple, you'll want to make sure you present them with a product they can enjoy and share.

# Sharing Your Photos

After your photos have been culled, adjusted, and ordered, you are ready to output those files on your computer. *Outputting* might mean uploading to a photo-sharing site or making prints to collect in an album or box. Following are some ideas.

| Tip |
| --- |
| Before you output your images, I strongly recommend you back up the entire collection of photos on a small external hard drive or a DVD. Another complete set of images can be made for the couple at the same time, and in the same manner. |

## Photo-Sharing Sites

It's easy to create an online album of photos, and dozens of websites will host them for you. Depending on the number of pictures you are outputting, consider making one big album and one highlights album; that way, viewers can take the long route through the day or opt for a shorter version. Your couple will like having a pared-down set of shots that they can send to a wider audience.

A few that I especially like are Zenfolio (www.zenfolio.com, shown in Figure 11.1), PickPic (www.pickpic), and SmugMug (www.smugmug.com). Although none of these sites are free, the customization options, ease of use, and clean, professional look are worth the relatively low price. Shutterfly (www.shutterfly.com, shown in Figure 11.2) is an excellent free site. While their options for customization aren't as nuanced or elegant as some of the paid sites, it is simple, straightforward, and well-designed.

Here are some considerations for choosing a site to host your images:

- **Cost.** Many sites are free, while some charge for storage. Often, you will find different levels of membership within a single site, with the most basic version being free and a paid subscription model offering additional features such as more storage space and fewer advertisements.

- **Privacy.** Most sites will allow you to password-protect your images. However, some privacy features are easier to use than others. Couples are often quite protective of their event, so make sure you have a privacy feature that is easy to work with if it is important to the couple.

- **Comments, contributions, and downloads.** Some sites are more interactive than others. Do you want viewers to be able to comment on your photos, download your images, and upload their own? That can fun—and keeps with the spirit of a DIY project. On the other hand, given the amount of work you have put in, you might choose to maintain the integrity of the album as you designed it. Although many

**Figure 11.1**
Zenfolio allows you to easily customize the look of your site, changing the colors, fonts, and basic layout between galleries, as well as more advanced features such as selling options.

**Figure 11.2**
Shutterfly is an excellent free site, with an easy to navigate design.

sites allow you to download images for free, many professional photography sites facilitate payment schemes so that different-sized images can be downloaded by viewers for a fee payable to the photographer. Depending on the agreement between you and the couple, this might be worth exploring.

■ **Prints and merchandise.** Lots of photo-sharing sites enable visitors to purchase prints and other items personalized with your images—T-shirts, mugs, magnets, calendars, cards, etc. Make sure the site you use has a decent reputation for their printing, and take a peek to see if you think their merchandise is something your circle of friends might like. (See Figure 11.3.)

■ **Accompanying video.** If you are uploading video as well as photos, you might want to choose a site that accommodates both in a user-friendly way.

■ **Thematic aspects.** Some sites are specifically oriented around family events and offer associated features, such as video capacity, timelines, and maps. Of course, some thematic sites are all about skiing photography, cat pictures, and rock star images. Choose accordingly.

■ **The look and feel of the site.** The hardest to describe, but likely the most important, is the look and feel of the site—the aesthetic of the design and the ease of use. Is it elegant? Slick? Corporate? Pretty? Ad-riddled? Make sure your photos are housed on a site that you like the look of (or that you can customize) and can manipulate easily and quickly.

**Figure 11.3**
The product customization options can be quite intricate. For this card offered by Zenfolio, you can customize the orientation, paper, colors, writing, and coating.

# Making Prints

It is easy to order prints of your digital images online. Just specify the size, the quantity, matte or glossy, and border or borderless, supply your payment information, and *voilà*! Images at your door. Most photo-sharing sites will also offer printing for standard sizes, which is by far the most convenient way to go; you only have to upload once, and viewers of your gallery can order prints here too. If you don't like the printing options or quality of the site you are working with (I've never had major problems), one highly recommended printing site is White House Custom Color (www.whcc.com), which is affiliated with PickPic.

Of course, you can also print images yourself on a digital photo printer. This is no small endeavor, however—and often significantly more expensive than ordering from a lab. I recommend that you discuss the style your couple wants and gain some familiarity with your printer options, ink, and settings before you take on the printing task; the experimentation involved can be expensive and time-consuming. Here are some considerations if you are going to make your digital prints at home:

- **Choose your paper and ink carefully.** Different inks will look, smudge, and age differently. Some experimentation will teach you what works best. It is generally agreed that inks made by the same manufacturer that makes your printer will do a better job. As well as deciding about the weight and finish of the photo paper, the ink being used should be considered, as certain papers are made for certain inks.

- **Uncompressed version.** The images you upload and send around are likely to be compressed files, such as JPEGs. Ideally, though, you aren't printing from those files. Instead, print from an uncompressed version of your image, such as a TIFF. The files are much bigger, but you will get smoother and cleaner images.

- **High resolution.** Make sure you are printing from a high-resolution version of the image so you have enough pixel data for a clean, crisp print. A general rule of thumb is there should be no fewer than 200 pixels of data per inch of printing. So if you want a 4×6-inch print, you should have at least 800×1,200 pixels; for an 8×10-inch print, you should have at least 1,600×2,000 pixels. While more image data is generally good, you actually *can* get too much data; with too much resolution, your image might get artifacts or jagged edges. Every image, printer, ink, and paper combination will be slightly different, but a resolution of between 200 and 300 pixels per printed inch is a safe bet. (See Figure 11.4.)

- **Dots per inch.** Your photo printer will likely have different settings for the amount of ink it uses, or *dots per inch* (dpi). Higher dpi means richer images. Although you will go through ink faster, don't skimp on your dpi; make sure to start at 300 dpi.

- **Printer configuration.** Higher-end digital printers will have a lot of parameters that can change how rich your images look. Spend time getting to know your printer so you can place the settings to match your paper and ink decisions, as well as the settings for quality.

*More pixel data*

*Less pixel data*

**Figure 11.4** More pixel data allows you to display and print an image at a larger size without losing quality.

## Compiling Albums

Before digital wedding photography, the wedding album was the culmination of the photographer's hard work—carefully printed images placed in a beautiful book, often with matting and vellum to protect the images. Typically, these albums contained one 8×10 formal shot followed by another and another and another....

Digital photography allows for a more journalistic approach to weddings, which has in turn dramatically changed album presentation. For some couples, the album is less important; the collection of digital images serves as its own album of sorts. For others, the album remains important although much changed, as there are so many more options available. Following are some different wedding-album styles:

- **Slip-in album.** In a *slip-in album*, a photograph is bound (taped or glued) to a mat, which is then slipped into a page, which might be in turn slipped into the album or permanently bound in it.

- **Matted album.** In a *matted album*, an image is permanently glued to a page, with a mat placed over it. The mat will be slightly raised from the surface of the image, so opposing images won't touch each other. In a matted album, mats can be custom cut; you can have as many images as you want per page, in various sizes.

- **Flush album.** A *flush album* has one image per page, pressure glued to cover the entire page.

- **Digital album.** Usually printed and bound like a coffee-table book, digital albums mix the look of a flush album with the variety of a matted album. Images can be printed to cover a whole page or custom sized to incorporate several per page. Borders, backgrounds, and effects can be added.

A quick Internet search will indicate there are dozens of styles of albums: leather, linen, monogrammed, coffee table paper, etc. Most album designers will allow you a great deal of creative control within the guidelines of their album specifications. The costs involved will vary according to the quality and type of album, the type of binding, and the number and layout of the pages.

Many image-hosting sites include albums among the products they provide. If you don't like the look of the albums your hosting site offers, most album manufacturers also will use your images to create your album for you. I like the look of Kolo albums (www.kolo.com); they are sturdy and well made, while having a fun and colorful look to them. Of course, there is an album for every taste; you might opt for something more delicate or more masculine.

To go completely DIY, you can take album design a step further and build one yourself using mats, tape, and glue to add your pictures to an album you purchase. A high-quality art-supply store or paper shop will help you locate the mat-cutting equipment, tape, and glue you should use for the album you choose. It is unlikely this will be a less expensive process, and it will certainly be significantly more time-consuming, but it can be a lot of fun—and you will have complete creative control.

> **Tip**
>
> If you have a particular image from your gallery that you want to showcase (as opposed to the whole collection), a specialty frame or digital image printed on canvas can be a wonderful gift for the bridal couple or their families. Shutterfly is one company that prints images on canvas.

## Assembling Images in Photo Boxes

If you are looking to cut costs, an alternative to the album is a photo box. It is a less elegant display piece; photos are printed and kept loosely to be handled, rifled through, and pored over. You certainly run a higher risk of image degradation, as the prints will be continually touched. On the other hand, digital prints can be re-created relatively inexpensively, should something like a cup of coffee or a toddler's sticky hands meet them or when time takes its toll: Matting the images helps combat that problem. For the significantly lower price of a high-quality, well-constructed box, you can have a beautiful keepsake—a trousseau of images.

Like albums, photo boxes have numerous constructions, styles and sizes; you can get wood, metal, or a cloth-covered, heavyweight box. Kolo and Archival Methods are two companies that make beautiful cloth-covered boxes designed exactly for this purpose.

# Sharing Video

Even when the last titles and transitions are placed, the audio is properly mixed, and your video is fully edited, you don't *quite* have a piece that you can show off…unless your audience is standing next to your computer. Without your editing software and the raw media, the video file will not be very useful until it has been *exported*. Exporting the file creates a version (usually compressed) that can be viewed easily on a number of platforms. The exported version will contain the media instead of the pointers to the media (like the sequence in your editing software), which means you can view it independently of all the video clips.

Editing applications often have an Export or a Share menu that lists a lot of viewing platforms for your file, such as YouTube, iPhone, DVD, or Blu-ray. Simply determine where the video will be used and select accordingly. You will most likely make lots of versions of your final movie, using different output options for the versions that will be viewed on YouTube, from an authored DVD, or on an iPad. (See Figure 11.5.)

**Figure 11.5**

The export presets in your nonlinear editor make it easy to determine what settings you need for your given destination.

**Tip**

Before you export, look into adding chapter markers for longer sequences. This allows users to move through the video by section. Find out what chapter-marking capabilities your editing system has; some are simple placeholders to improve navigation, while others are robust, with the potential to add titles and images.

After making all the compressed versions of the video, you also need to export an uncompressed master file. This will serve as both a high-quality version of the video that can be viewed on a desktop or laptop and used as your archival video. Even without the raw media, you will be able to reimport the final, uncompressed version of the video back into your editing system and make changes if need be, without losing image data to compression.

In addition to an uncompressed master video sequence (which you can give your couple on a hard drive or a data DVD), following are some other ways to share your video with them.

## Video-Sharing Sites

Like photo-sharing sites, there are a number of websites on which you can host a video for your couple. Many sites, in fact, host both photo and video. Most of the considerations for hosting video are the same as for hosting photos, as discussed previously; cost, privacy, comments, and the look of the site should all be factors in your video-hosting decision. Another key factor is the ability and ease of *embedding* the video into another website—using code on your own (or any) website that will draw the data and play the video from the video hosting site.

Vimeo (www.vimeo.com) is an excellent hosting site that offers both a free and a professional version. The site's look is extremely clean, and it is very easy to use. The professional version allows for files large enough to post long videos at high resolution (see Figure 11.6). The privacy feature makes it an excellent way to screen both rough cuts and final versions for the intended audience(s), and the site's embedding tools help facilitate easily sharing.

An additional and perhaps the most major consideration is how large a file you can post. If you want to display a three-minute highlights video, you won't have any problems. But if you are looking to post a full-length video, you will find that some sites either won't accept such a large file or will force you to compress your video to such a degree you might not find it acceptable. If you plan to post a longer video, you will have to consider breaking it into pieces or hosting it on a site that you (or the couple) pay for.

**Figure 11.6**
The professional version of Vimeo makes it easy to privately post long rough cuts. (This one is 46 minutes!) This is a great way to solicit feedback from key individuals before you are ready to post your final version.

## Authored DVD

There are two types of DVDs that you can burn from your computer:

- **Data DVD.** A *data DVD* simply holds files. These files can be of any format as long as they fit on the disc. (A standard blank DVD holds 4.7 gigabytes, a dual layer DVD holds 8.5 gigabytes, and a Blu-ray disc holds 25 gigabytes.) A data DVD is a handy way to back up and transport your files.

- **Authored DVD.** An *authored DVD* (regular or Blu-ray) is encoded so that when it is put in a DVD player on your computer, television, or gaming station, it will go through a series of steps. The steps might be simple ("play video") or involve some complexity, including menus and viewer interaction. Authored DVDs require video files to be encoded into a certain format (which differs for regular and Blu-ray DVDs) and imported into a DVD-authoring application. The DVD-authoring application will facilitate menus, allowing the viewer to specify which video, or which part of a video, they want to access. DVD creation can become a very elaborate process, with menus containing audio, video, and images. (See Figure 11.7.)

**Figure 11.7**
An authored DVD makes it easy for the viewer to skip to certain sections of the piece. It can have any number of menus, such as an opening menu (top) and a scene-selection menu (bottom).

## Compression

*Compression* is term often used without clear understanding. It is helpful to have a basic idea of how compression works so you can make adjustments to the basic compression formulas offered in your Export or Share menu, if needed.

Compression eliminates the spatial and/or temporal redundancy in the pixels that create video images. Different compression schemes take advantage of both spatial and temporal image redundancy. *Spatial redundancy* refers to blocks of color within a single image. If the pixel colors are identical—or similar enough—a block of color can be reduced to one piece of data through compression. For example, instead of storing data for each white pixel in the bride's gown, the compression operation will label small blocks of pixels with the same white color—an average of the white colors of the pixels in question. Although some detail may be lost, the human eye is not nearly as adept at discerning color, or hue, as it is brightness; with small enough blocks of pixels being averaged, spatial compression is often unnoticeable. *Temporal redundancy* refers to pixel changes—or lack thereof—over time. For example, if a bride stays in the same position for two seconds, moving only her head, all the visual information pertaining to her dress—60 frames' worth—can be compressed into a smaller piece of data. With high levels of temporal compression, a piece of video will look jumpy and jarring, but there can often be quite a bit of temporal compression before that happens.

Normally, your experience of compression will be a simple matter of selecting a preset compression standard as you output the sequence from your editing software to create a file appropriate for the device on which it will be viewed. However, you might find yourself in a situation where you need to tweak the standard settings to make a file smaller or to make the compression look less jagged. In addition to file type, here are some of the most important factors that influence compression:

- **Size.** This determines the output screen size, measured in pixels. Reducing the size of the image is by far the easiest way to reduce your file size. This works very well until the size of your video becomes too small to comfortably view or unless you need a standard size for the output.

- **Data rate.** Also called the *bit rate*, the *data rate* is the amount of information that can be transmitted during each second of playback. Lowering the data rate increases compression.

- **Keyframes.** When compressing a video file, certain frames spaced at regular intervals are compressed with spatial techniques (like JPEG), not temporal ones. These frames are called *keyframes*. Compression utilities use keyframes as image-data benchmarks, extracting spatial and temporal data from the frames in between, or *intermediate frames*. The spacing of keyframes is a big determinant in how much the piece is compressed; more keyframes, or frames with more image data, mean less overall compression.

There are a number of DVD-authoring applications, some associated with an editing application in the same suite. Once you have exported a video file (you will need to export to different formats for regular DVDs and for Blu-ray DVDs), you can bring it into any DVD-authoring application. Some common ones are Adobe Encore, Roxio Toast, iDVD (Mac only), Sony DVD Architect (PC only), and WinDVD (PC only).

## DIY Idea: Screening Party!

A DIY wedding tends to rely heavily on the close group of friends and family who lend their time, skills, and energy to making the wedding happen. A small event to thank the people who helped out, like a potluck or dessert gathering, is a nice gesture from the couple. It also serves as wonderful opportunity to use all those new kitchen gadgets, honor people for the tasks they performed, drink any leftover wedding wine, and of course show off all the hard work that was put into the photo album and wedding video! (See Figure 11.8.)

**Figure 11.8**  A DIY wedding relies on close friends and family helping out. Count your blessings!

# Glossary

## A

**action mode**   A semi-automatic camera mode that is helpful for shooting fast-paced action because shutter speed and/or ISO are increased.

**aperture**   The opening through which light is passed to the camera sensor. The amount an aperture is opened helps determine the amount of light allowed onto the sensor, and therefore exposure of the image.

**aperture priority mode**   In this shooting mode, the user chooses the aperture setting, and the camera will determine shutter speed. This setting is useful to control depth of field.

**artifacts**   Various types of image degradation caused by processing.

**aspect ratio**   The ratio of the width of an image to its height.

**automatic focus lens**   A lens that will automatically focus when the shutter is half pressed.

**authored DVD**   A DVD that is encoded to follow certain playback instructions when placed in a DVD player.

## B

**backlight**   A light used to illuminate the subject from behind.

**bin**   A folder used to organize media in video-editing applications.

**bird's eye**   A camera angle obtained by placing the camera above the scene and shooting down.

**bit rate**   The amount of data processed over a specific amount of time, usually seconds. This is a factor in compression schemes. Lower bit rates decrease file size and increase compression. Also called *data rate*.

**burst mode**   A camera mode that allows for a sequence of images to be taken in rapid succession. Also called *continuous mode*.

## C

**camcorder**   A portable video camera and recorder in the same unit.

**channel mixing**   Channel mixing is a way to change the color components that make up an image in an image-editing application.

**chapter markers** Designated points in a video sequence that enable the viewer to easily access different parts of a finished video.

**chrominance** Color information.

**clip** A small section of video.

**Clone tool** An image-editing tool that copies pixels from one part of an image to another part of the image. Also called a *rubber stamp*.

**close-up** A type of shot in which the subject fills the whole frame.

**cloudy setting** A white-balance setting used to warm up the cool tones in cloudy or shady settings.

**color correction** The process of altering the colors in an image to print the image, to display it properly, or for special effects.

**color temperature** A measurement used to determine the color of light, which may often present different color casts.

**compact camera** See *point-and-shoot camera*.

**compositing** The combination or stacking of multiple visual elements in an image-editing application.

**composition** The way in which visual elements are placed within a frame.

**compression** A way to store image data using fewer bits.

**contact sheet** A set of multiple images printed at the same size on the same page or a group of pages used to look at an entire collection of images.

**continuous mode** See *burst mode*.

**contrast** The tonal range, or amount of distance between blacks and whites in an image.

**crop factor** A measure of a digital camera sensor size in relation to a full 35mm film format.

## D

**data DVD** A DVD that holds information stored in unauthored files that can be read on a computer.

**data rate** See *bit rate*.

**daylight setting** A white-balance setting that is considered "neutral" or "normal." It does not need warming or cooling for balance.

**depth of field** A measure of at what depth, or distance, an image comes into focus.

**desaturate** The removal of color intensity from an image.

**digital album** A wedding album in which the images are printed directly on the bound pages.

**directional audio** A microphone that picks up an audio signal in a particular direction, or vector, as opposed to all around it.

**dissolve transition**   A type of transition between clips of video where the opacity of the outgoing clip decreases as the opacity of the incoming clip increases, creating a soft blend of the two.

**dolly**   An advanced camera move that places a video camera on a cart (or other moving vehicle) to enable smooth movement of the camera in relation to the subject.

**dolly zoom**   An advanced video camera move that combines the smooth physical movement of the entire camera in relation to the subject with a zoom of the camera lens.

**DPI**   Short for *dots per inch*. A measurement value used to describe how much visual information a printer will provide.

**DSLR**   Short for *digital single lens reflex*. A type of digital camera whose viewfinder looks through the same lens that the camera uses to make the image.

**Dutch tilt**   A camera angle obtained by tilting the camera to one side so that the horizon is on an angle.

**dynamic range**   The ratio between the minimum and maximum light intensities of an image.

## E

**establishing shot**   An image that provides contextual information to the viewer, usually placed at the beginning of a video or series of photographs.

**export**   A software command that allows a file (or part of a file) to be saved, renamed, and/or put into a different file format, often for use in a different application.

**exposure**   The process of allowing light into the camera to produce a recorded image.

**extreme close-up**   A type of shot in which the subject covers the whole frame, often so close that not even the entire subject will fit.

**extreme wide shot**   A type of shot that is so wide, it may not have an obvious subject. Often used to establish context.

**eye-level angle**   A camera angle that is generally neutral, appearing to the viewer as a real-world or expected perspective.

**eye line**   The direction in which someone is looking.

## F

**f-stop**   A number given to the size of an aperture. The f-stop value is inversely proportional to the size of the aperture.

**fade to black**   A type of transition on a video clip or between two video clips where the opacity of the outgoing clip is brought to zero, or black.

**fill light**   A small light used to illuminate, or fill in, the areas of a scene that might otherwise be in shadow.

**filter**   A particular effect that can be applied to an image or part of an image.

**fixed-focus lens**   A lens with one focus length, as opposed to a zoom lens.

**fixed-head tripod**　A tripod whose head remains in one specific orientation until changed by the user. Good for still video shots and photography.

**fisheye lens**　An extremely wide-angle lens that distorts the perspective of an image.

**flash transition**　A type of video transition where a few frames of white are shown between clips, mimicking the flash of a camera.

**fluid-head tripod**　A tripod whose head sits on an oil or similar fluid so that the camera can be moved smoothly while shooting. Good for camera moves, as it reduces likelihood of jerky, jagged motion.

**flush album**　A wedding album whose images are adhered to the pages (or onto cards adhered to the pages) directly, without mattes.

**fluorescent setting**　A white-balance setting used to warm up the cool tones of fluorescent lighting.

**focal length**　The distance between the center of a lens and the point at which it is focused.

**formal shot**　Posed portraiture of individuals and groups.

**freeform crop**　A post-production cropping of an image that doesn't follow traditional aspect ratios.

## G

**gain**　The amplification of a signal.

**gamma point**　A luminance measure that represents the midpoint between an image's black and white levels.

**grayscale**　An image composed in blacks, whites, and grays.

**Gaussian blur**　A type of blur, based on a specific mathematical function, commonly used to smooth images in an image-editing program by reducing noise and detail.

## H

**head**　The portion of the tripod that includes the plate to which the camera is attached.

**headroom**　The visual space between the top of a subject and the top of the frame.

**Healing Brush**　A tool in Photoshop that paints over pixels with image data selected by the user to cover an image flaw such as a blemish, stray hair, or dirt.

**high angle**　A type of shot where the camera is positioned above the eye line and is shooting downward onto the subject.

**high definition**　High definition, or HD, video refers to any video with a higher resolution than standard-definition (SD) video. Common HD resolutions include 1,280×720 and 1,920×1,080.

**histogram**　A graph of the distribution of tones within an image.

**horizontal resolution**　The number of pixels in the horizontal field of an image.

**hot shoe**  An accessory holder on the top of a camera or camcorder that allows a flash or other accessory to be stably mounted.

**hue and saturation**  Hue is the color component of a given pixel; saturation is the amount or quantity of that color. Together, they can be adjusted in post processing to change the color profile of an image.

# I

**import**  To bring a file into a software application, usually to be manipulated.

**in point**  A marker used to designate the beginning of a selection, or clip, in video editing.

**insert edit**  A type of video edit where a piece of media is added between other pieces of media. Everything after the inserted material shifts to accommodate the new media.

**intervalometer**  A piece of equipment that controls a camera, triggering it to shoot pictures at regular intervals.

**ISO**  In film photography, a measure of the film's speed, or light sensitivity. In digital photography, a measure of the sensor sensitivity.

# J

**JPEG**  Short for Joint Photographic Experts Group. An extremely common compression scheme for images.

**jump cut**  An edit point that is visually jarring, usually because the same subject is in a similar but slightly different position and/or framing in two consecutive shots.

# K

**key light**  The primary light source used to illuminate a subject. Also called *main light*.

**keyframe**  In animation, a keyframe is a frame with defined parameters; animation can then be interpolated across the intervals in between keyframes. In a compressed file, a keyframe is a frame that is encoded using spatial but not temporal techniques.

**keywords**  Inputtable data that enables you to categorize and describe your video clips and still images, making them easier to sort and search.

# L

**landscape mode**  A semi-automatic camera mode that is helpful for shooting landscapes. In this mode, a small aperture provides a large depth of field, allowing many parts of the image to be in focus.

**layer mask**  A tool in Photoshop that allows part of an image layer to be blocked, or masked, from view. Useful for compositing image layers.

**lens correction**  A tool in Photoshop that allows correction of common lens flaws.

**levels slider**  A tool in Photoshop that allows adjustment to the brightness of an image by moving and stretching the image histogram.

**logging**  The organizational process of adding notes about video clips to describe content or quality.

**low angle**  A camera angle that shows the subject from below, with the camera pointed up.

**luminance**  Brightness information.

## M

**macro lens**  A lens designed to take pictures unusually close to the subject.

**main light**  The primary light in a lighting setting. Also called a *key light.*

**manual mode**  A camera mode that gives the user complete exposure control.

**mask**  A method to protect certain parts of an image from being altered by exposure to filters in an image-editing application.

**master shot**  A type of shot that is wide and static. Also called a *safety shot.*

**matted album**  A wedding album in which the printed images are matted (mounted on stiff cardboard frames) and the mats are adhered to album pages. The mat serves to both preserve and artistically present the image.

**medium close-up**  A type of shot that shows a person from the shoulders up.

**medium shot**  A type of shot that shows a person from the waist up.

**megapixel**  One million pixels. An easy way to round and describe the exact resolution of a camera sensor, which is the number of horizontal pixels multiplied by the number of vertical pixels.

**metadata tag**  Information about a particular piece of data, which helps describe the content and context of the data itself. In the case of digital photography, a metadata tag might provide information about how an image was taken, such as the exposure variables.

**monopod**  A single pole or stick used to support a video or still camera and prevent movement in the vertical plane.

## N

**natural audio**  The audio that is linked to the video in a given scene. This represents the noise that actually occurred as opposed to effects, music, or voiceover that may be added afterward.

**night mode**  A semi-automatic camera mode that is helpful for shooting at night. It provides a long shutter speed to capture background details as well as a short flash burst to illuminate the subject.

**noise**  An undesirable feature of some image capture, characterized by unusual variance in luminance and chrominance data.

**non-destructive image editing**  An editorial process in which changes to an image are stored as a list and applied to an image in real time so that no data in the original version is lost or altered.

**non-directional audio**    A microphone that picks up all the noise around it equally.

**non-linear editing**    A type of video editing that permits random access to any given piece of footage and allows *insert edits*, or edits that place a video clip between other existing video clips without erasing or covering any footage, but instead moving the surrounding footage.

**neutral density filter**    A camera filter that reduces the amount of light striking the sensor by nearly uniformly absorbing light.

## O

**optical zoom**    An enlargement of an image that occurs on the sensor by moving the camera lens to change the focal point of the image being captured.

**out point**    A marker used to designate the end of a selection, or clip, in video editing.

**outdoor setting**    See *daylight setting*.

**overscan area**    The area in a video frame that is outside the viewing area of a television screen.

**overwrite edit**    A type of video edit where a piece of media is added to a sequence, covering up anything that might have previously been there.

## P

**pan**    A basic camera move that refers to horizontal movement, either left or right.

**pedestal**    A basic camera move that refers to the movement of the whole camera vertically with respect to the subject, while maintaining a constant angle.

**picks**    See *selects*.

**picture in picture**    A type of split screen imaging in which one stream of video is embedded in a larger one, intended to show two things occurring at the same time.

**pixel**    A dot that represents the smallest element of data contributing to a digital image.

**pixel aspect ratio**    A ratio describing the width of a pixel compared to the height of a pixel. Pixel aspect ratios may be square or rectangular.

**playhead**    A moving icon that indicates where in a timeline any given frame of video is.

**plug-in**    A small application or piece of code that works within a larger editing application to provide specific tools.

**point of view**    A type of shot that shows the view from the subject's perspective.

**point-and-shoot camera**    An easy-to-use camera with mostly automatic settings.

**portrait mode**    A semi-automatic camera mode that is helpful for shooting portraits. A large aperture provides a small depth of field, allowing the subject to be in focus and softening the background.

**prime lens**    Technically, a prime lens is the first lens a camera uses. However, *prime lens* has come to mean the same thing as *fixed-focus lens*, or one that only has one focal point.

**program mode**   Similar to automatic mode, program mode controls many of your exposure settings for you but leaves some options in user control, such as flash and ISO. Different program modes vary, so it is important to read your camera manual.

## R

**RAW**   Pixel data that is uncompressed. It is one way to store image files, and it requires a post-camera processing that would otherwise be performed in the camera.

**red eye**   The red eyes that appear on an image when the camera flash is bounced off a subject's retina and back into the camera lens.

**red-eye tool**   A simple tool in most image-editing software to eliminate red eye in an image.

**reference white**   The definition of white used to set the rest of the colors in an image relative to it.

**resolution**   A measure of the amount of detail, or data, that an image holds.

**RGB mode**   Stands for red, green, and blue, which are the colors that combine to produce all other colors in your camera.

**rough cut**   The first draft of a video sequence.

**rubber stamp**   See *Clone tool*.

**rule of thirds**   An image composition technique that suggests key elements in an image be placed along horizontal and vertical axes that divide the image in thirds.

## S

**safety shot**   See *master shot*.

**saturation**   The dominance of a particular hue in a color. Effectively, the amount of a color.

**selects**   The images or clips chosen from all the raw takes in post production of photography or video.

**shady setting**   See *cloudy setting*.

**shooting ratio**   The ratio between the amount of footage shot and the amount of footage used in a piece.

**shutter priority mode**   In this shooting mode, the user chooses the shutter speed, or how long light will hit the camera sensor, and the camera adjusts the aperture accordingly.

**shutter speed**   An exposure control that determines how long light is allowed to strike the camera sensor.

**slip-in album**   A wedding album in which images are placed into the pages, but not adhered, offering easy removal, replacement, and rearrangement.

**slow sync flash**   A function on many cameras that gives a longer shutter speed as well as firing the flash.

**spatial redundancy**    Blocks of color in one image that can be reduced to one color to compress the amount of data needed for the image.

**split screen**    A video term to describe two pieces of video (or other media elements) playing at the same time in a given frame. Each piece of video must be reduced in size to play split screen.

**sports mode**    See *action mode.*

**Spot Healing tool**    A tool in Photoshop that paints over pixels with image data from neighboring pixels. Used to clean up small aberrations and blemishes in an image.

**sunny setting**    See *daylight setting.*

# T

**tally light**    A small light on the front of a video camera that indicates that the camera is recording.

**telephoto lens**    A camera lens that magnifies the subject, with a longer focal length and narrower field of view. The opposite of a wide-angle lens.

**temporal redundancy**    Blocks of pixels that change, or don't change, over time in sequential video frames, allowing reduction of data required to describe each frame.

**tilt**    A basic camera move in which the camera angle changes in the vertical plane, although the camera maintains a constant vertical position.

**time lapse**    Capturing a series of images at preset intervals.

**tonal range**    See *contrast.*

**tone**    The brightness of a particular pixel or portion of an image, ranging from highlights (light tones, white) to shadows (dark tones, black).

**track**    A layer of media in a video-editing application.

**transcode**    The process of translating a file from one format, or code, to another.

**transition**    The point between clips or scenes in a video.

**trimming**    The process of lengthening or shortening a video clip by adjusting its in or out points.

**TTL metering**    Short for *through the lens metering.* A mechanism that allows the camera to meter light through the lens used to expose an image.

**tungsten setting**    A white-balance setting used to cool down the warm tones of indoor tungsten (incandescent) light.

**two shot**    A type of shot that includes two people as the subject, usually, although not always, from the torso up.

# V

**vellum**  A strong and decorative paper made to imitate the smooth finish of a parchment made from animal skin.

**vertical resolution**  The number of pixels in the vertical field of an image.

**vignette**  A darkening of the edges of an image.

# W

**white balance**  A color-calibration method for a still camera or camcorder. By defining white, systemic changes can be made to display other colors accordingly.

**wide-angle lens**  A camera lens that diminishes the subject, with a shorter focal length and wider field of view. The opposite of a telephoto lens.

**wide shot**  A type of shot that encompasses enough scenery that it could show a person from head to toe.

**workflow**  The progression of steps between production, post production, and output of images or video.

# Z

**zebra stripes**  Stripes shown on an image in a camera or in image-editing software that indicate when luminance levels are too high.

**zoom**  A camera shot that moves from a wide shot to a close-up, or vice versa.

**zoom lens**  A lens with a variable focal length.

**zoom transition**  A type of transition between clips of video where the size of either the outgoing or incoming clip changes dramatically and then goes quickly back to normal.

# Index